LOOK AT LIFE

KODAK'S

LOCK AT LIFE

AWARD-WINNING PHOTOGRAPHS

Kodak International Newspaper Snapshot Awards 1991

Kodak's award-winning photographs come from the many entries in the Kodak International Newspaper Snapshot Awards (KINSA) contest. They are pictures submitted by amateurs around the world and are presented in KODAK'S LOOK AT LIFE.

Copyright © Eastman Kodak Company 1991. All rights reserved. Published by Eastman Kodak Company and Time-Life Books.

No part of this book may be reproduced or utilized in any form or by any electronic or mechanical means, including photocopying or information storage and retrieval devices or systems, without prior written permission from the publisher, except that brief passages may be quoted for reviews.

First printing. Printed in U.S.A. Published simultaneously in Canada

TIME-LIFE is a trademark of Time Warner Inc. U.S.A.

Kodak, Ektar, Kodachrome, and Ektachrome are trademarks of Eastman Kodak Company.

Library of Congress Cataloging in Publication Data

Kodak's Look at Life: Kodak's Award Winning Photographs, 1991.

p. cm.
ISBN 0-8094-8400-5: \$29.95
ISBN 0-8094-8401-3 (lib. bdg.): \$19.95
I. Photography, Artistic.
I. Eastman Kodak Company.
II. Time-Life Books.
TR654.K634 1992
91-41011
779'.09'049—dc20
CIP

CONTENTS

FOREWORD	KODAK'S KINSA AWARDS 1
CHAPTER I	Sharing Special Moments 3
CHAPTER II	The Year's Best 9
S	EECTION ONE CHOOSING BEST OF SHOW 11

Grand Prize 12

First Prizes 14

Second Prizes 16

Third Prizes 18

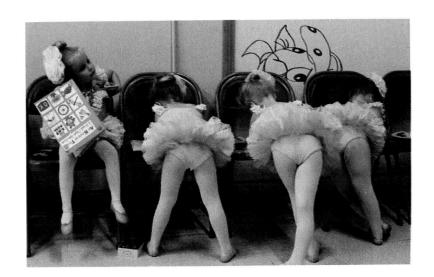

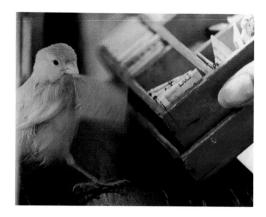

THE WORLD IN MOTION ACTION 22

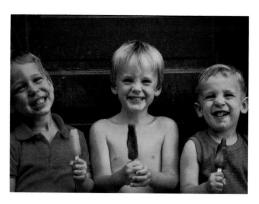

FAMILY AND FRIENDS PEOPLE 40

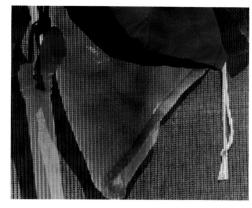

THE ARTIST'S EYE ABSTRACTS AND STILL-LIFE 58

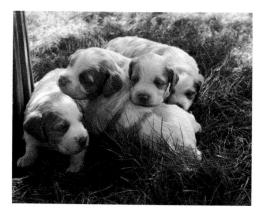

OUR CONSTANT COMPANIONS ANIMALS 76

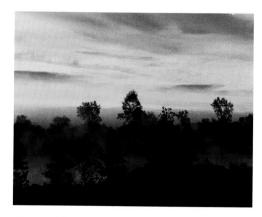

GRAND VISTAS LANDSCAPES AND SCENICS 90

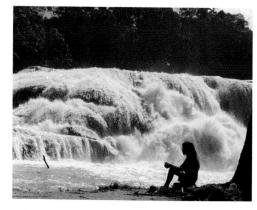

CELEBRATING OUR WORLD THE ENVIRONMENT 108

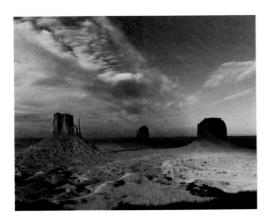

ENLARGING COLORS
KODAK EKTAR FILM 122

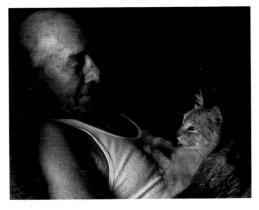

THE GOLDEN YEARS SENIORS 134

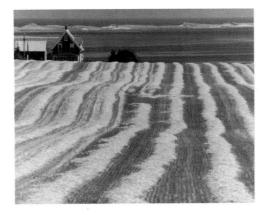

PRINTS FROM SLIDES
KODAK TRANSPARENCY FILMS 150

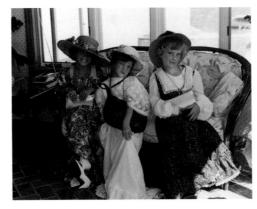

VISIONS OF THE HEART SPECIAL MOMENTS 164

CHAPTER III THE JUDGES 182

CHAPTER IV FIFTY-SIX YEARS OF KINSA PHOTOGRAPHS 188

Time-Life Books is a division of TIME LIFE INC., a wholly owned subsidiary of THE TIME INC. BOOK COMPANY

PRESIDENT: John M. Fahey

TIME-LIFE BOOKS

PRESIDENT: Mary Davis

PUBLISHER: Robert H. Smith

VICE-PRESIDENT AND ASSOCIATE PUBLISHER: Susan J. Maruyama

Marketing Director: Frances C. Mangan Production Manager: Prudence G. Harris

Editorial Director: Blaine Marshall

Editorial Administrator: Myrna Traylor-Herndon

EASTMAN KODAK COMPANY

Consumer Imaging Division

VICE-PRESIDENT AND GENERAL MANAGER: Peter M. Palermo

MANAGER, WORLDWIDE MARKETING COMMUNICATIONS AND SUPPORT SERVICES: James M. Gallery, Jr.

MARKETING COMMUNICATIONS DIRECTOR, SUPPORT SERVICES: Vivian Amos

MANAGER, PUBLICATIONS AND SUPPORT SERVICES: Jeffrey J. Pollock

KINSA Contest Coordinator: Janet N. Porter Marketing Coordination: Susan A. Lees

Editorial Coordination: Linda L. Cooney and Susan F. Morris

DOLEZAL AND ASSOCIATES

Creative Director: Robert J. Dolezal Design and Layout: Michael Yazzolino

PRODUCTION COORDINATORS: Tim Boyd and Stan Jenkins

Typesetting: Recorder Typesetting Network Separations and Stripping: Lanman Progressive Printing and Binding: Ringier America, Inc.

PAPER: Westvaco Sterling Web Gloss

FOREWORD

KODAK'S KINSA AWARDS

THE WINNERS OF THIS YEAR'S KODAK INTERNATIONAL NEWSPAPER SNAPSHOT AWARDS, OR KINSA, CONTEST are photographs to delight and surprise and even inspire. They were chosen as the best of 1991 from a field of more than 500,000 pictures sent to more than 160 newspapers in Canada, Chile, Mexico, and the United States. Each newspaper held its own weekly photo contest to select winners from its area's most outstanding pictures, then sent them to Kodak for the international judging and awarding of prizes by a distinguished panel of independent judges. This year, Kodak received more than 1,200 photographs, the largest number ever in the contest's 56-year history.

A total of 257 photographs were honored in this year's contest, with cash prizes totaling \$52,500. They included a grand-prize winner of \$10,000 for the best photograph entry, and two first place awards of \$5,000 each for the top pictures in color and in black-and-white. Two second place awards of \$3,000 and two third place prizes of \$2,000 were given in the color and black-and-white categories. In addition, 50 honor awards of \$250 and 200 special-merit awards of \$50 were presented for pictures taken in 10 subject categories.

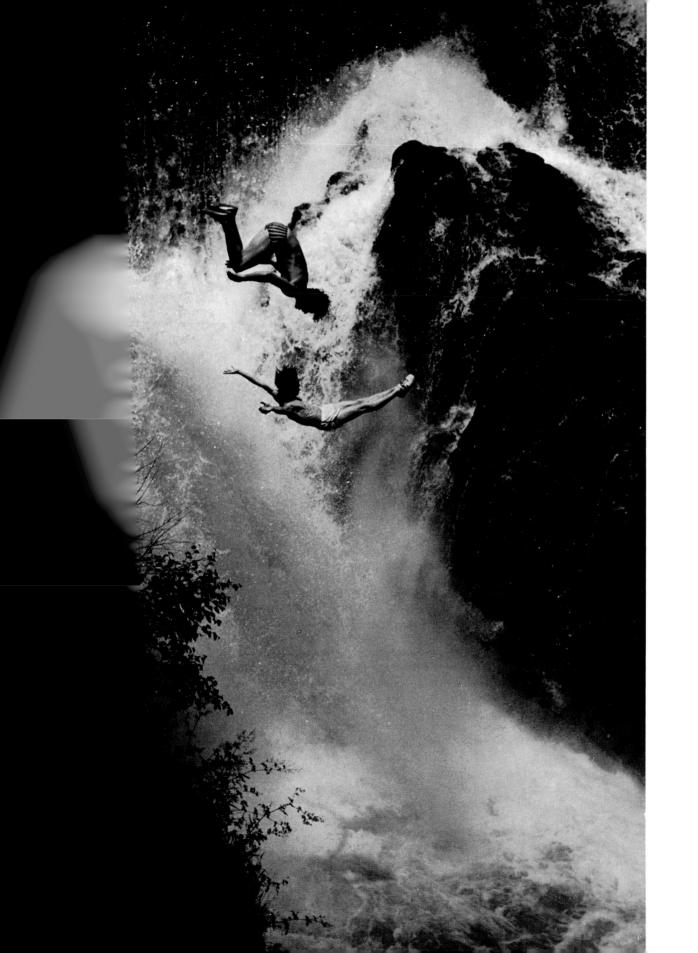

CHAPTER

I

SHARING SPECIAL MOMENTS

By JACK WEISER

DIRECTOR OF PHOTOGRAPHY TIME-LIFE BOOKS INC.

PANT IN THIS FIRST PUBLICATION OF THE PHOTOGRAPHS OF THE WINNERS OF the Kodak International Newspaper Snapshot Awards (KINSA), and to be able to view the exhibitions of the original photos at Explorer's Hall of The National Geographic Society and at WALT DISNEY WORLD EPCOT Center. These organizations, along with Time-Life and Kodak, have long shown their commitment to communication and education among the people of the world, a process often accomplished through the use of photography. Their participation in the KINSA contest reaffirms their support for the talented amateur photographers whose pictures bring a view of their lives and homes to a wide audience.

In my current position of Director of Photography at Time-Life Books, I spend my days happily immersed in thousands of photographs, but my interest in photography began in my youth. Like many children in the 1950s, I grew up in a home where the weekly arrival of *Life* magazine brought with it a huge variety of shared visual pleasures: photos of newsmakers, the world of nature, parties, famous personalities, entertainment, fads, world politics, sports—the magic moments of life in our time.

I received the chance to capture the magic moments in my own life when, at Christmas in 1955, I pulled from under the tree Kodak's sleek new Brownie Hawkeye camera.

OPPOSITE: Plunge into a waterfall, from the 1972 KINSA contest.

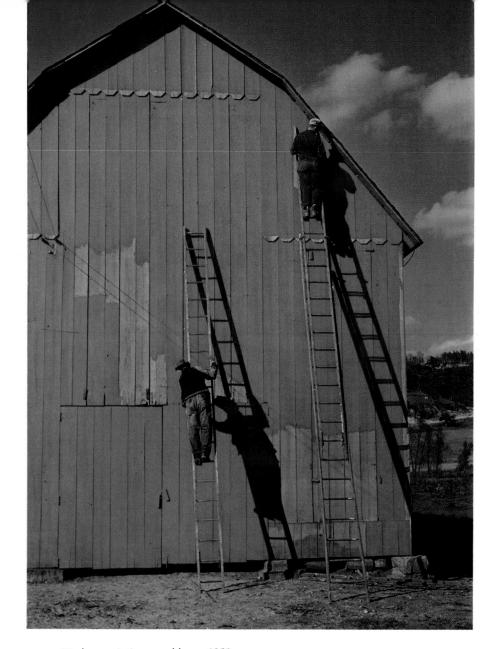

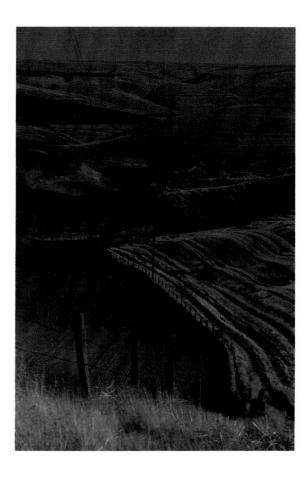

ABOVE: Workers painting a red barn, 1958.

RIGHT: A rural farm amidst wheat fields, 1963.

At first, I thought of the camera as a simple tool that would allow me to record a history of pets, places, and people that I knew. I diligently captioned and dated each photograph and placed it neatly in an album. As I became more proficient in my visual journal, I began to study the snapshots carefully as they came back from the processor—in those days, often a matter of weeks. Was I cropping the image so that one's interest was immediately drawn to the subject? Was my focus sharp? Were people smiling, looking their best, posed properly? Was I standing in the right spot to record the image? As I became increasingly concerned with the "right" look of the photographs, I also became aware that I had lost the spontaneity in the photographs of those special moments in my world.

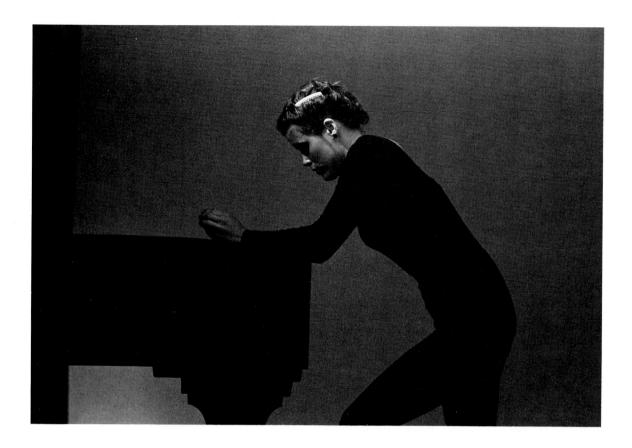

When that "Eureka!" sounded, and I realized I had lost my license for spontaneous creativity, I let go of the studied look and began to capture the natural moments in life. Using *Life* magazine as a guide, I tried to model my "look" on photographs by *Life* staff photographers Alfred Eisenstadt, Eliot Elisofon, Margaret Bourke-White (a former KINSA judge), Mark Kauffman, and others. Although I never progressed beyond amateur status, my photographs took on a fresher look and were more suggestive of the real world around me. Thirty-something years and 49 photo albums later, I am able to share the visual history of my life with family and friends through snapshot memories.

Over the years, thousands of photographers from all over the world have passed through our Photography Department here at Time-Life Books. Many bear famous names; others are struggling young professionals. Still others are amateurs who nurture the dream of appearing in one of our publications. They all bring examples of their work; sometimes I sit down in front of a carefully prepared portfolio, at other times I've had to sift through flimsy cardboard boxes filled to the brim with transparencies. It is when I begin to examine the photos themselves, though, that the true test begins. Much of what the photographers bring is slick, perfectly composed, delighting the design sense of the eye—works of art created by many hours of thoughtful prepara-

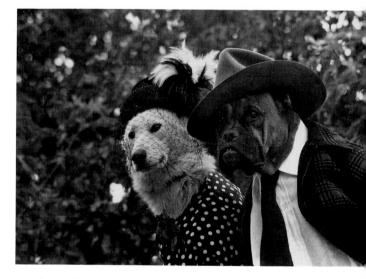

TOP: A sensitive portrait, 1983.

ABOVE: Dressed up dogs, a perennial favorite, 1951.

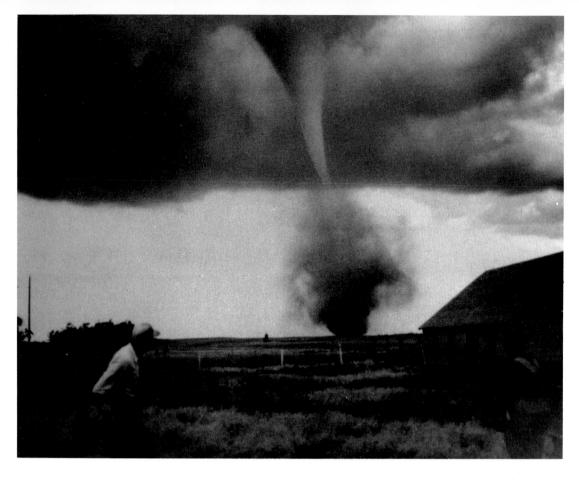

ABOVE: A tornado bears down on a midwestern farm, 1972.

tion in front of and behind the camera. Other work is what some call "amateur," created by men and women caught up in the wonderful world of snapshot photography.

Each viewing is a delight and a challenge for me. Can I offer encouragement? Can I find a place for a promising amateur in one of our books? Should I challenge the photographers to improve upon what they have done?

Some years ago, I was picture editing a book called *Storm* in our Planet Earth series. Over a period of two months, I reviewed more than 30,000 photographs from professional photographers, academics, students, and homemakers. As I selected what I considered to be the best images to illustrate our text, I was drawn to those photographs whose creators had seen a subject, grabbed their cameras and snapped. All of it was spontaneous and captured a moment in time never to be repeated.

The book was published to considerable acclaim. Two of its greatest strengths are marvels of amateur photography, both made by homemakers. The first is a series of twelve photographs of a twister that touched down near Osnabrock, North Dakota, in 1978; it shows a classic pattern of tornado development. The homemaker, who saw the tornado forming from her kitchen window, snatched her camera from the other room and recorded the entire event. Another amateur photograph, so powerful

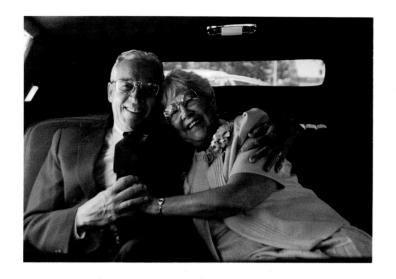

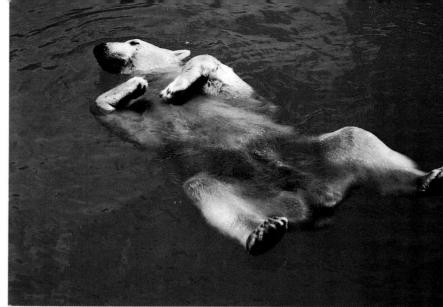

that we chose it for the cover of the book, shows the funnel of a tornado exploding into a thundering, ragged column of debris as it touched the plains of western Kansas in 1979.

Amateur photography? Yes. Great photography? Absolutely.

The photographs that appear in this book were taken for many reasons. Some, like the tornado pictures mentioned earlier, are lucky shots—the photographer was at the right place at the right time. Others are carefully crafted; the photographer selected a subject that was intriguing, or waited for light and shadow to bring out the best in what might otherwise be a dull scene. The great thing about photography is that no matter what one's level of expertise, anyone can make a memorable photograph. A slightly out-of-focus photo that holds great sentimental value is as prized by its creator as the photo taken by the advanced amateur who has mastered a new technique.

All of us have the ability to see people, places, events, emotion, and to capture those special moments in time. If we are fortunate, we may create great photographs. And, if we have a special story to tell, our pictures can tell it for us. Even across international boundaries and language barriers, we can speak to each other through our photographs.

Photographs that speak to the variety of human experience are what KINSA is all about. Each of the photographers whose photographs appear in this book have shared their memories of a special time and place in their lives. They have given us, and themselves, a record—a lasting gift of one special moment. They celebrate their world with each of us by sharing the record of something they care about that, in turn, touches us, moves us, and relates to each of our lives.

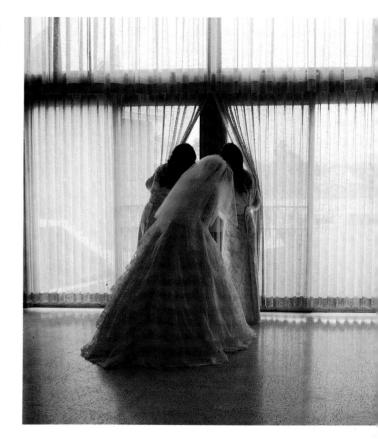

TOP LEFT: A celebration hug in a limousine, 1987.

TOP RIGHT: A polar bear floats in the summer heat, 1974.

ABOVE: Anxious wedding party awaits the music, 1974.

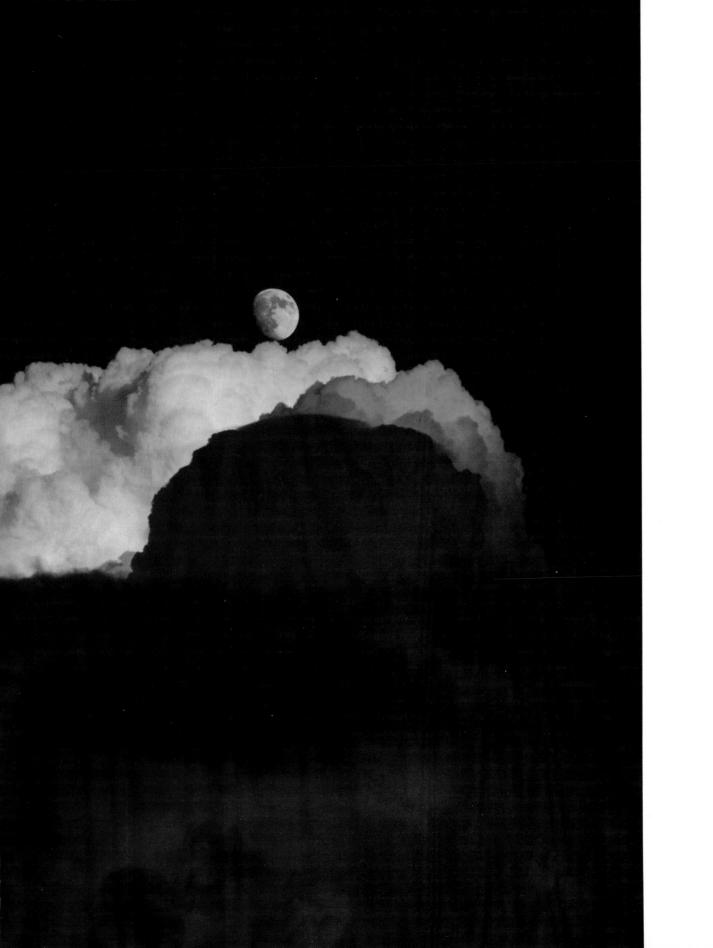

CHAPTER

THE YEAR'S BEST

 $E_{\text{VERY ONE OF THE WINNERS WAS}}$ selected from an international field of more than 500,000 pictures. All were taken on kodak Film by amateur photographers in the United States and throughout the world.

Here are people—funny, eye-catching, and moving. Caught at home and at play, every photo tells a story about life. There are warm and cherished moments, heart-stopping thrills, and tender looks at love. Young and old, friends are found on every page.

Here are pets and other animals—old family friends and surprising glimpses of wildlife and nature. From unexpected behaviors to dramatic appearances, every dog, cat, fish, and fowl is a favorite for the camera's lens.

Here is the world—striking, scenic pictures of mountains, oceans, lakes, and rivers. From autumn colors to desert sands, breathtaking views capture a variety of moods and moments in the always-changing landscape.

Here are all the special moments—captured on film. Never-tobe-forgotten times and places that refresh our memories of life's treasures and joys.

Here, then, is Kodak's look at our world in 1991, the 56th annual *Kodak International Newspaper Snapshot Awards* photograph contest—Kodak's look at life.

OPPOSITE: The moon rising over sunset clouds, from the 1973 KINSA contest.

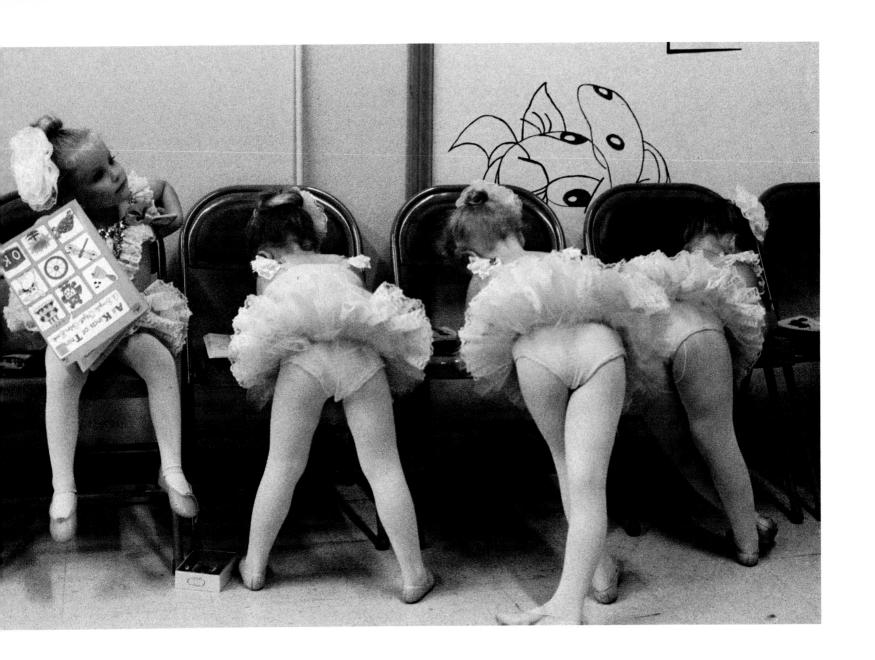

CHOOSING BEST OF SHOW

 $F_{\rm ROM\ THE\ 257\ FINALISTS}$, seven photographs were chosen for special honor. One special photograph was selected for the grand prize award, while first, second, and third prizes were awarded to three pictures taken in color and to three in black-and-white.

In choosing as the best of this year's KINSA entries, the judges evaluated each photograph on five elements: *human interest*—the feeling it generates in the viewer, *general appeal*—its ability to catch the eye or fascinate, *uniqueness*—capturing a moment that is a stroke of luck or a chance, *composition*—containing a new or different look at a common subject, and *quality*—sharpness, exposure, and focus.

In addition, as the judges examined each photograph, they also asked, "Is it interesting? Does it have snapshot quality and appeal? What is most appealing about the photograph, and why? Would a cropping recommendation make it a winner?"

After hours of debate and discussion, the prize winners were selected. The winning photographs captured special moments that set them apart from the others. But one stood alone, a delightful photograph that captivated the judges and kept them coming back for another look. After considering a final time, the choice was unanimous.

OPPOSITE: Little ballet dancers preparing for their debut, the grand prizewinner in the 1983 KINSA contest.

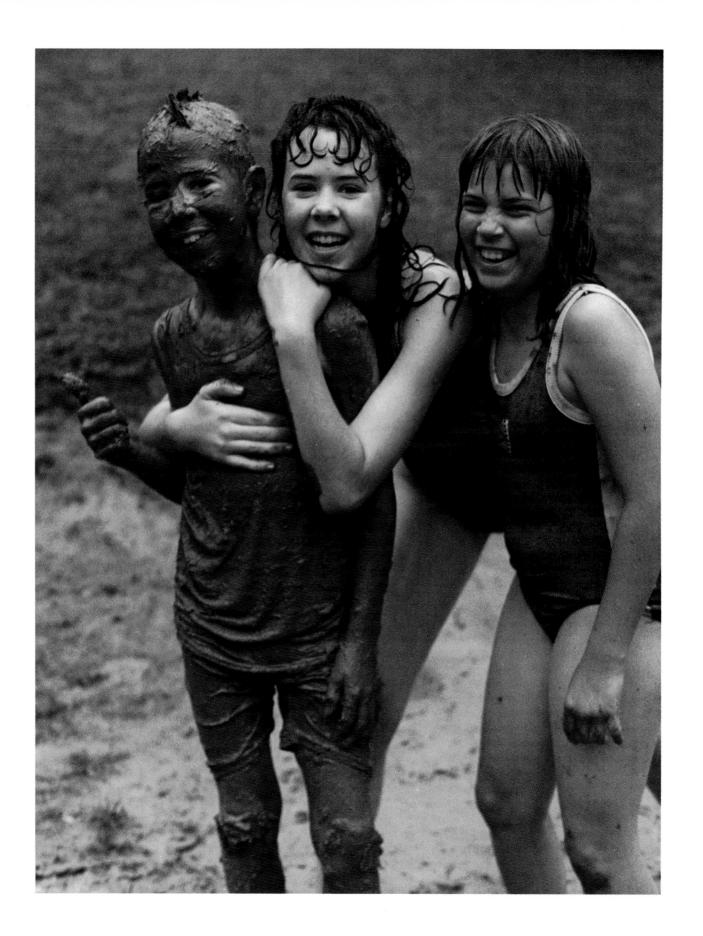

GRAND PRIZE

Playing with the Mud Monster

CONNIE S. HORN
Crooksville, OH USA
The Times Recorder

CONNIE HORN was visiting out-of-town friends when her husband called to tell her that her photo of their two children and a friend playing in the rain in the backyard had won the 1991 KINSA grand prize. She was so excited that she turned directly around and came right home again.

Her excellent photograph captures the essence of a moment that

could have taken place anywhere in the world, given the mixture of children, life, summer, fun, and mud. There is innocence of feeling, the children love each other, and the subject is timeless. The situation didn't exist a moment before or afterwards and was totally unplanned. Everyone who sees it smiles and laughs with delight.

The judges and we wonder what happened next? The photo is intriguing and involving.

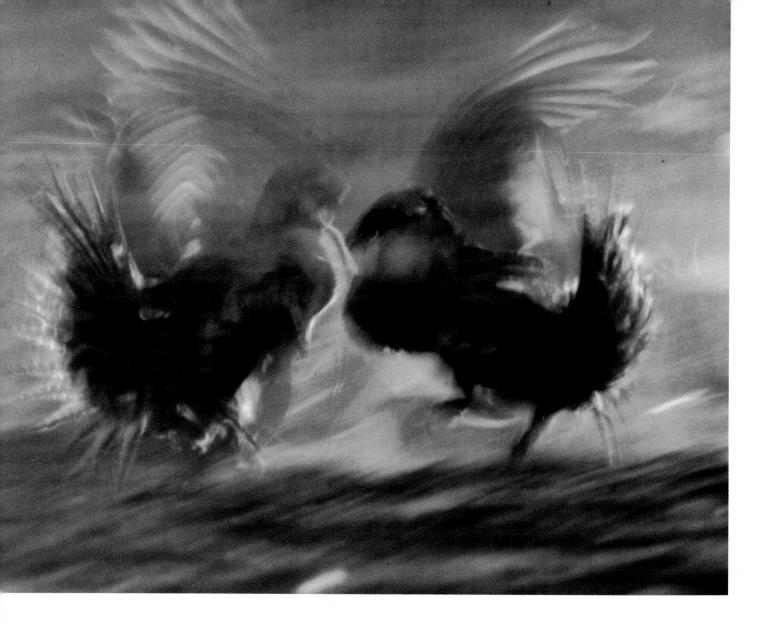

FIRST PLACE—COLOR

Fighting Sage Grouse

F. Budd Titlow
East Longmeadow MA usa
The Boston Globe

BUDD TITLOW used a slow shutter speed on his Pentax MX to emphasize the action and movement of male sage grouse defending their breeding territories in North Park, Colorado. His prizewinning picture records the results of patience, opportunity, and careful preparation. His artistry enhances a seldom-seen situation.

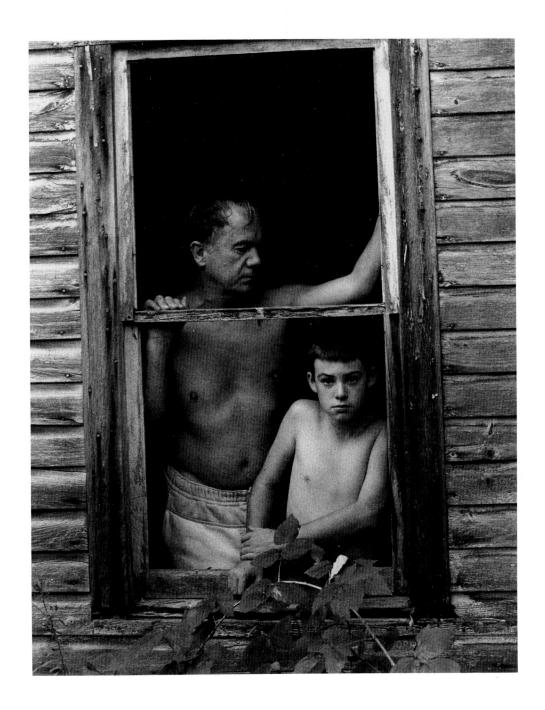

FIRST PLACE—BLACK-AND-WHITE

Father and Son

CONSTANCE FIEDLER Stone Ridge NY USA The Daily Freeman This photograph by Constance Fiedler of a father and son in an old, abandoned house rivets one's attention and evokes a strong emotional response. The son's challenging gaze into the camera is offset by the tender look of the father at his child. It is a photograph that poses a thousand questions and could only have existed in black-and-white.

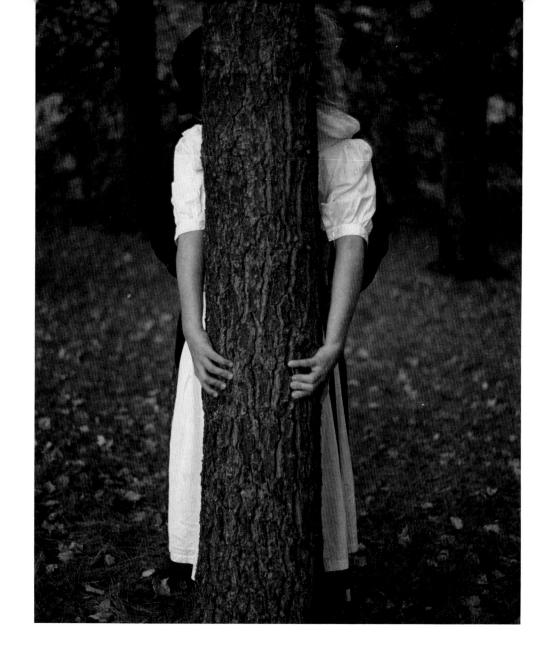

SECOND PLACE—BLACK-AND-WHITE

Romance

STEPHEN H. SHEFFIELD Wellesley MA USA The Boston Globe This couple embracing behind a tree, by Stephen Sheffield, suggests feelings beyond the image itself. There exists an enigmatic quality that raises every viewer's curiosity. Sheffield's meticulous planning of composition and exposure clarifies and simplifies his idea and the photo's metaphor.

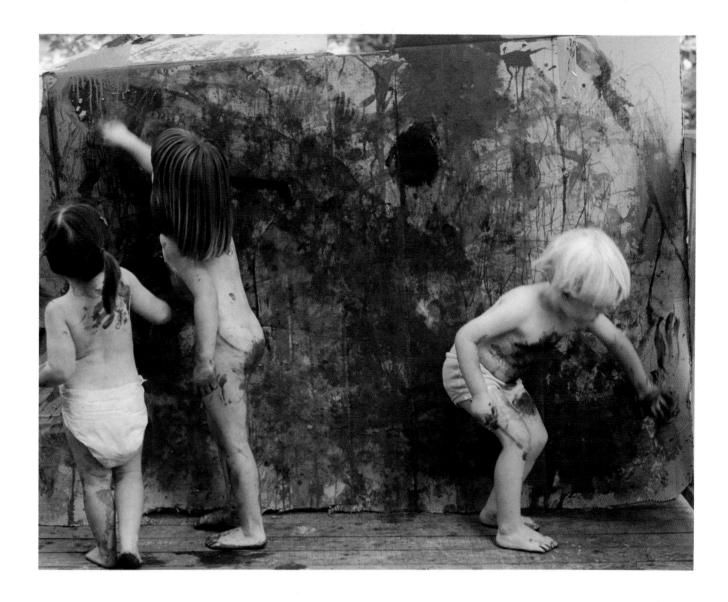

SECOND PLACE—COLOR

Art Nouveau

PETER BUSTIN
Halifax, Nova Scotia Canada
The Daily News

Peter Bustin's children were using their hands, feet, and entire bodies to paint a large picture outdoors in his backyard when he raised his camera and caught the image on film. The mirth and delight evident in the photograph's special moment draws everyone—parent or not—into the picture of children in their all-absorbing creativity.

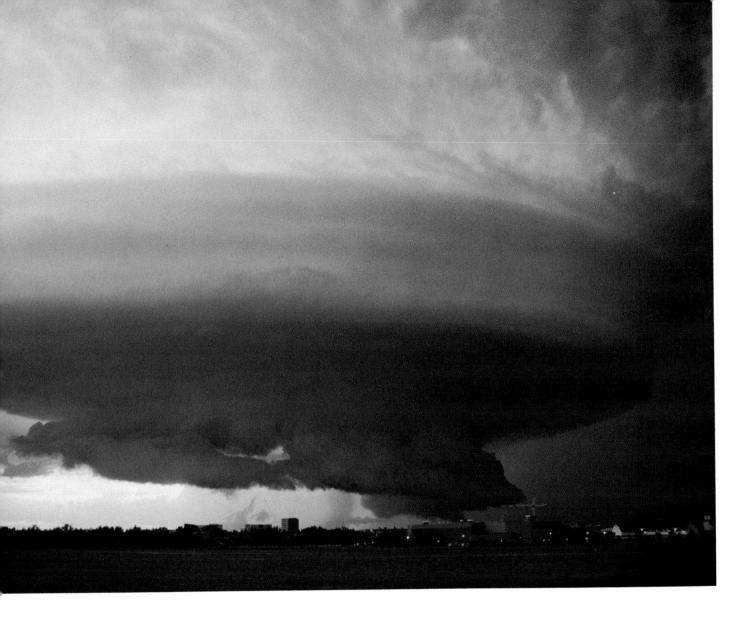

THIRD PLACE—COLOR

The Cauldron

IAN D. SUTHERLAND Saskatoon, Saskatchewan CANADA *The Star Phoenix* IAN SUTHERLAND captured a very powerful image of a rare, natural phenomenon. The dramatic cloud, more than 10 miles away from the camera, appears to touch a nearby crane. Even using a 28mm lens on his Canon A1, he was only able to photograph a portion of the storm cloud. The large storm system contained hail, which caused extensive damage to crops and property.

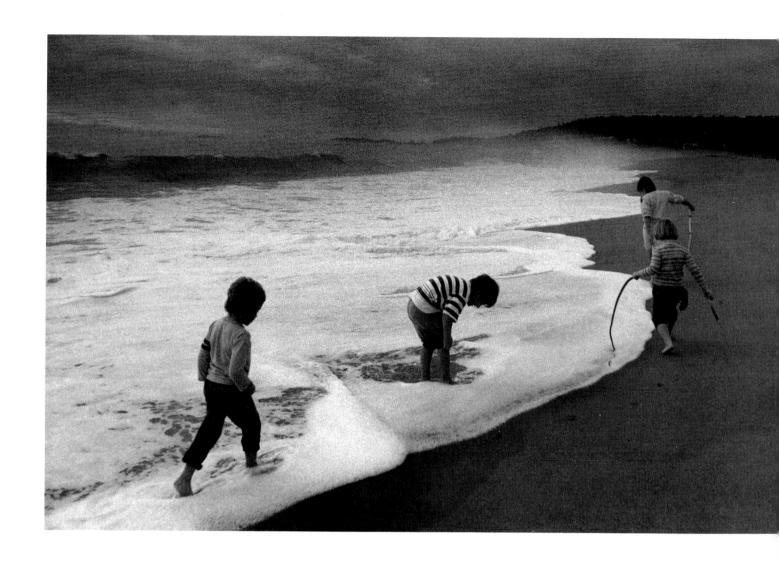

THIRD PLACE—BLACK-AND-WHITE

After the Storm

TONY MARPLE
Whitefield ME USA
The Kennebec Journal

Tony Marple took this photo of his children playing in the waves after an October tropical storm-lashed Reid State Park in Georgetown, Maine. It conveys a sense of the moment with good composition and captures the spirit of vitality—the very essence of a snapshot. It radiates with the children's joy.

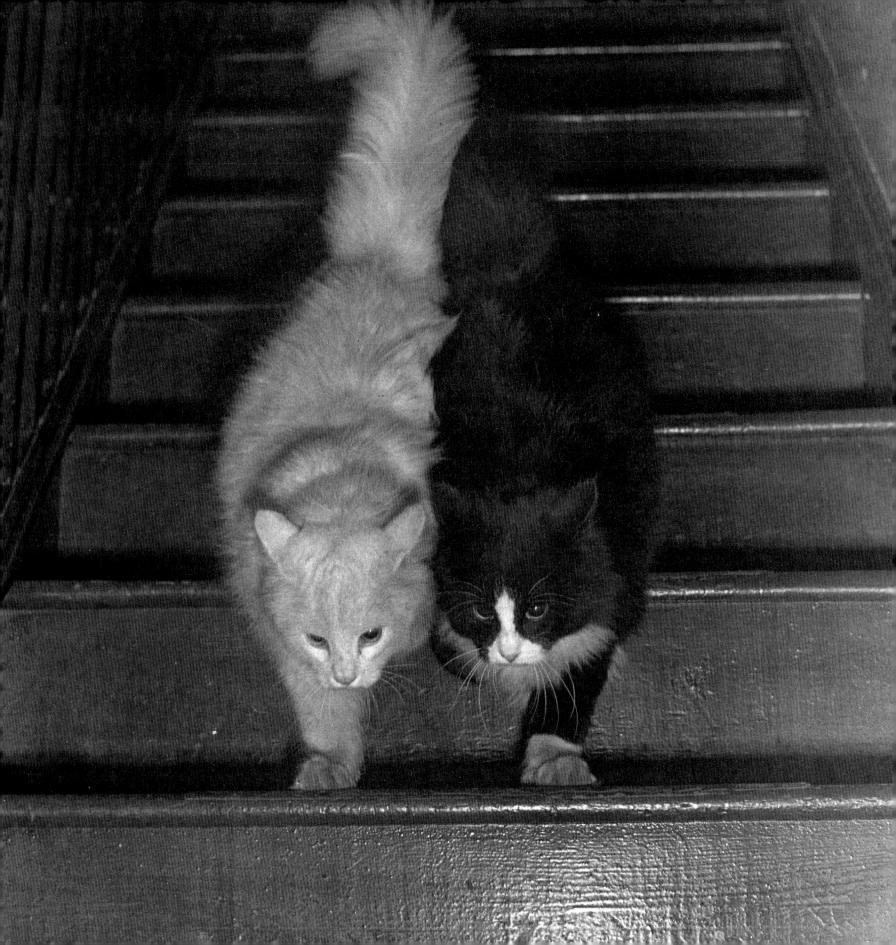

THE KINSA AWARDS

The judges divide the best kinsa photographs into ten content categories, mirroring patterns that most amateur photographers follow as they take pictures. In each category, five photos are distinguished further, receiving honor awards of \$250, indicating the best pictures in that category.

Five of the 10 subject categories are taken from the great themes of photographic art—people, abstracts, still life, action, and landscapes. Since photography's earliest beginnings as an art form in the mid-1800s, these subjects of enduring value have been pervasive. To reveal a subject, a photographer may wield light, shadow, color, or tone, much like an artist wields a paintbrush. Composition is especially important in the abstracts, still life, and landscape categories, while the subject matter is considered most important in people and action photographs.

Kodak chose three other subject categories because of their enduring interest—seniors, environment, and animals. Here, the pictures convey visual messages about their subject matter, drawing the viewer closer to the content and stirring emotions. The last two content categories showcase the advances in the frontiers of film technology—color prints and color transparencies.

THE WORLD IN MOTION ACTION

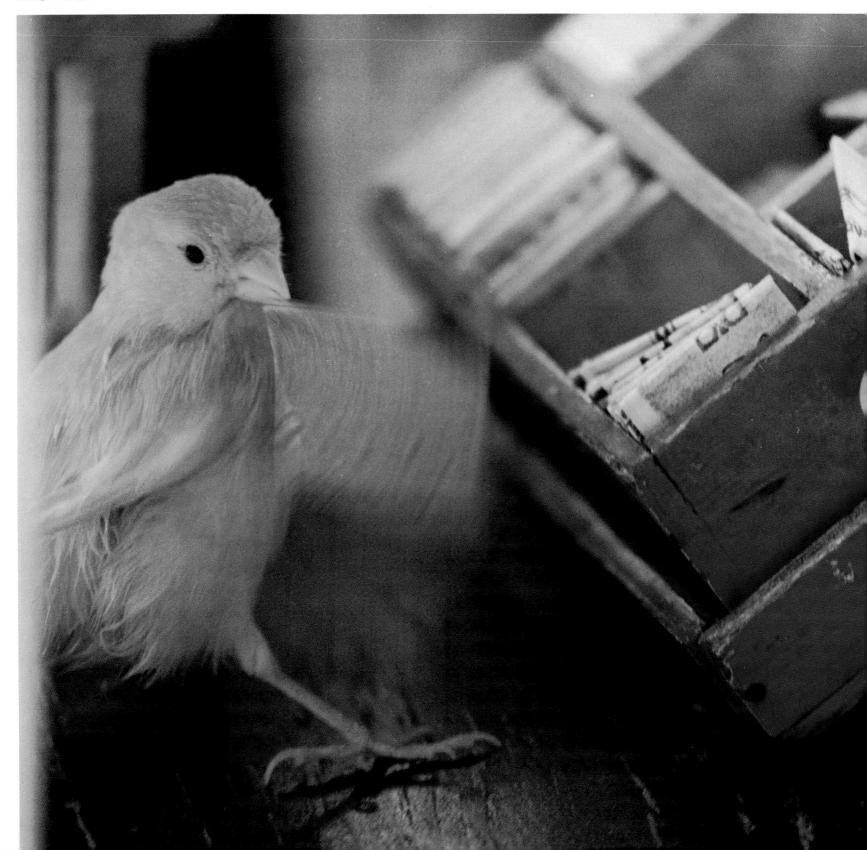

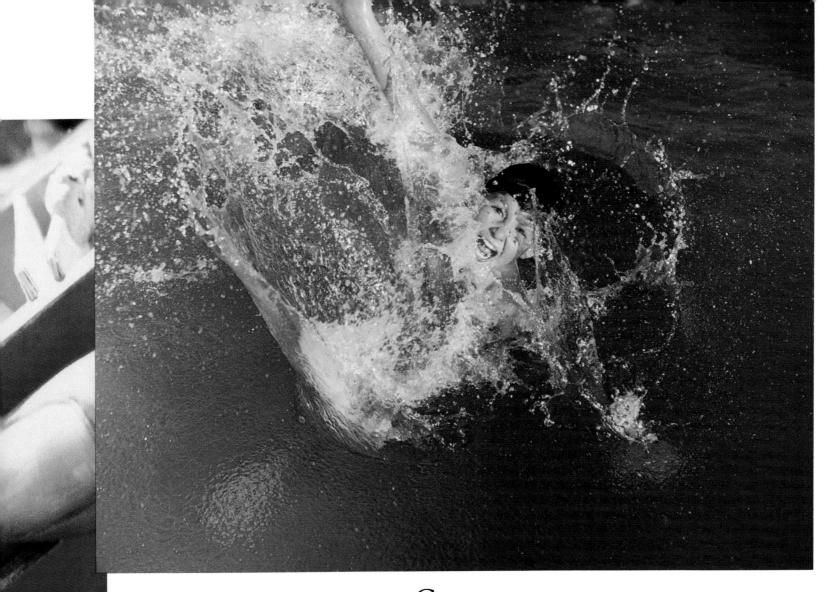

Splash ABOVE: Bright sunlight and a fast shutter capture the exact moment of the boy's plunge.

HONOR AWARD

JOAQUIN SARGIO MENDOZA GONZALEZ Hermosillo MEXICO *El Imparcial* KODAK GOLD 100 Film

Little Bird of Luck

opposite: The motion blurred perfectly in this picture of a little fortune-telling bird.

MERIT AWARD DR. JAIMIE E. ETIENNE Tampico MEXICO El Sol de Tampico KODACOLOR VR-G 200 Film Capturing movement in still photographs, without sacrificing the details needed to convey the subject, challenges amateur photographers of sport, event, and action subjects. One basic choice is whether to freeze movement with a fast shutter or an electronic flash, or to allow it to blur with a slow shutter. The photographs selected in this category demonstrate true creativity within these guidelines and are outstanding examples of technique.

And...They're Off: overleaf: Racehorses and jockeys become a pattern of blurred, vibrant color.

HONOR AWARD LYDIA J. CHARAK

Toronto, Ontario canada The Guardian Kodak Gold 100 Film

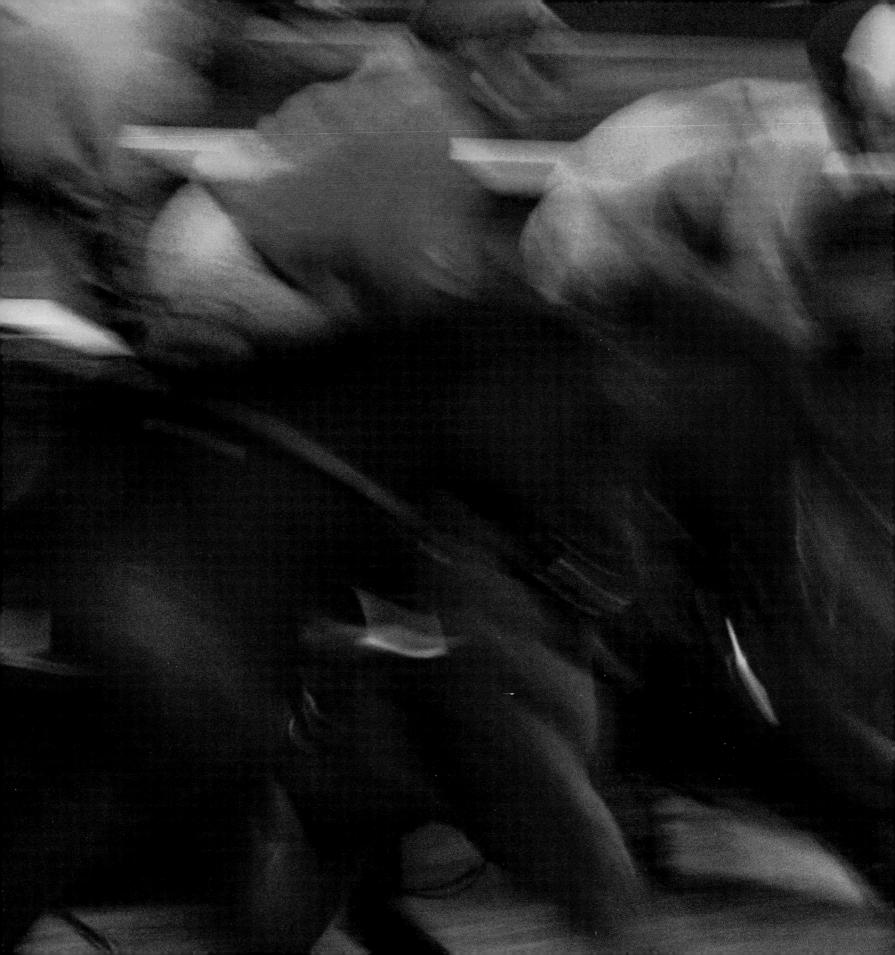

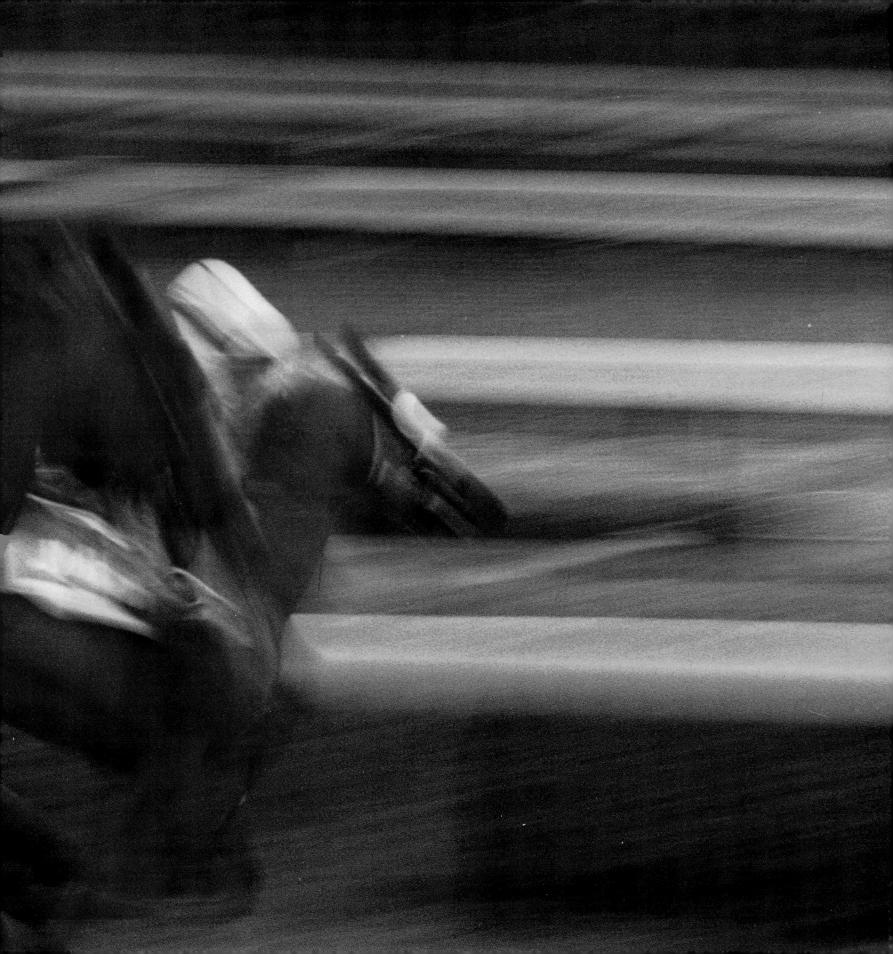

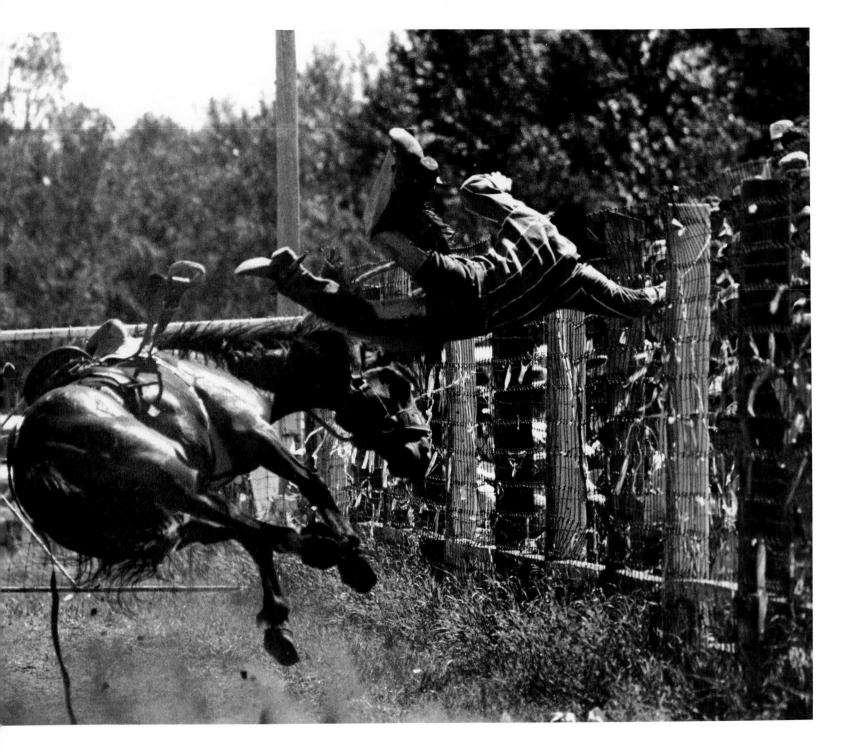

Rodeo Fun ABOVE: The bronc bucks off the cowboy, but loses its own footing, too. The unusual angle makes the picture.

HONOR AWARD GARFIELD SPETZ
Saskatoon, Saskatchewan canada The Star Phoenix
KODAK T-MAX 400 Professional Film

THE WORLD IN MOTION

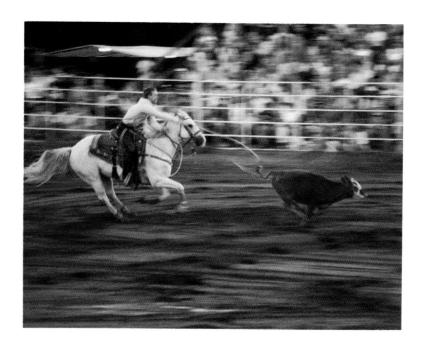

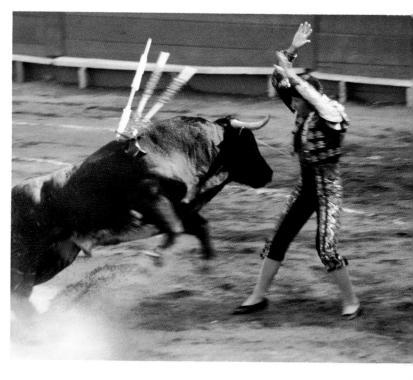

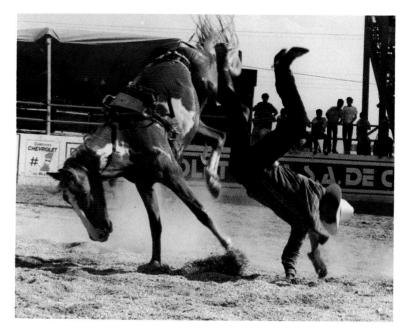

Gotcha! TOP LEFT: Calf-roping action at a rodeo in Manawa, Wisconsin.

MERIT AWARD SANDY MARTEN

Wausau WI USA The Daily Herald KODAK GOLD 400 Film

Disagreements ABOVE: The unanswered question—What happened to the matador?

 HONOR AWARD
 SRA. ARTURO VALENZUELA DIAZ

 Saltillo MEXICO
 Vanguardia
 KODACOLOR VR-G 100 Film

Courage LEFT: The horse and its rider are caught just touching the ground, mirroring each other.

MERIT AWARD GERARDO SALCIDO ESPARZA

Torreon MEXICO La Opinion KODAK GOLD 100 Film

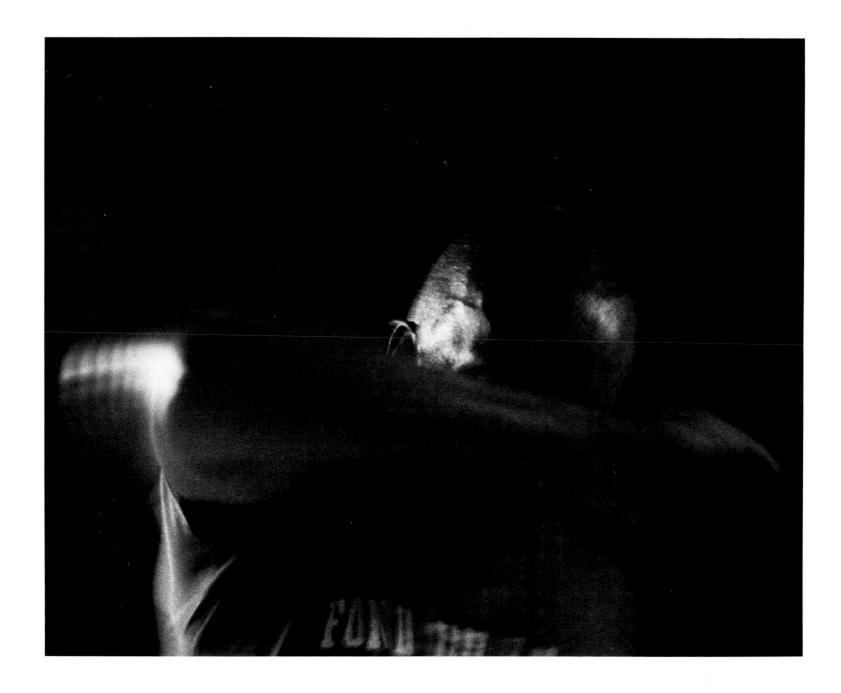

Right Cross Above: I captured the boxer's power as he trained for the Golden Gloves Championship.

MERIT AWARD ARTHUR F. HASTINGS

Whitefish Bay WI USA The Milwaukee Journal

KODAK T-MAX 3200 Professional Film

Jump! Opposite: A jump from a bench at Marywood College, Pennsylvania, transforms person into ghost. **MERIT AWARD** ANN MARIE KEENAN

Scranton PA USA *The Times* KODAK T-MAX 400 Professional Film

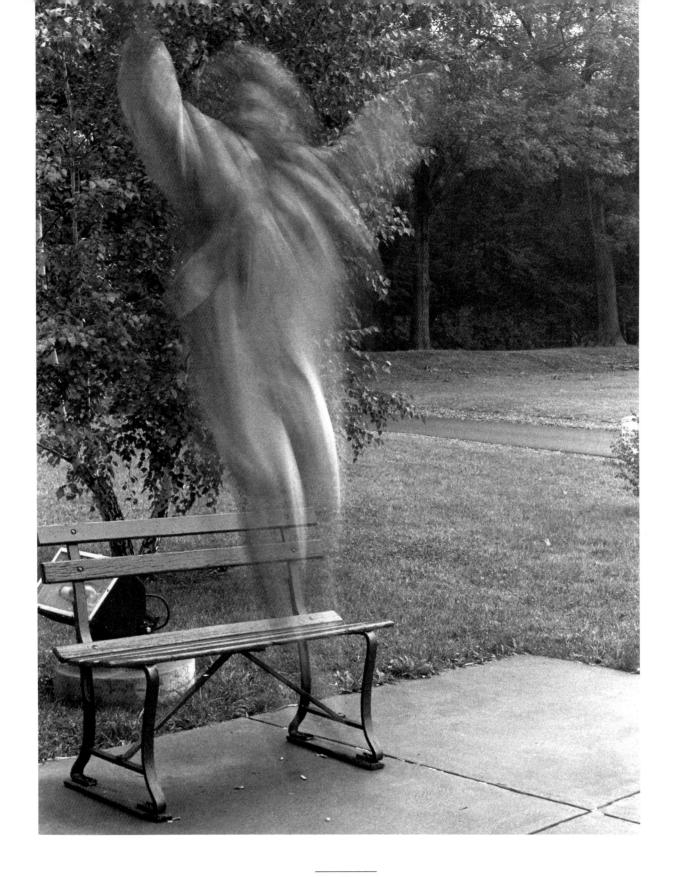

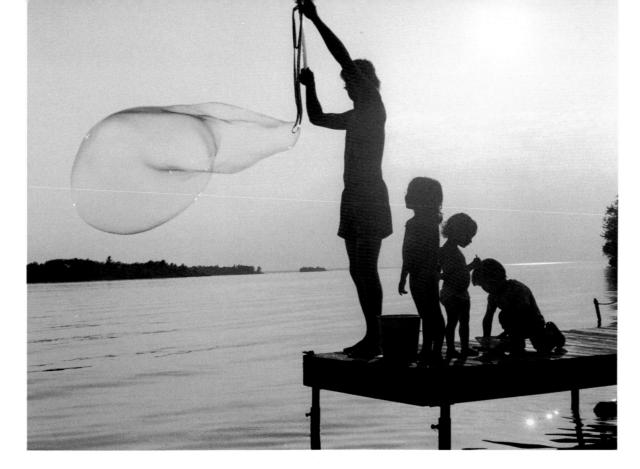

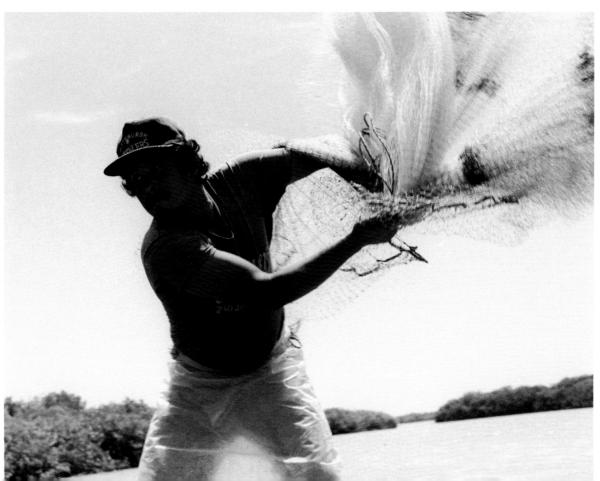

THE WORLD IN MOTION

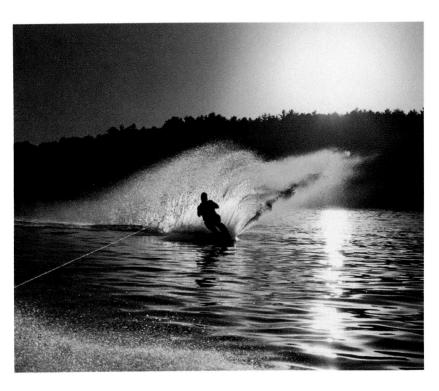

Fun in the Sun OPPOSITE TOP: People making soap bubbles, silhouetted by a sunset.

MERIT AWARD CYNTHIA C. LOYST

North Bay, Ontario canada The Nugget Kodak Gold 100 Film

Fishing OPPOSITE: The right combination of motion and moment catches the essence of net fishing.

MERIT AWARD FERNANDO JARAMILLO

Guadalajara mexico El Occidental Kodak Gold 100 Film

Slalom at Sunset ABOVE: Labor Day with friends—it took three pictures to get the perfect shot.

MERIT AWARD ERIC A. ZERFAS

West Bend WI USA The Daily News KODAK GOLD 100 Film

The Crawl BeLow: An eye-arresting photo of a swimmer's arm.

MERIT AWARD GILBERTO MORENO ROMERO

Hermosillo MEXICO El Imparcial KODAK GOLD 100 Film

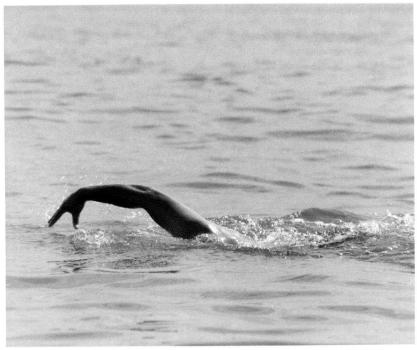

THE KINSA AWARDS

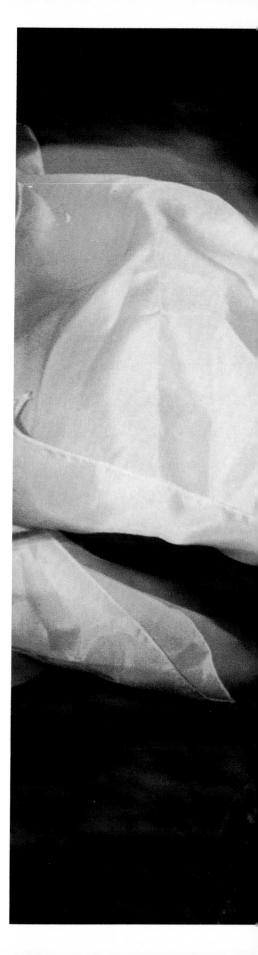

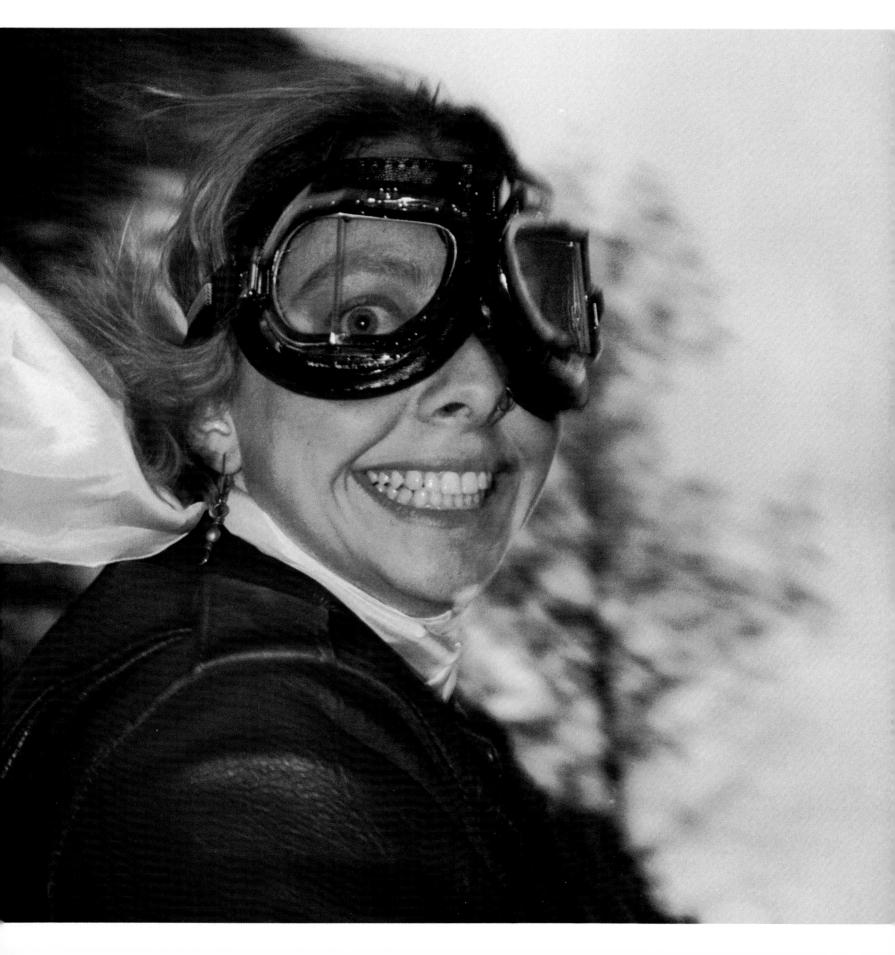

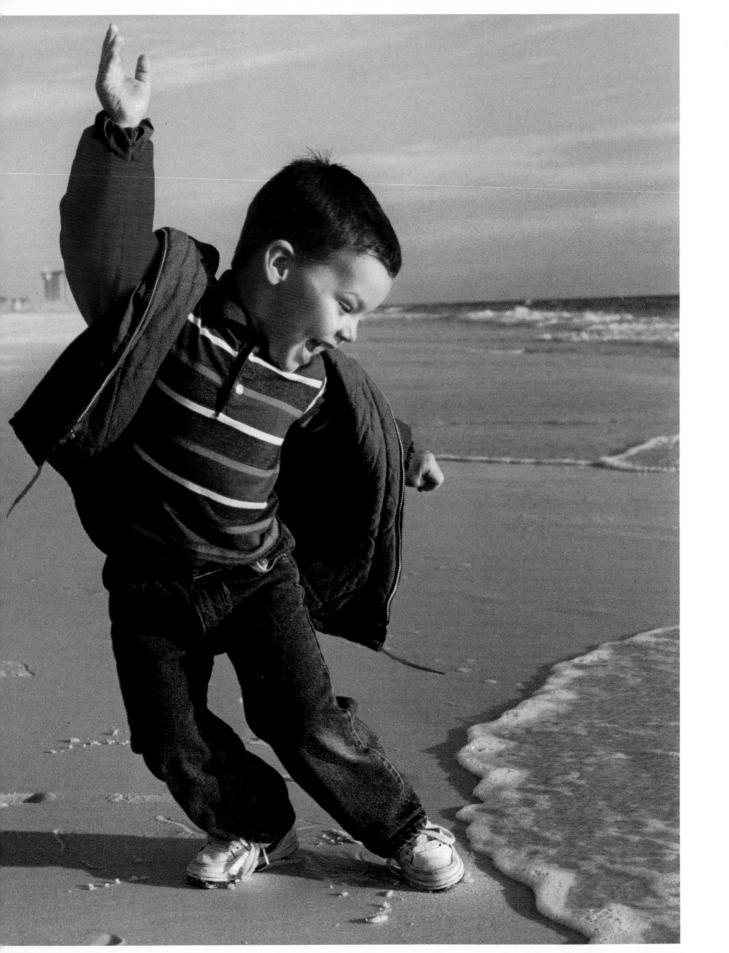

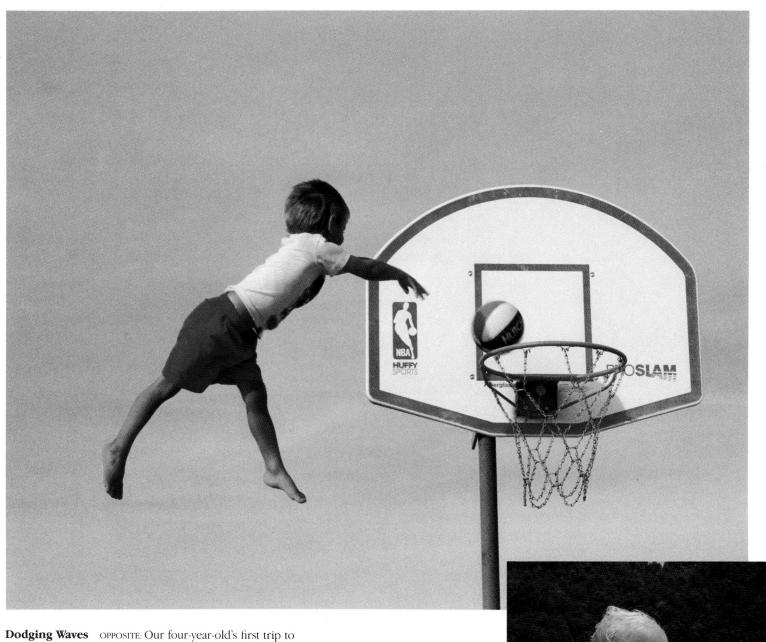

Dodging Waves opposite: Our four-year-old's first trip to the beach—having fun chasing waves but not getting wet. **MERIT AWARD** VICKIE G. SELDENRIGHT

Panama City FL USA The News Herald KODAK GOLD 400 Film

Air Baby ABOVE: My two-and-a-half-year-old shooting baskets while airborn.

MERIT AWARD LINDA S. HOOVER

Helendale CA USA The Daily Press KODAK GOLD 100 Film

Cool Dude RIGHT: Our 16-month-old baby at the wheel of a 58-foot houseboat.

MERIT AWARD DEBORA L. JUNGBLUTH

Waukesha WI usa The County Freeman Kodak Gold 200 Film

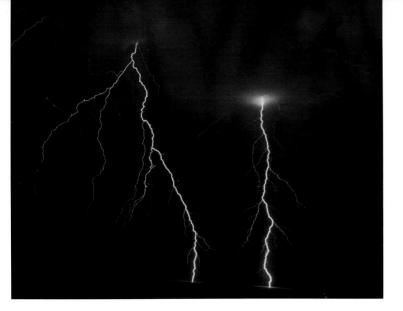

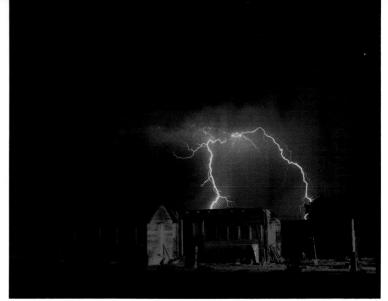

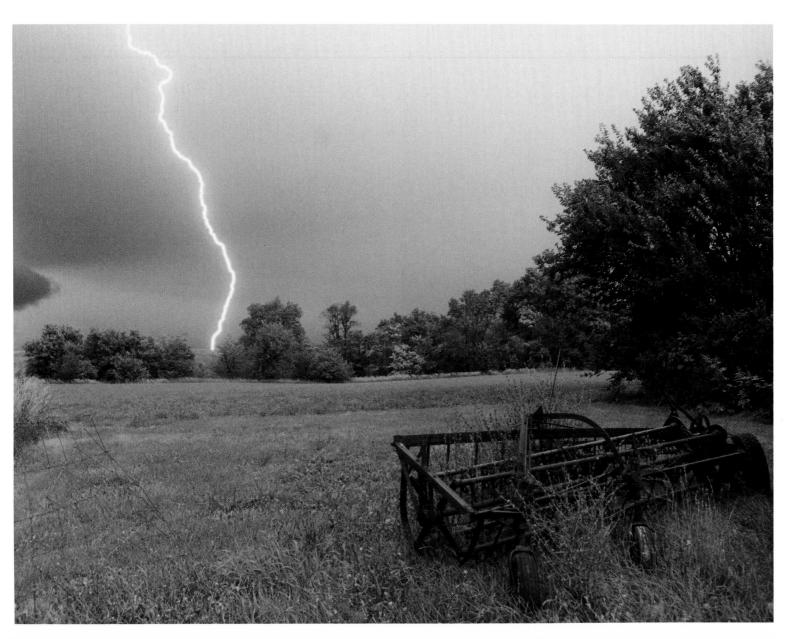

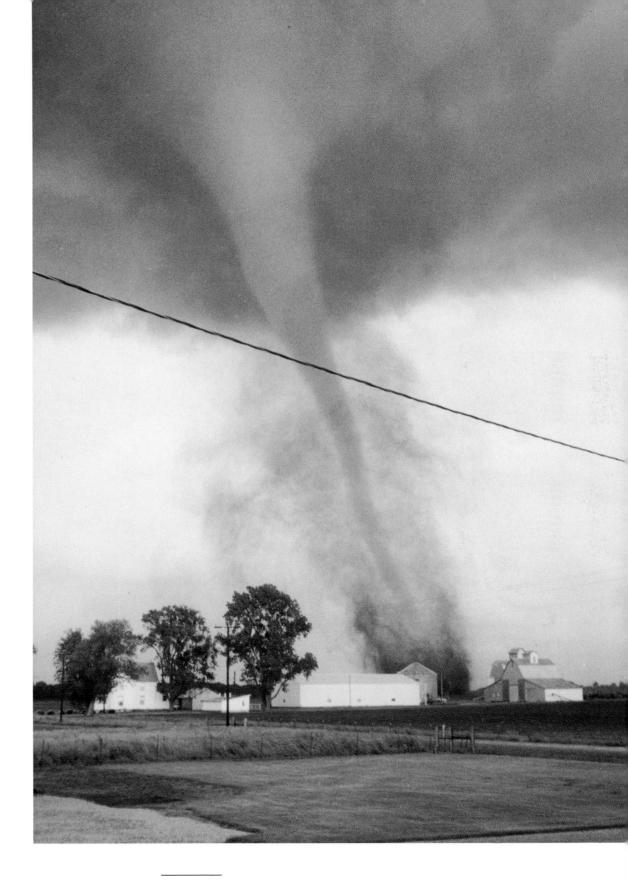

A Night of Fury OPPOSITE, TOP LEFT: Lightning storm on a wheat field in Lewiston, Idaho.

MERIT AWARD ANGIE STAMPER Lewiston ID USA The Morning Tribune KODAK GOLD 200

Storm's Eerie Light OPPOSITE, TOP RIGHT: Time exposure behind my aunt's chicken shed on a farm in Kirk, Colorado.

MERIT AWARD

STEPHEN MICHAEL SCHNEIDER Springfield OR USA The Register-Guard KODAK GOLD 200 Film

Storm Across the Prairie

OPPOSITE, BOTTOM: A bolt of lightning over our field on a stormy afternoon.

MERIT AWARD MARIANNE KEENE El Paso IL USA *The Pantagraph* KODAK GOLD 400 Film

Too Close for Comfort!

RIGHT: Tornado approaching my neighbor's house in Findlay, Illinois.

MERIT AWARD RON RAGAN
Findlay IL USA The Herald & Review
KODAK GOLD 400 Film

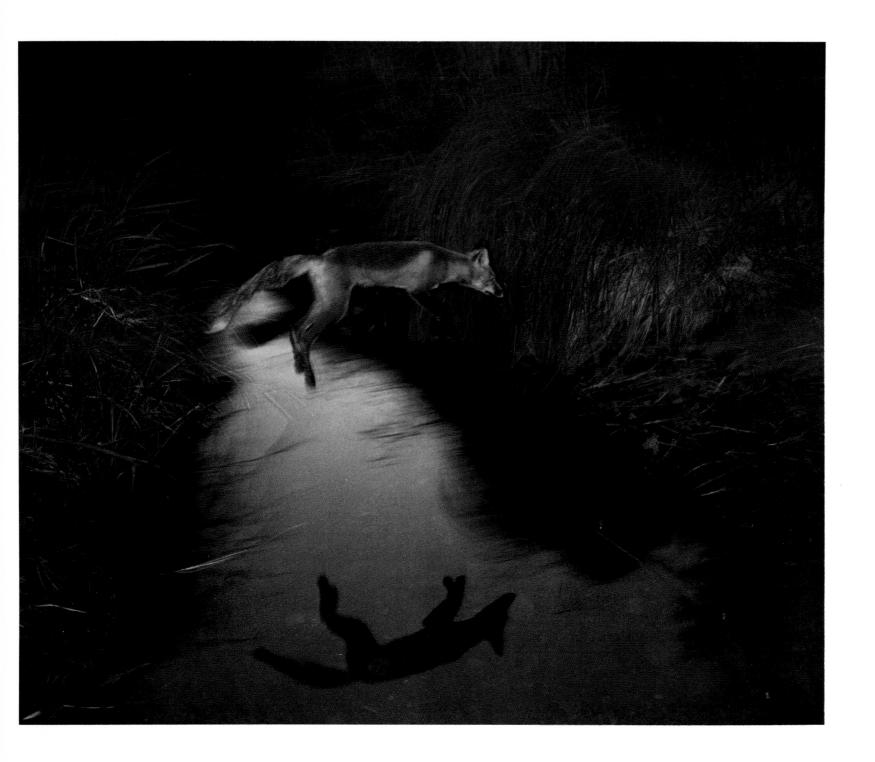

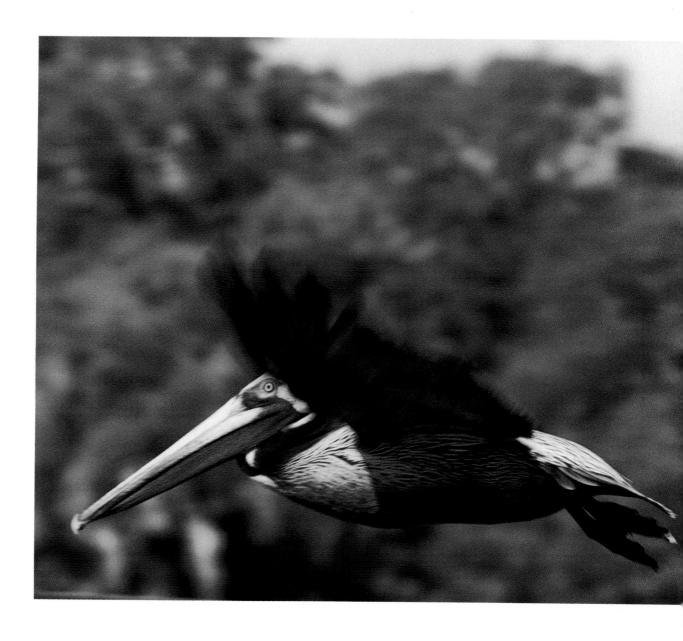

Reflecting on Nature OPPOSITE: Fox gracefully leaping over creek at Daisy Farm, in Isle Royale National Park, Michigan. **HONOR AWARD** LYNNE WICKSTROM
Laurium MI USA *The Daily Mining Gazette* KODAK GOLD 200 Film

She's Got Bette Davis Eyes ABOVE: Pelican in flight—taken from a boat in motion.

MERIT AWARD BETH MILLER COPPOCK

Campbellsville KY USA **The Journal KODAK GOLD 100 Film

FAMILY AND FRIENDS PEOPLE

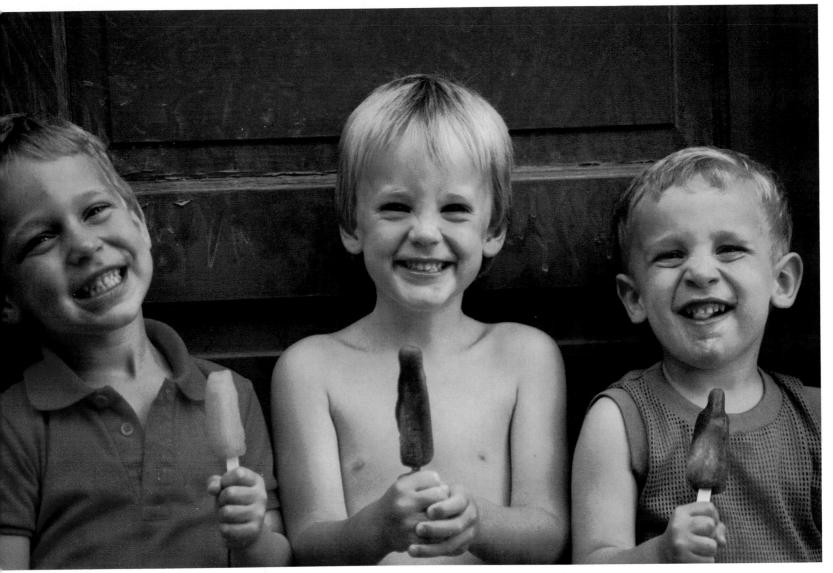

Lickin' Good ABOVE: Three boys sitting on a step at our summer home eating ice pops together. **MERIT AWARD** LINDA HEIM

Delmar NY USA *The Times* KODAK GOLD 100 Film

Sweet Pea Opposite: Three-year-old Kristen Sarah on vacation in Ocean City, New Jersey.

MERIT AWARD DANTE A. PARENTI

Vineland NJ USA The Press KODACOLOR VR-G 200 Film

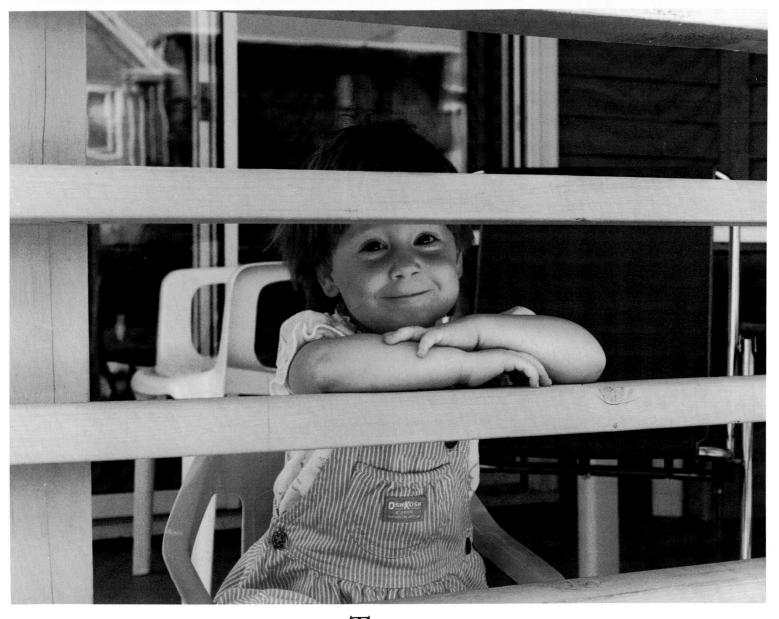

Taking good photographs of people requires a combination of luck, skill, and dedication. People's gestures, movements, and looks are momentary—and when gone, are gone forever. Without quick reflexes and an excellent sense of timing, the opportunity for memorable photographs could be over before the shutter snaps. The photographs that follow were selected because they capture people in unique and special moments and because each one tells a story.

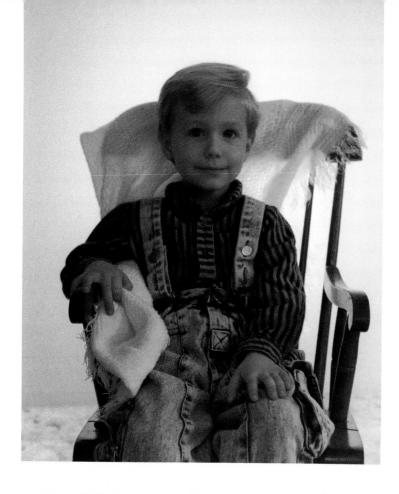

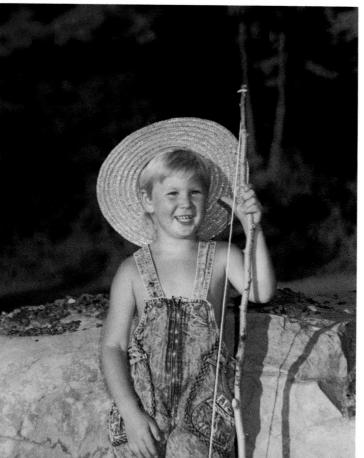

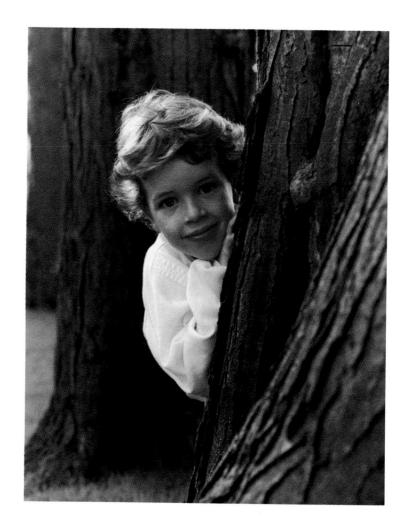

Devin! TOP LEFT: My son in a wooden rocking chair.

MERIT AWARD CINDY L. STAMPER

Lewiston ID usa The Morning Tribune KODAK GOLD 100 Film

A Peek from Justin ABOVE: My son, Justin, peeking around a "double-locust tree" at our home.

MERIT AWARD CONSTANCE M. TRUGISCH

Belleville, Ontario CANADA The Intelligencer KODAK GOLD 100 Film

The Fisherman BOTTOM LEFT: Chad Heffner ready to fish at Reynlow Park, Pennsylvania.

MERIT AWARD STEPHANIE L. HEFFNER

Reynoldsville PA usa The Courier-Express KODAK GOLD 100 Film

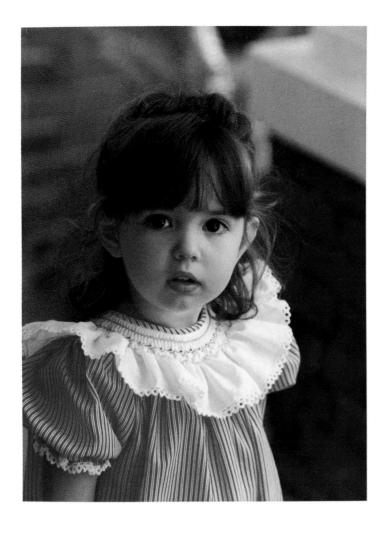

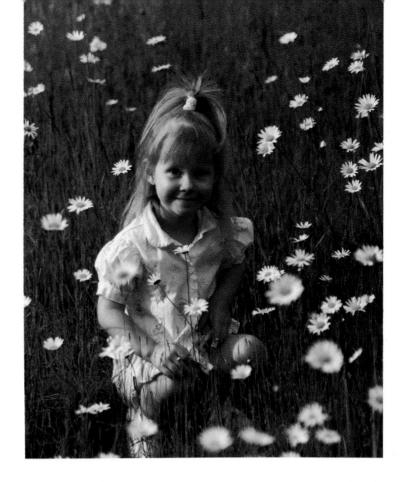

Captured Innocence ABOVE: A two-year-old on my front porch swing.

MERIT AWARD VICTORIA M. BOLLING

Auburn AL usa The News KODAK GOLD 100 Film

Loves Me, Loves Me Not TOP RIGHT: A girl in a field of daisies

MERIT AWARD SHANE POWER

Port Alberni, British Columbia салада *The Valley Times* кодак gold 100 Film

Woodland Ballerina BOTTOM RIGHT: A little girl standing in an overgrown field, almost dancing.

MERIT AWARD SARA MALINE ADAMS
FAIR ROCKAWAY NY USA The Daily Record

KODAK VERICOLOR III Professional Film

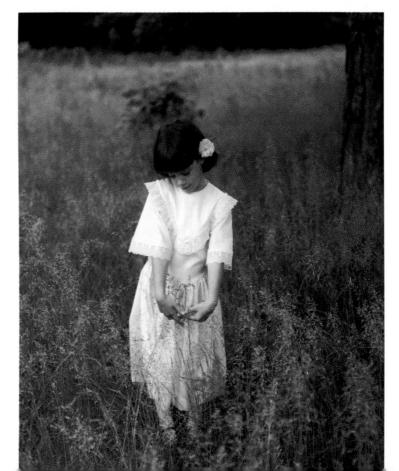

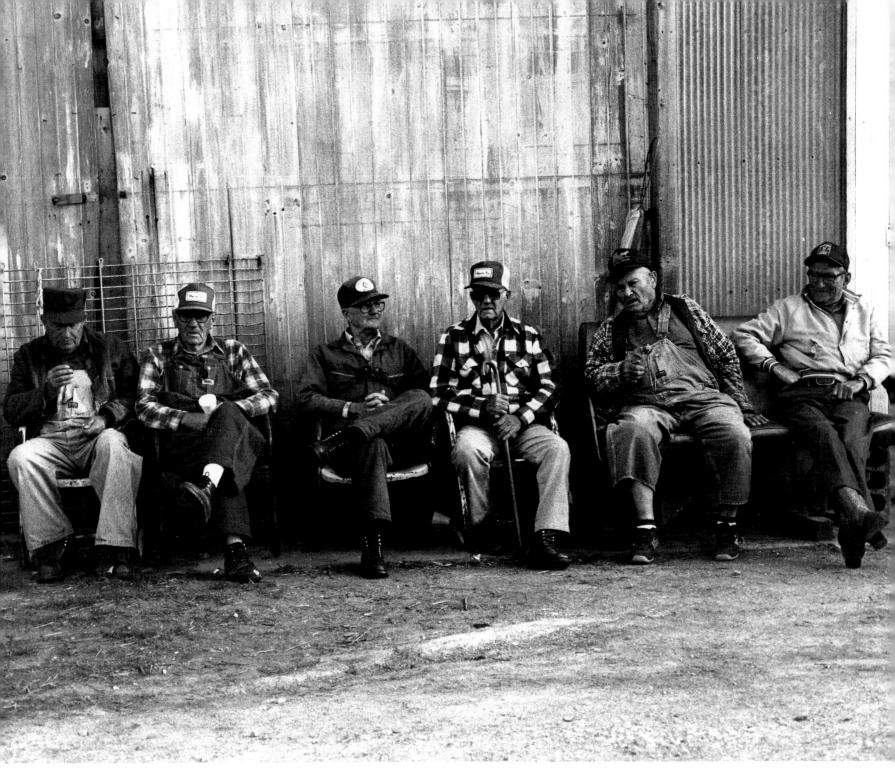

Watching the Crops Grow ABOVE: Farmers of the small town of Cropsey, Illinois, relax and talk during a weekly auction.

MERIT AWARD BRIAN E. VAUGHAN
Cropsey IL usa The Pantagraph KODAK T-MAX 400 Professional Film

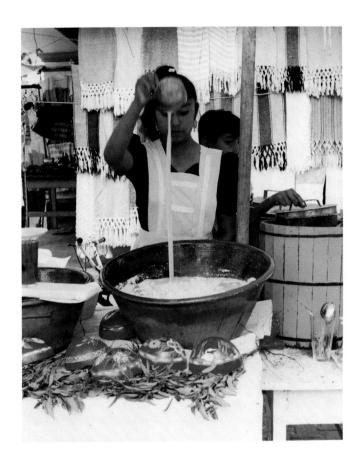

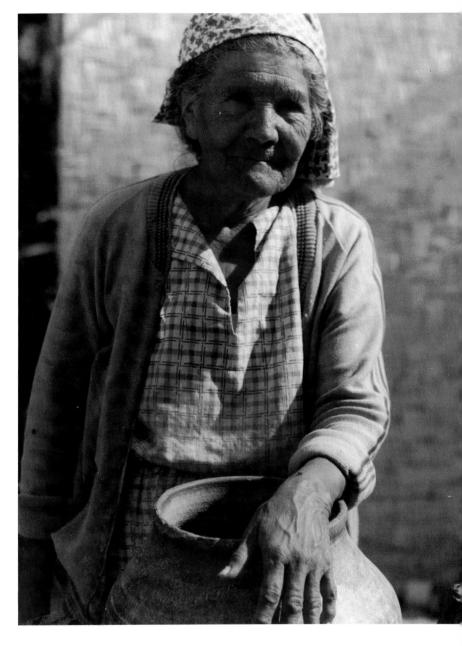

Mixing of Colors Above: The simple act of a vendor pouring batter invites and entices.

MERIT AWARD BEATRIZ E. LOPEZ MONTOYA
Oaxaca MEXICO El Sol de Tampico KODAK GOLD 100 Film

Maria in the Shadows RIGHT: The glowing light of an arbor highlights every detail of Maria Sombra's face.

HONOR AWARD ARTURO VILLASENOR ATWOOD

LOS MOCHIS MEXICO Noroeste de los Mochis KODAK GOLD 100 Film

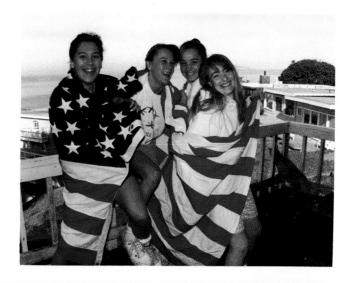

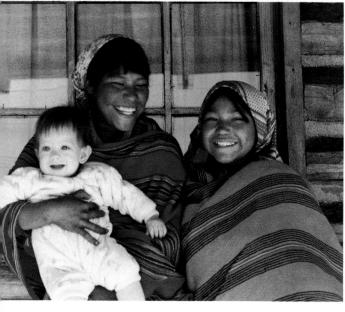

All-American Girls Top Left: Teenagers wrap themselves in the American flag.

MERIT AWARD ALAN CYPERT

Watsonville CA USA The Register-Pajaronian KODAK GOLD 200 Film

T-Ball High-Five TOP RIGHT: Five boys heading for a victory salute at game's end.

MERIT AWARD ARMANDO MORALES
El Paso TX USA The Herald-Post

KODAK GOLD 100 Film

Smiles Without End BOTTOM LEFT: Happy moments in the mountains of Chihuahua.

MERIT AWARD DR. ROBERTO LARA DE LA FUENTE
Chihuahua MEXICO El Heraldo KODAK GOLD 100 Film

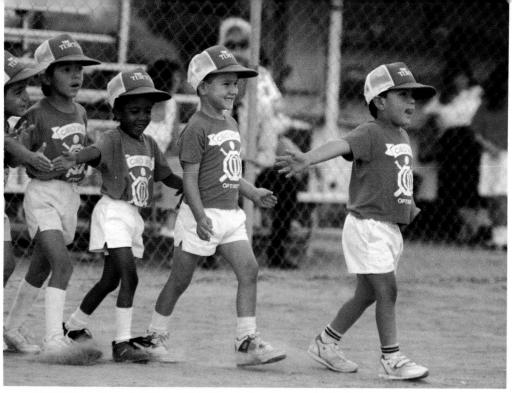

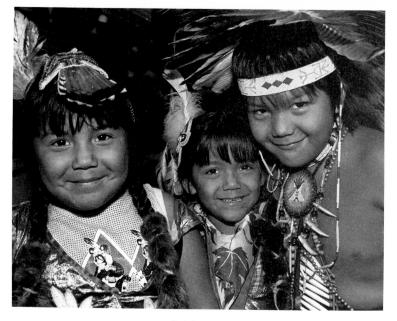

Children at Powwow BOTTOM RIGHT: Erika, Nadia, and Thomas Holycross, all Lummi tribe children, at a Blackfoot powwow.

MERIT AWARD KAY BRIDGES

Lacey WA USA The Olympian KODAK T-MAX 400 Professional Film

Brothers Sharing Different Perspectives Opposite: Taken after these brothers experienced their first ski lesson. **HONOR AWARD** JOHN COHN

Telluride CO USA The Times Journal KODAK GOLD 100 Film

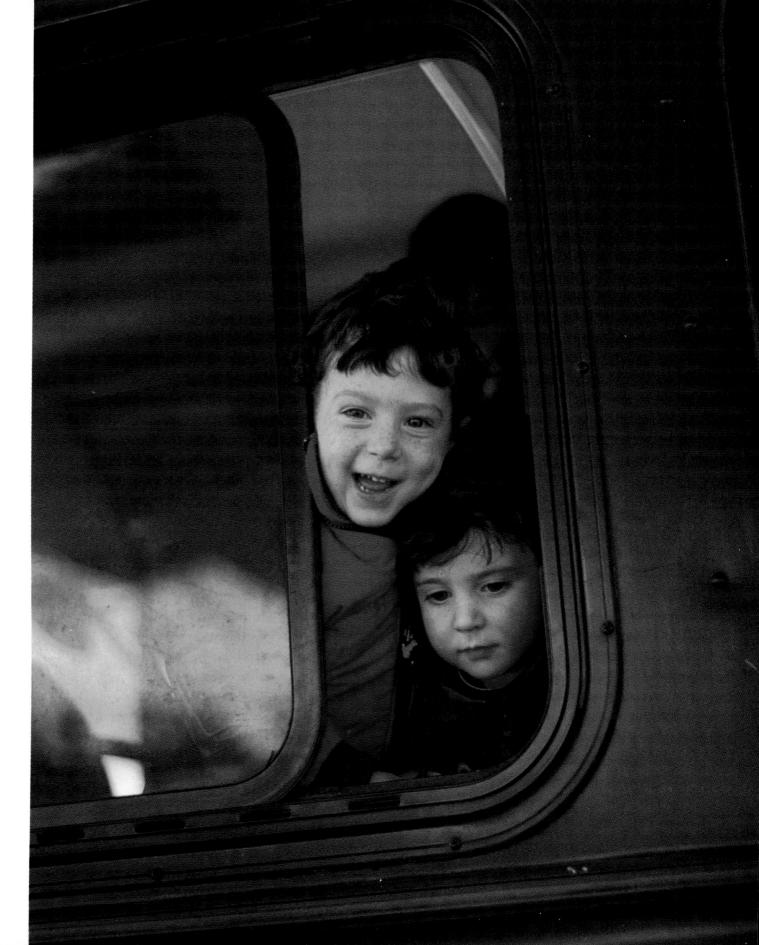

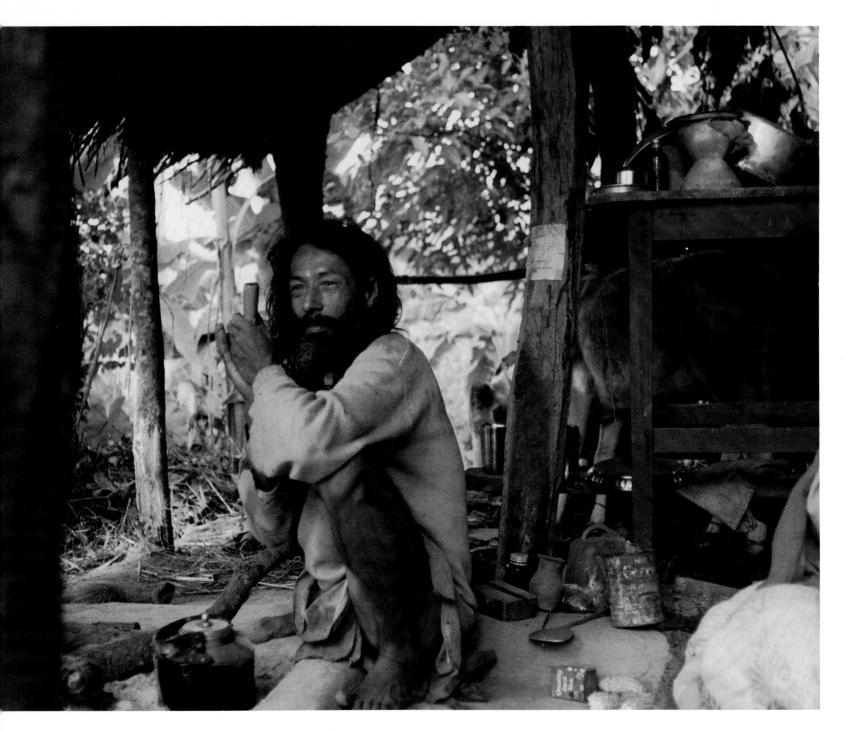

High Holy Man A holy man sits in his living area in the mountains of Nepal.

MERIT AWARD BETSY E. YOUNG

Zanesville OH USA The Times Recorder KODAK GOLD 200 Film

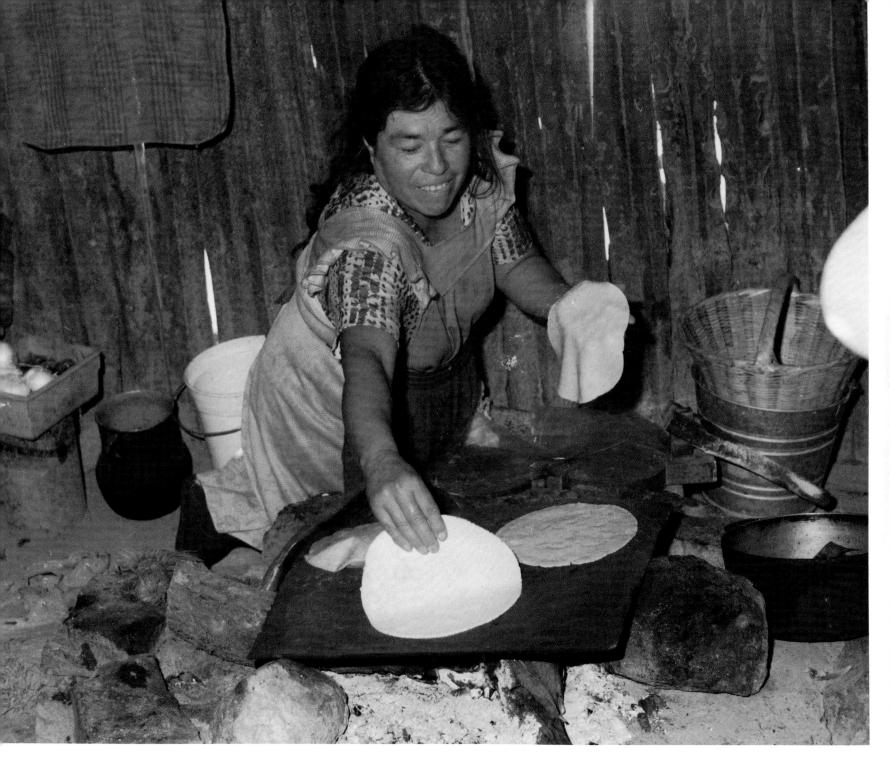

Tortillas A woman cooks at the ranch of San Luis Potosi in Chihuahua, Mexico. MERIT AWARD SRA. NORMA CORRAL DE ROCHA Chihuahua Mexico *El Heraldo* kodacolor vr-g 100 Film

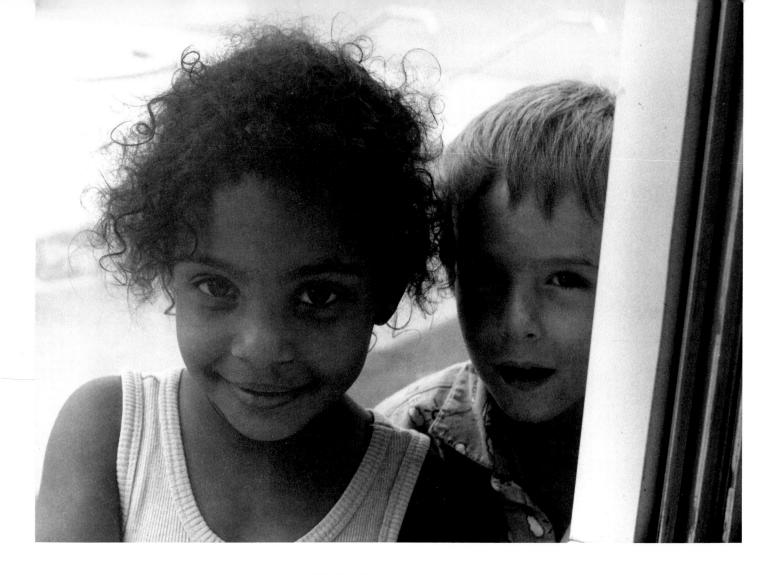

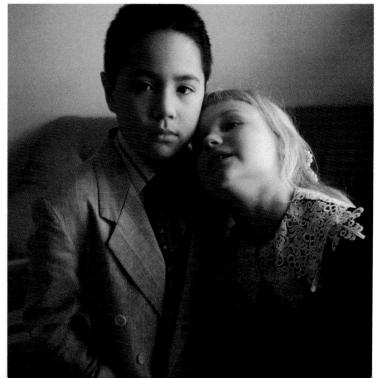

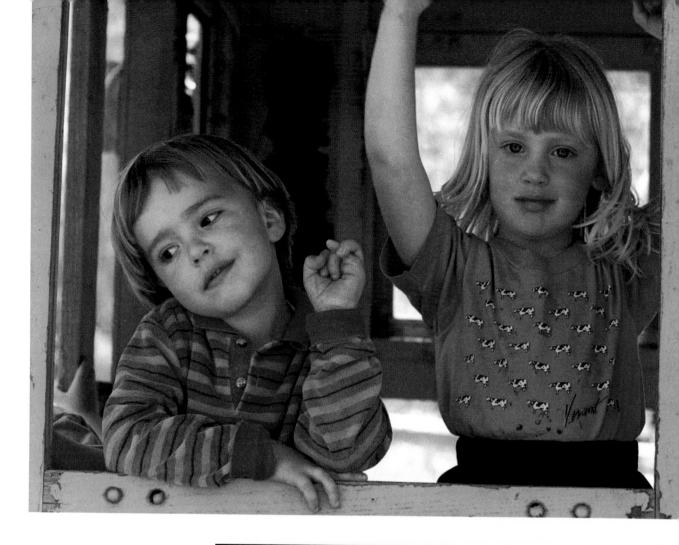

Wide-Eyed Onlookers Opposite, top: Close-up of a girl and a boy framed in a window.

MERIT AWARD RENEE E. PAGE
ROME NY USA The Daily Sentinel

KODAK T-MAX 100 Professional Film

Friends Forever! OPPOSITE, BOTTOM: Tad and Kara rest in our living room after Easter lunch.

MERIT AWARD LEON F. TOMASIC

Feighenle AK and F. TOMASIC

Fairbanks AK USA Daily News-Miner KODAK GOLD 200 Film

Two Friends at Morning Playground TOP: Friends play in the cab of a snow plow.

MERIT AWARD DEBORAH WARD LYONS
Burlington VT usa The Free Press Kodak Gold 100 Film

Innocence BOTTOM: Small girl and boy, backlit, in natural sunlight.

MERIT AWARD KIMBERIY A. GEHLE-ROMBERGER Bellvue NE USA *The World-Herald* KODAK T-MAX 400 Professional Film

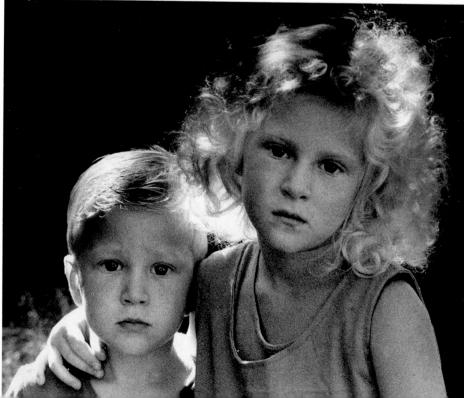

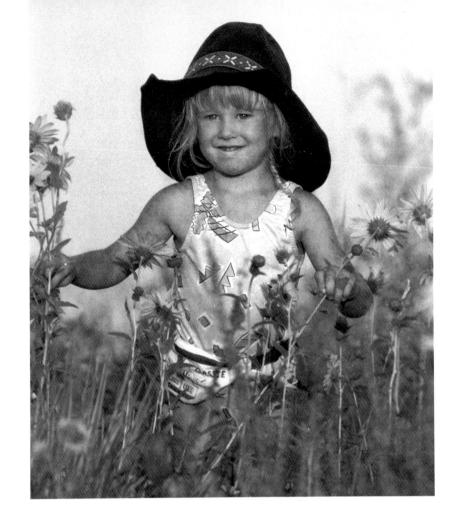

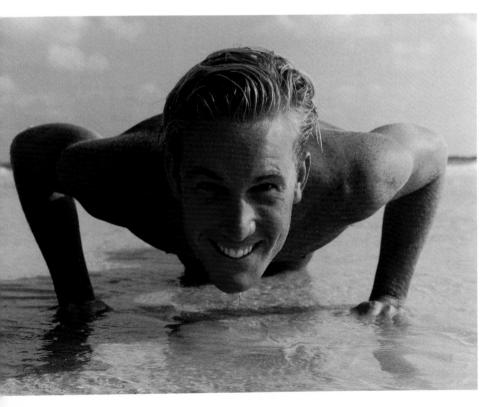

Summer Joy Top: Cassie Mulloy walking down a sandhill full of flowers on her parents' ranch. **MERIT AWARD** SIDNEY L. MILLER

Gering NE USA *The World-Herald*KODAK T-MAX 400 Professional Film

Push-Ups in the Surf Left: An unusual, eye-level view from Seaside, Florida.

Merit Award George M. Skaroulis

Panama City Fl usa *The News Herald* Kodak Gold 200 Film

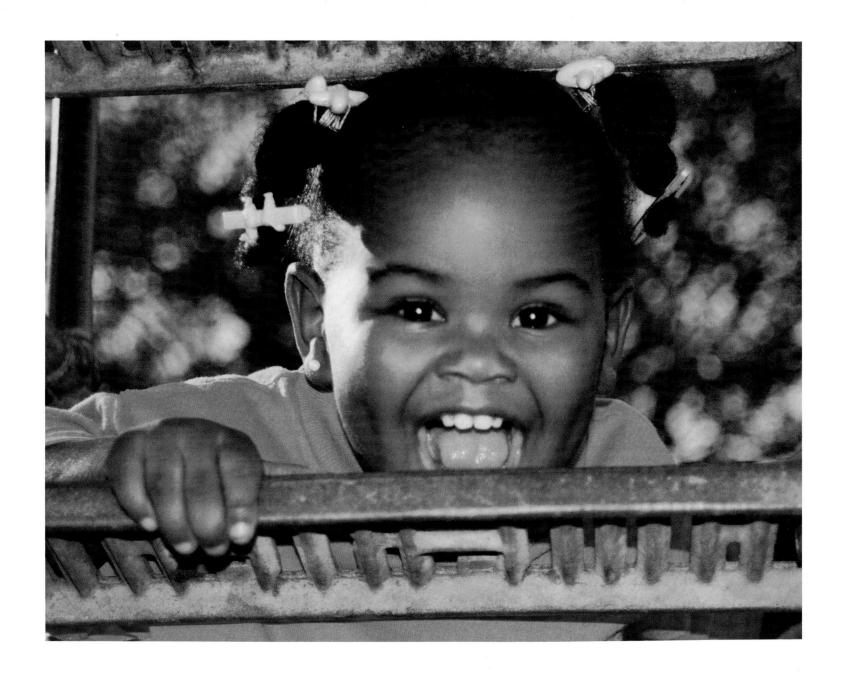

Morning Glory in Dreamland Park A two-year-old child climbing the ladder of a park slide at a Martin Luther King Day Celebration.

HONOR AWARD DIANE B. LIFTON

Port St. Lucie FL usa The News Kodak Gold 200 Film

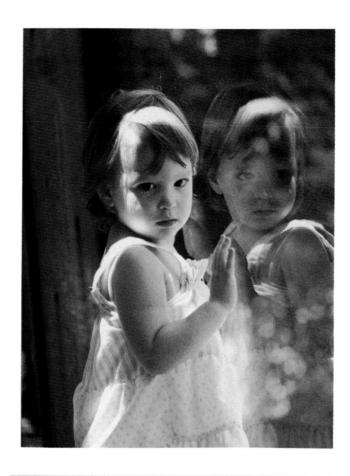

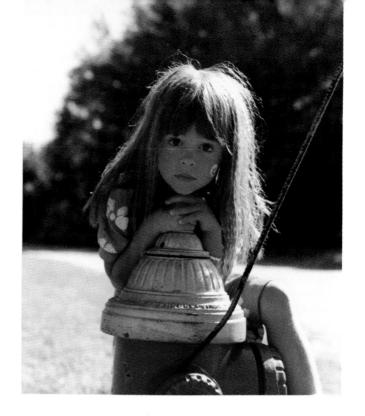

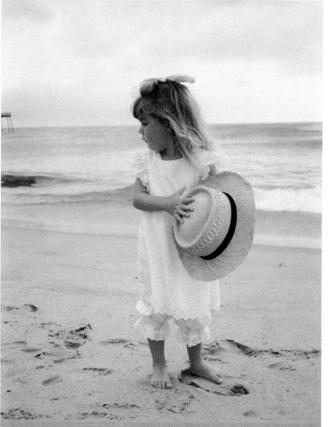

Little Girl by Window TOP LEFT: My granddaughter at a plate-glass window.

MERIT AWARD ETHEL L. GREER

Benton LA USA The Times KODAK GOLD 400 Film

First Day of School TOP RIGHT: Jessica's first day of kindergarten, waiting for her brother at the bus stop.

MERIT AWARD SHARMAN H. COHEN

Londonderry NH USA The Eagle-Tribune KODAK GOLD 200 Film

Sweet Sadie LEFT: A little girl with a big beach hat.

MERIT AWARD PAT WARTHEN

Newark OH USA The Advocate KODAK GOLD 100 Film

Awaiting Easter Mass OPPOSITE TOP: A child sitting in front of a church in Morelia, Mexico.

MERIT AWARD CARTER J. COREY

Fort Lauderdale FL usa The Sun-Sentinel KODACOLOR VR-G 400

Day for a Daydream! OPPOSITE BOTTOM LEFT: Little boy on a bike.

MERIT AWARD BUBBA PINO

Dartmouth, Nova Scotia canada The Daily News Kodak Gold 100

Tender Tears OPPOSITE BOTTOM RIGHT: David Figueroa Sanchez suffers a disappointment.

HONOR AWARD FRANCISCO JAVIER SANCHEZ VALDEZ

Tampico Mexico El Sol de Tampico Kodak Gold 100 Film

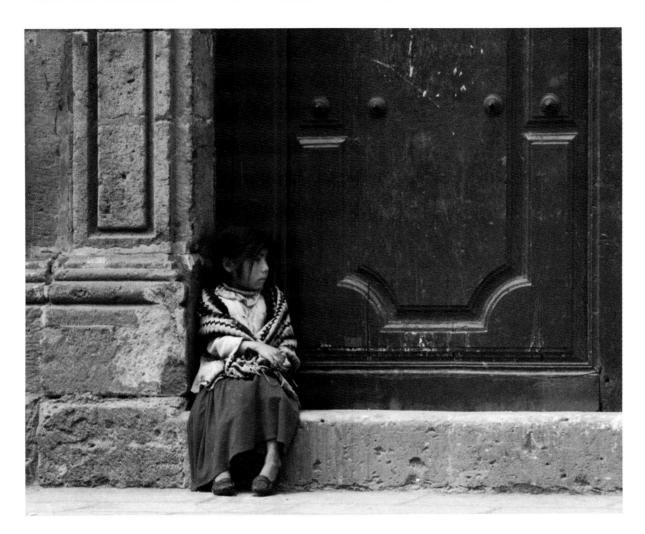

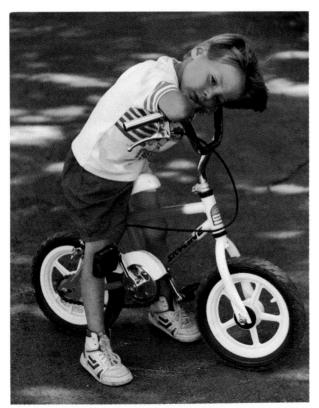

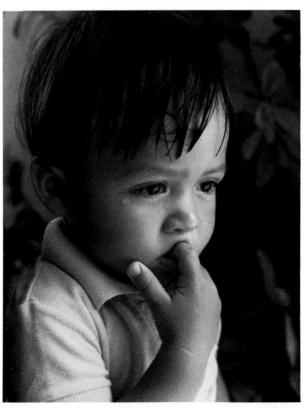

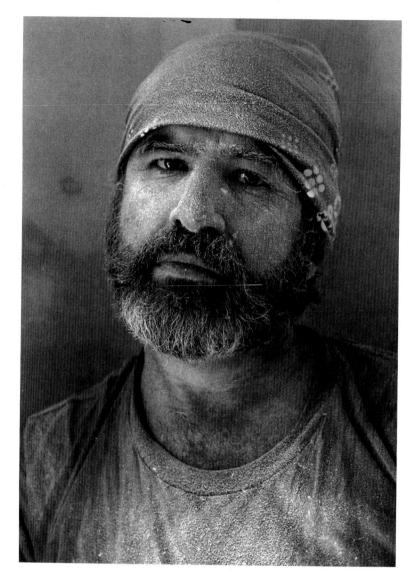

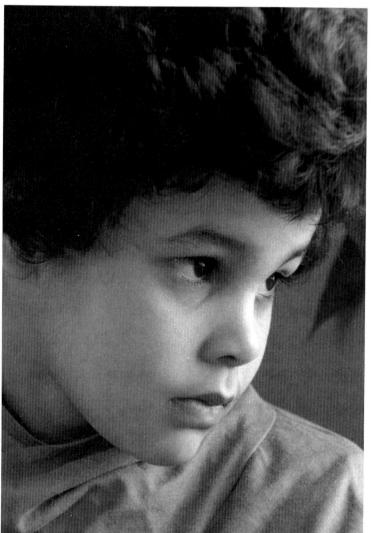

Drywaller ABOVE: My husband, Charlie, wearing a bandana and covered with dust at the end of the day.

HONOR AWARD RHONDA SCHWARZ

Baltimore MD usa The Baltimore Sun Kodak Plus-x Film

Portrait of Lorrie LEFT: Taken with window light for my photo class at the community college.

MERIT AWARD MARY LOU ROUX Rome NY USA *The Daily Sentinel* KODAK T-MAX 100 Professional Film

Reflecting on her Twinkling Years OPPOSITE: An elderly woman, taken in Ojo Caliente, NM.

MERIT AWARD B. RICHARD TEMPLETON

Traverse City MI USA The Record Eagle KODAK TRI-X Pan Film

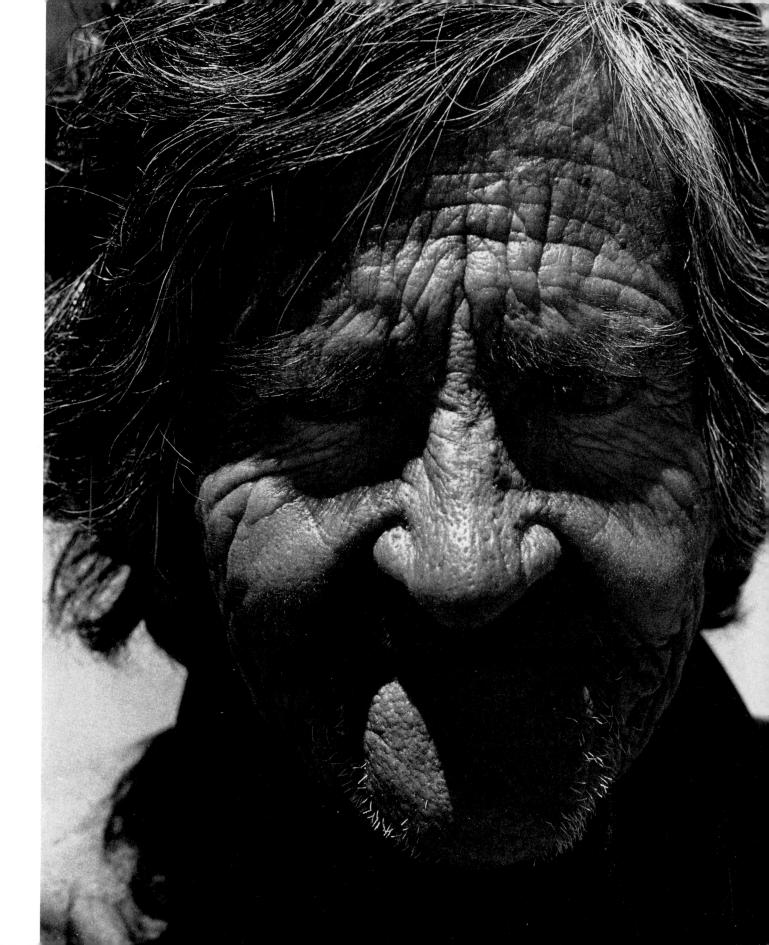

THE ARTIST'S EYE

ABSTRACTS AND STILL-LIFE

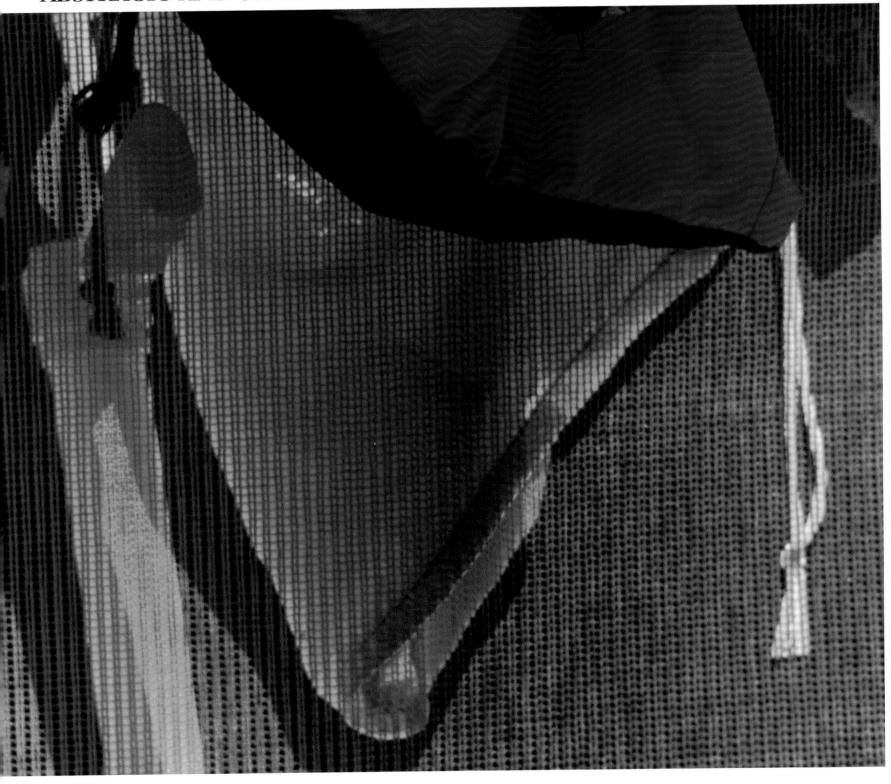

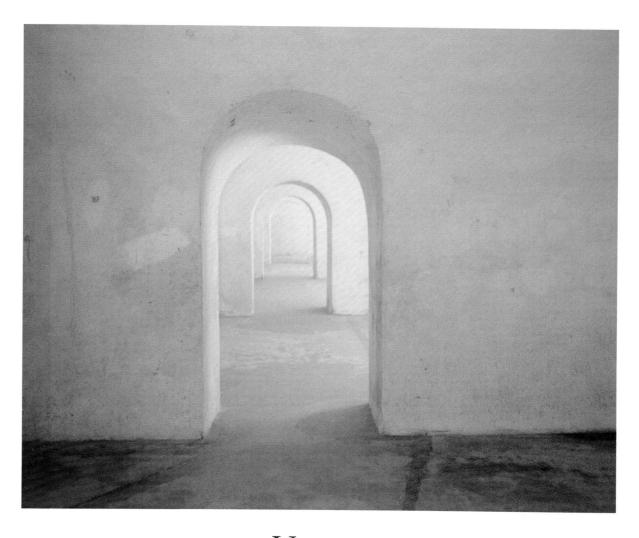

El Morro—Passages ABOVE: San Felipe del Morro Fort, Puerto Rico, dating from 1540. HONOR AWARD KRISTIN L. THOMPSON
Nashua NH USA The Union Leader
KODAK GOLD 100 Film

Wet Bathing Suits Drying OPPOSITE: Bathing suits drying in the sun on a screen by my sister's pool.

HONOR AWARD DR. HOWARD LAWRENCE FREY Mahwah NJ USA *The Times* KODACHROME 64 Professional Film Visual creativity is the central element in still photography as an art form. Photographers observe the form and composition of natural objects, or arrange them to create pleasing patterns of color, texture, light, and shadow. Abstract images are composed of geometric or graphic patterns, often obscuring the identity of the object being photographed. Still-life photographs, by contrast, show recognizable, inanimate subjects in a novel composition, whether found or created.

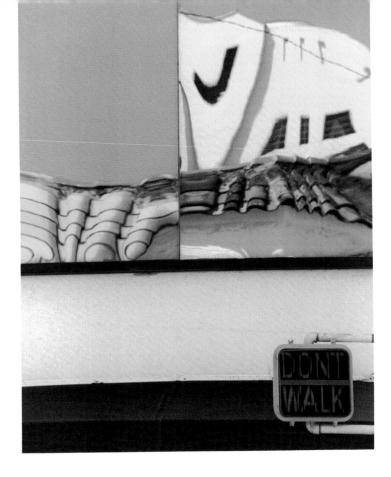

Don't Walk Left: Reflection on mirrored building at an intersection in Miami, Florida. **HONOR AWARD** PATRICIA A. OREAL

Fort Lauderdale FL USA *The Sun-Sentinel* KODAK EKTAR 125 Film

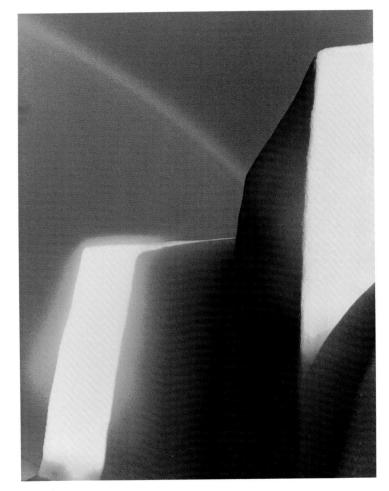

Sunset, Rainbow at Rancho De Taos RIGHT: An adobe church often painted by Georga O'Keefe, taken just before sunset with heavy mist in the air.

HONOR AWARD JOSEPH D. STRANO

Plantation FL usa The Sun-Sentinel Kodak Gold 100 Film

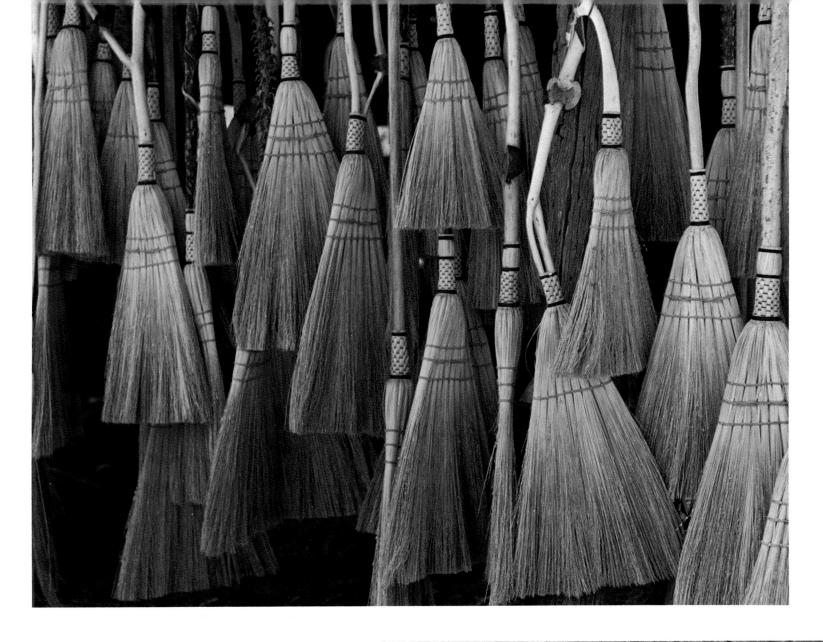

Geepers! Sweepers! ABOVE: Self-employed brooms make intriguing company.

MERIT AWARD GEORGE KLARMANN

Valrico FL usa The Tribune Kodak Gold 100 Film

Flight of the Hawk RIGHT: A chance moment becomes a surreal memory.

HONOR AWARD JORGE GARCIA CAMACHO
Neza MEXICO El Universal KODAK GOLD 100 Film

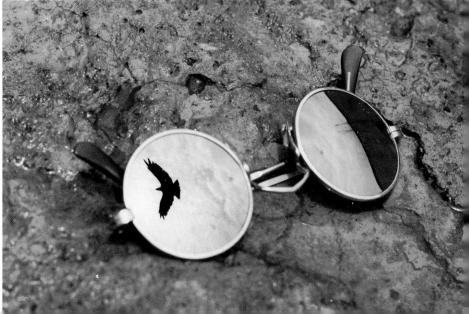

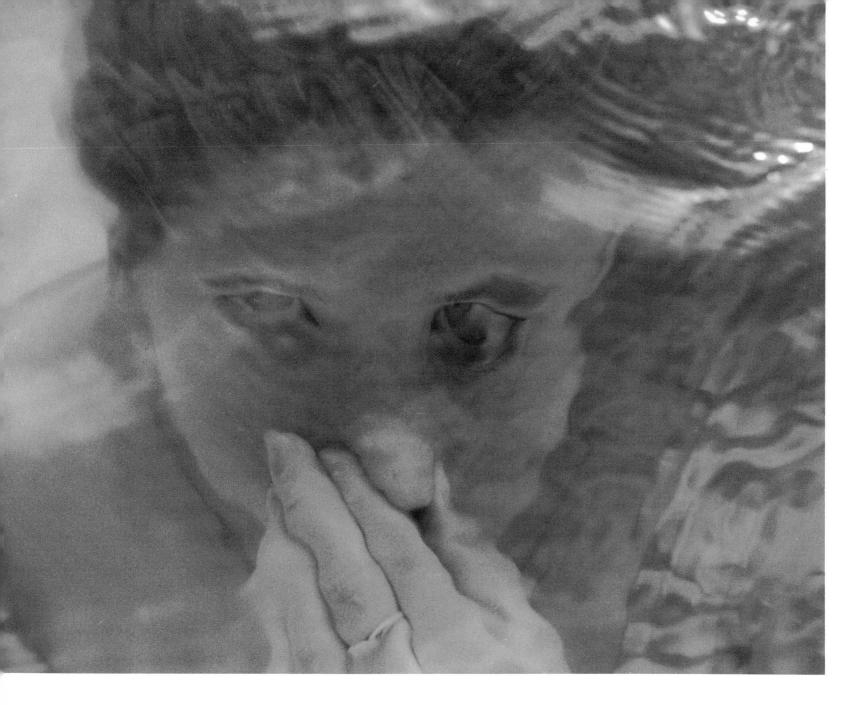

Underwater Images ABOVE: On Easter Sunday I was standing on the edge of the pool, photographing my daughter as she swam towards me.

MERIT AWARD ROBYN JACOBS

Boise ID usa The Idaho Statesman Kodak Gold 100 Film

Starfish in the Wind OPPOSITE, TOP: A tide pool filled with colorful starfish. Wind whipping across the water lends an impressionist touch.

MERIT AWARD JACQUELINE GREENE
Wellesley MA USA The Boston Globe KODAK GOLD 100 Film

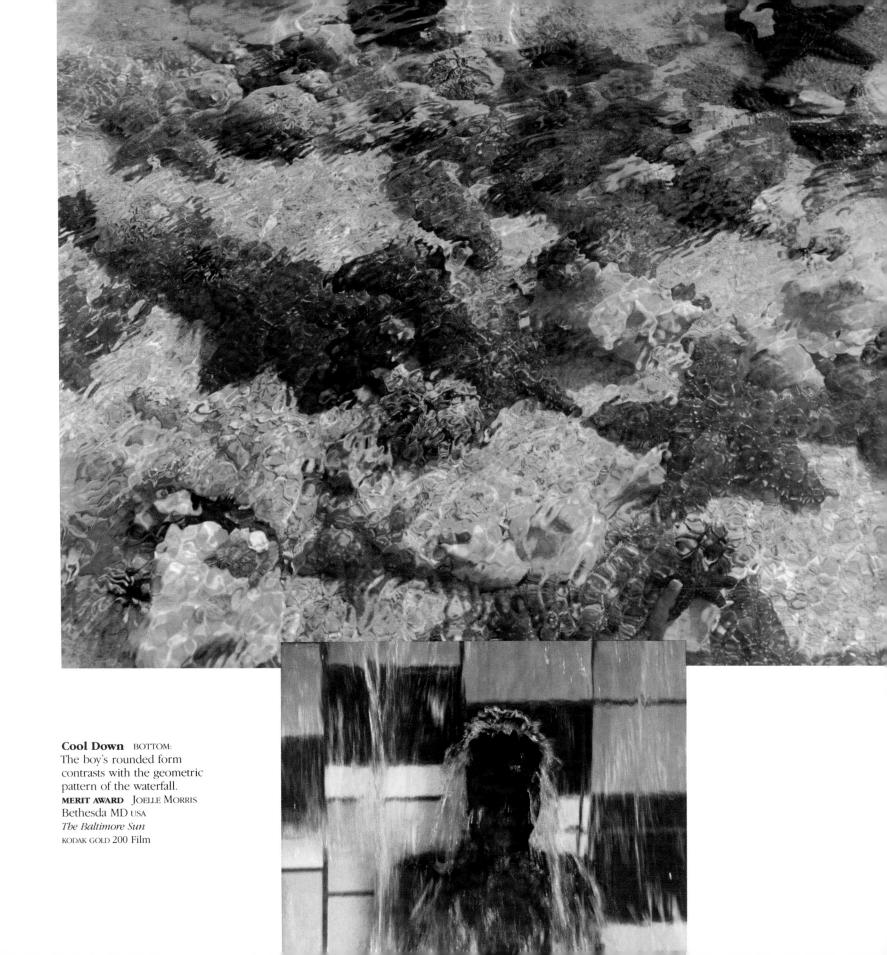

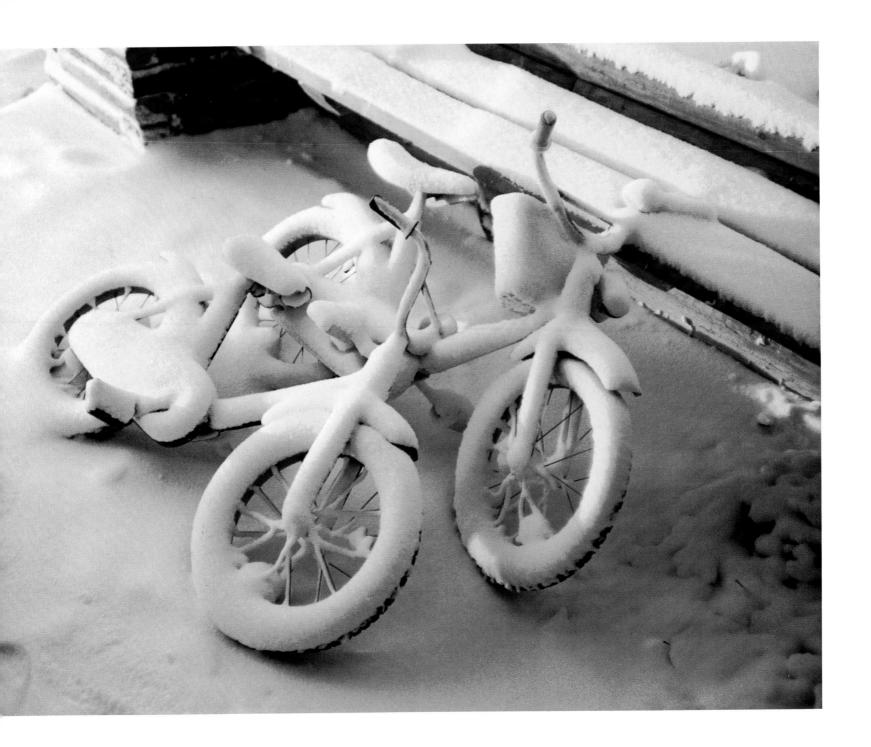

Snow Bikes Two children's bikes covered with snow at my home in Michigan capture the essence of summer's passing.

MERIT AWARD TAMARA J. TOWER-HEBERT

White Pigeon MI USA The Journal KODAK GOLD 200 Film

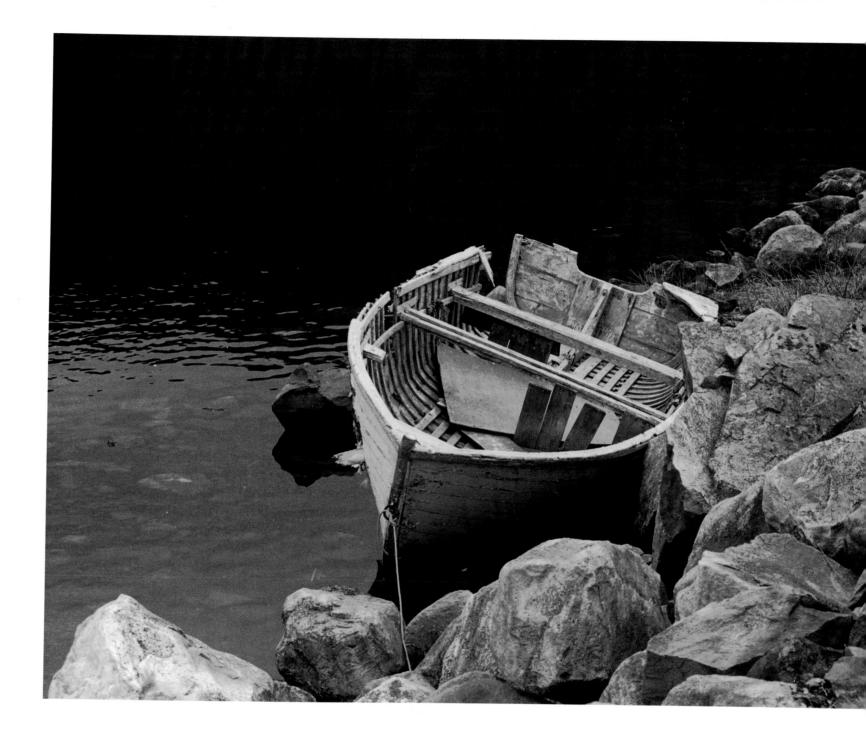

Dry DockA broken boat abandoned on the rocks.MERIT AWARDROBIN V. KIARMANNValrico FL USAThe TribuneKODAK GOLD 200 Film

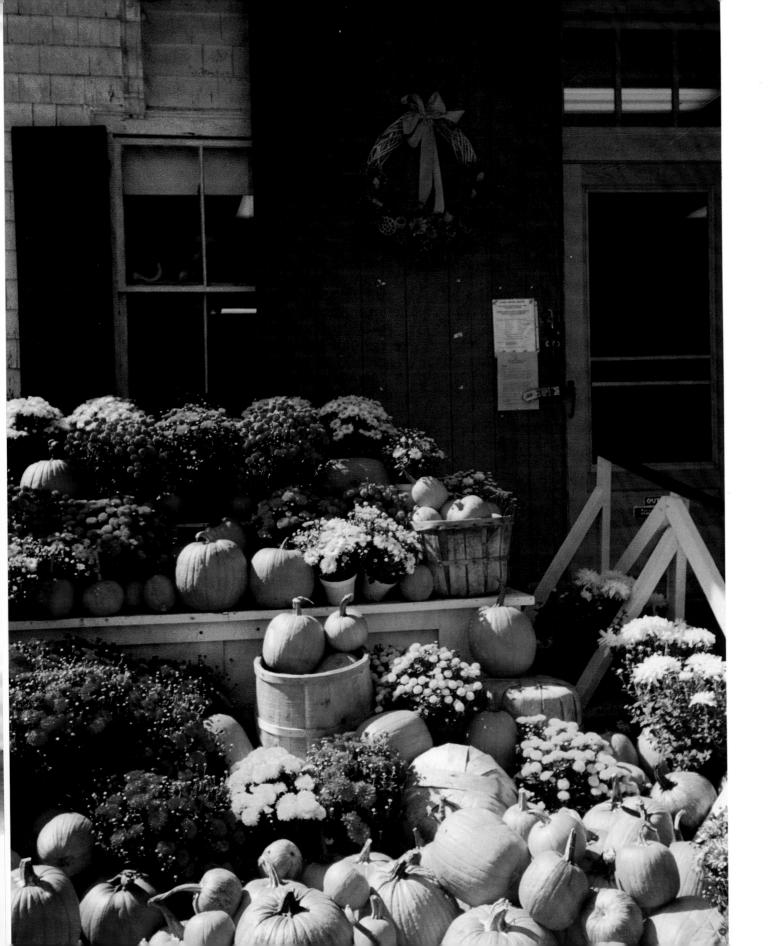

Harvest of Color Opposite: Local farmstand with colorful pumpkins and mums.

MERIT AWARD JEAN A. McGowan

Beverly MA USA The Evening News KODAK GOLD 100 Film

Grand Granada Top: Granada rose in our back yard. **MERIT AWARD** CHARLES NICHOLAS FRENCH

Opelika AL USA *The News* KODAK GOLD 100 Film

The Shadows on the Wall BOTTOM LEFT: Two amaryllis plants that I keep on my kitchen table.

MERIT AWARD BARBARA FORD

Richmond VA The News Leader KODAK GOLD 200 Film

Set Table BOTTOM RIGHT: A single shaft of sunlight pierces the darkness of a nightclub in Leon, Mexico. **MERIT AWARD** HUMBERTO ARIZPE TORRES GOMEZ

Palacio Durango Mexico *La Opinion* KODAK GOLD 100 Film

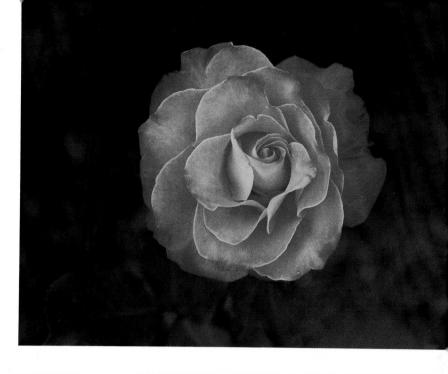

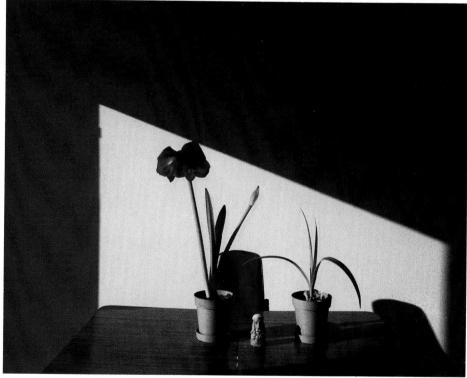

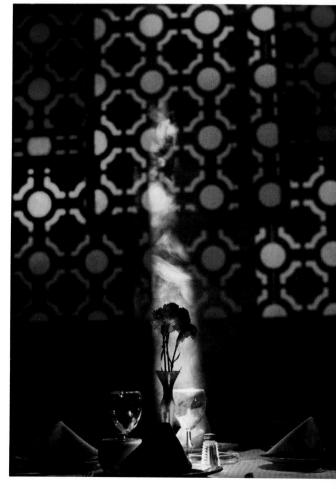

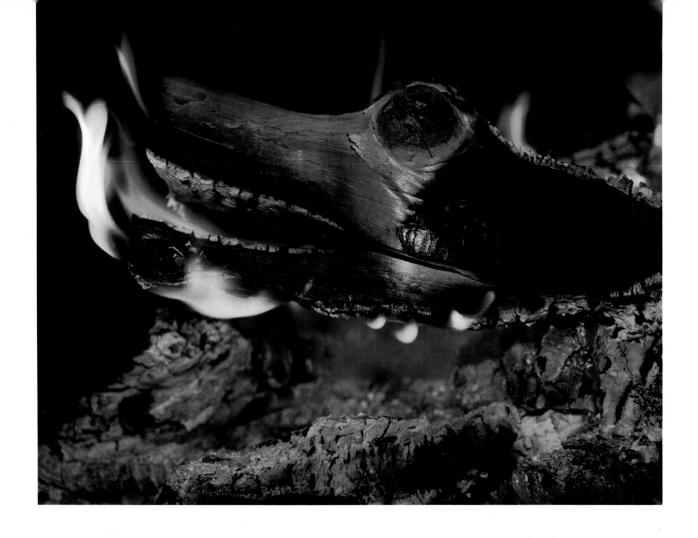

Out of the Flames Above: A burning log in a fireplace becomes a fire-breathing dragon.

MERIT AWARD JAMES R. SLIZIAK

Langley, British Columbia CANADA The Times

KODAK GOLD 100 Film

Get Off My Rope! Opposite: I noticed the tiny boat in front of the large ships while taking pictures in the Port of Saint John. The bow of the large ship looks like some kind of monster peering down at the tiny boat. **MERIT AWARD** ROBERT G. REEVES

Kennebecasis Park, New Brunswick Canada *The Telegraph & Evening Times* Kodak ektar 25 Professional Film

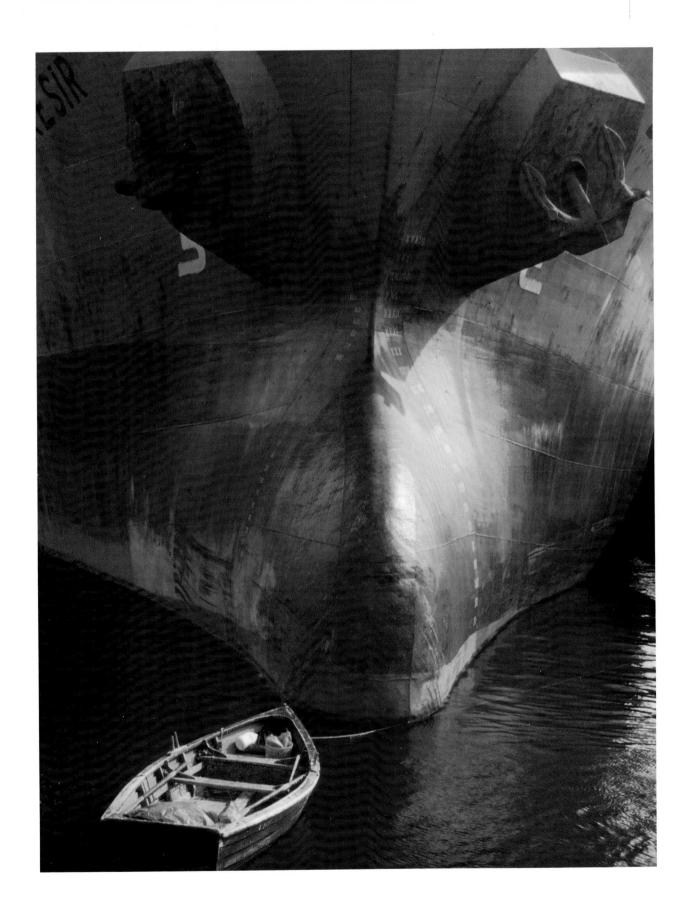

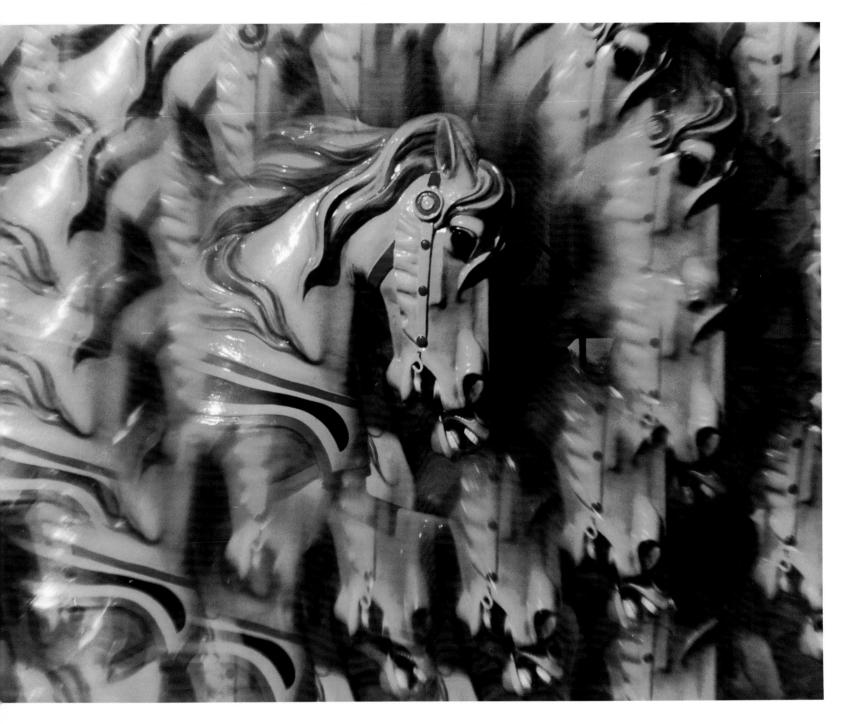

Horsing Around An image-multiplying filter makes a striking pattern of carousel horses.

MERIT AWARD LINDA LABONTE BRITT

LOWELL MA USA The Sun KODAK VERICOLOR III Professional Film

THE ARTIST'S EYE

Fast Paced City of Atlanta A zoom lens reveals the hurried pace of a large city in this dramatic nighttime shot of the Atlanta skyline.

MERIT AWARD JONATHAN WINTER
Dacula GA USA The Daily News KODAK EKTAR 125 Film

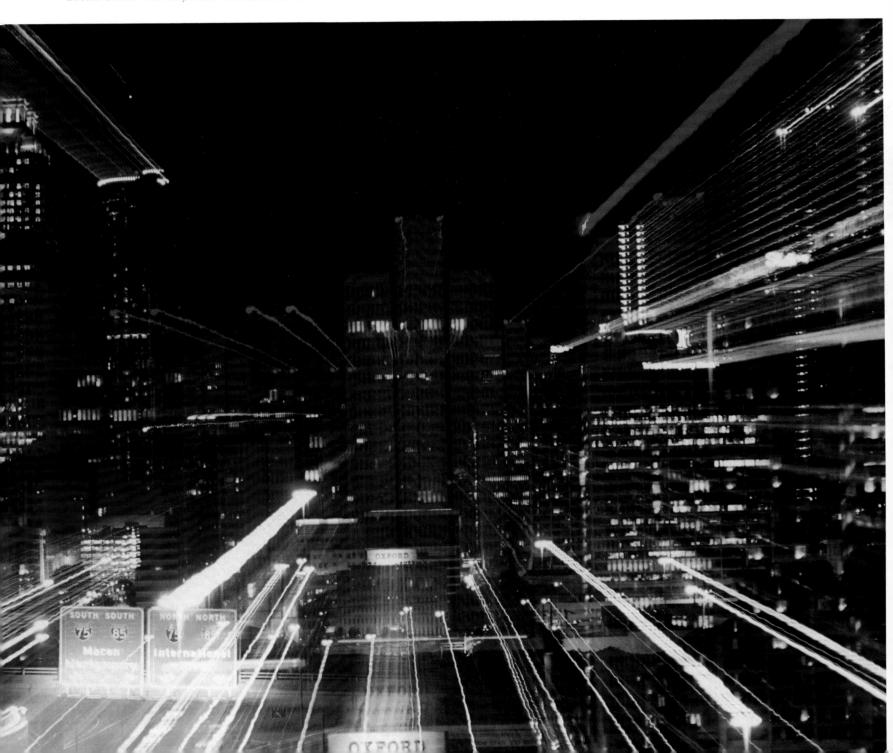

Our Constant Companions Animals

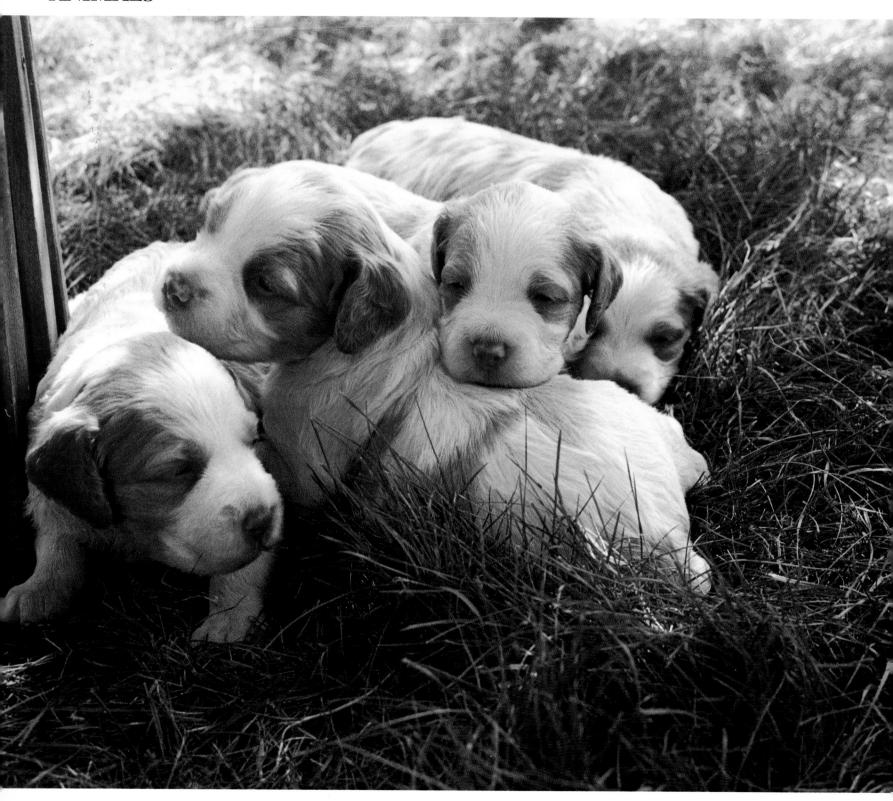

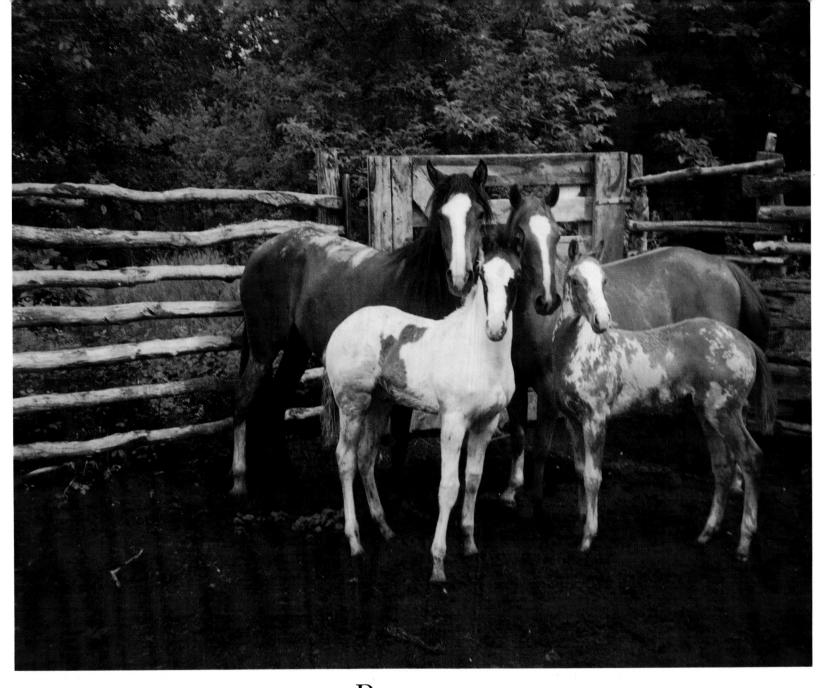

Spring Roundup ABOVE: Paint colts and mothers at a spring roundup, taken at my father's ranch in Interior, South Dakota.

MERIT AWARD RONALD E. HEATHERSHAW

Rapid City SD USA The Tribune

KODAK GOLD 100 Film

Let's Cuddle opposite: Two-week-old Brittany spaniel puppies bravely face the new world. **MERIT AWARD** JUDY W. HEARING

Marietta OH USA *The Times* KODAK GOLD 200 Film

Pet and wildlife pictures present a challenge to the photographer. Location, lighting, and action are usually determined by the animal's habits rather than the photographer's wishes. Photographing wild animals is even more difficult in those instances where the photographer's task is complicated by unfamiliar locale, unpredictable behavior, or uncontrollable weather conditions. The photos of animals featured on the following pages acknowledge the invaluable role animals play in our lives.

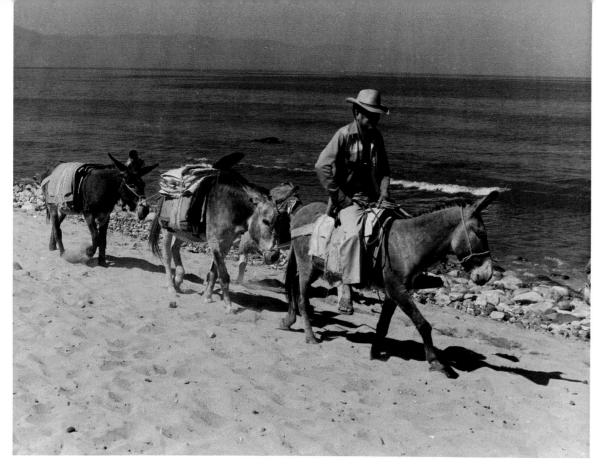

Burro Convoy Left: A man on the beach in Puerto Vallarta.

MERIT AWARD SRA. FELIX MARIO REOJAS

MERIT AWARD SRA. FELIX MARIO REOJA Aguayo Saltillo MEXICO Vanguardia KODACOLOR VR-G 100 Film

Dreaming Opposite: Sweet Jasmi Arvizo Gaytan in my house with her puppy.

MERIT AWARD JUVERA GAYTAN FIDEL

Hermosillo MEXICO El Imparcial

KODAK GOLD 400 Film

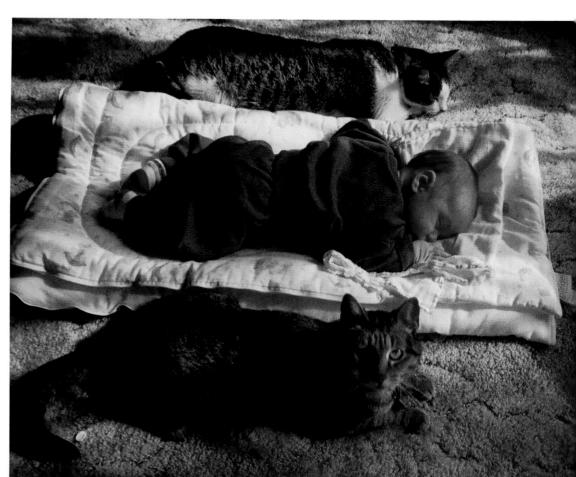

The Guard Cats RIGHT: Our baby sleeping with two cats in the morning sun.

MERIT AWARD LAURA L. WETTSTEIN

Wisconsin Rapids WI USA The Daily Tribune

KODAK GOLD 200 Film

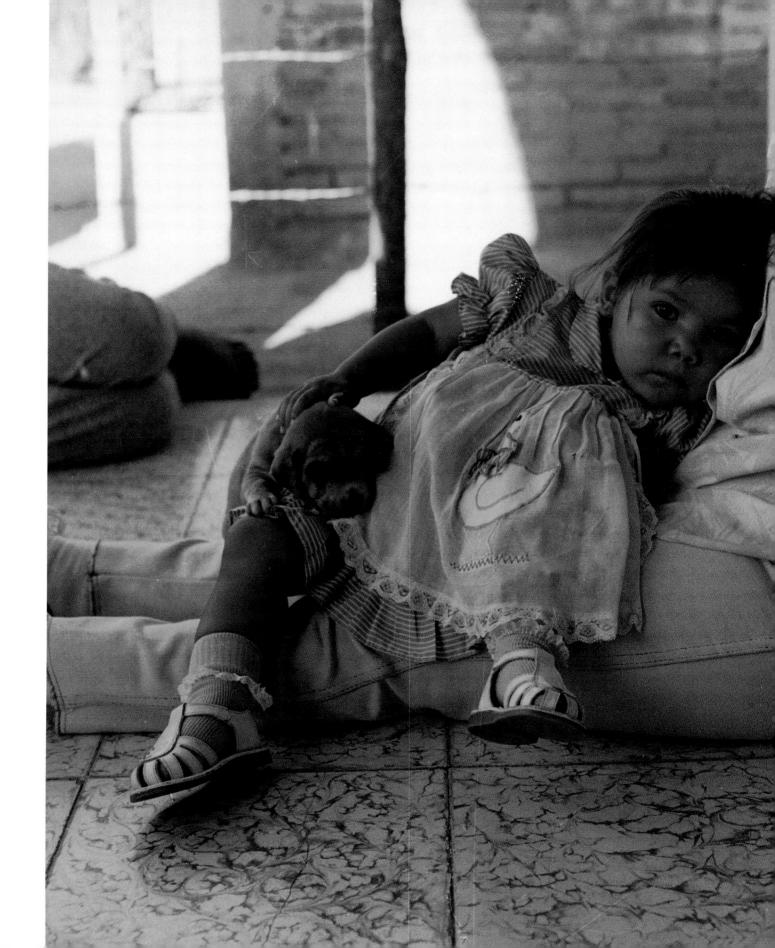

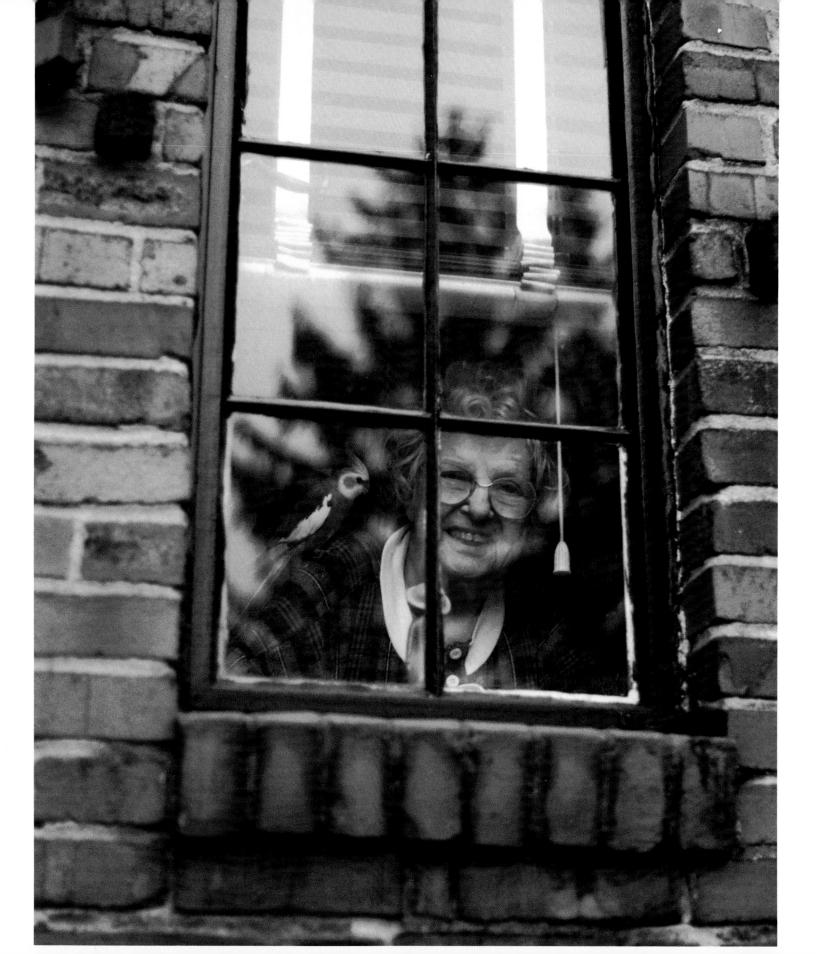

Nonny and Ernie—Together Again OPPOSITE: My grandmother with her bird, Ernie. Both have since passed away.

MERIT AWARD HEIDI K. TORQUATO
Winber PA USA The Tribune-Democrat KODAK GOLD 200 Film

Owl Be Watching You! RIGHT: Late afternoon on Arbuckle Creek, Avon Park, Florida.

MERIT AWARD LENNIS A. BARRINGER
RIVERVIEW FL USA The Tribune KODAK GOLD 200 Film

Color on a Limb BELOW: Scarlet macaw at the Cincinnati Zoo.

MERIT AWARD CHARLES E. HOLLIDAY Hamilton OH usa * The Journal News * kodak ektar 125 Film

True ColorsBOTTOM RIGHT: Closeup of a male peacock.MERIT AWARDLOUISE S. CLARKETampa FL USAThe TribuneKODAK GOLD 100 Film

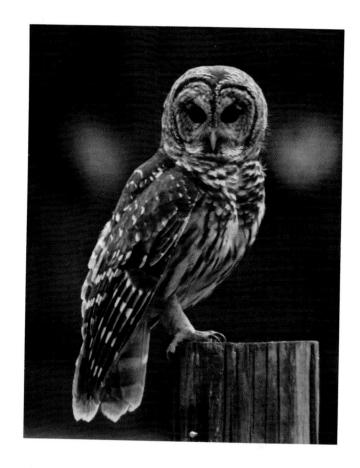

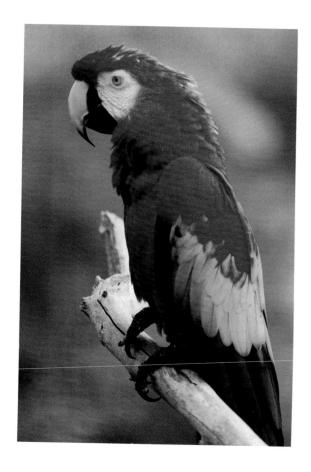

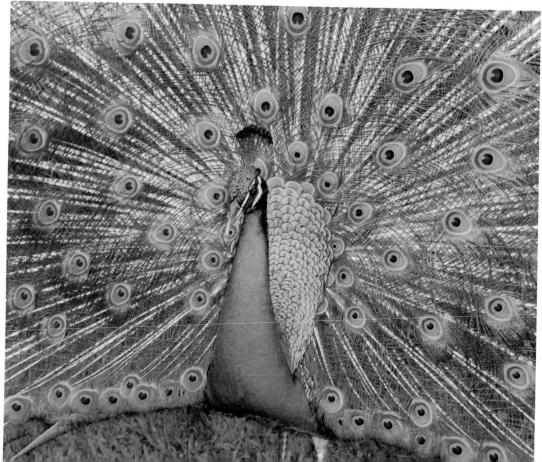

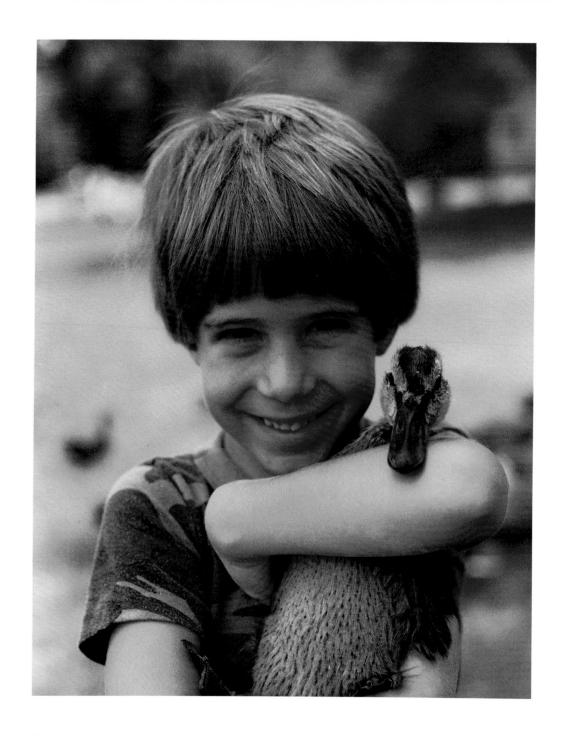

Best Friends A small seven-year-old boy holding a wild duck.

MERIT AWARD LINDA L. FUGE

Johnstown PA USA The Tribune-Democrat

KODAK GOLD 100 Film

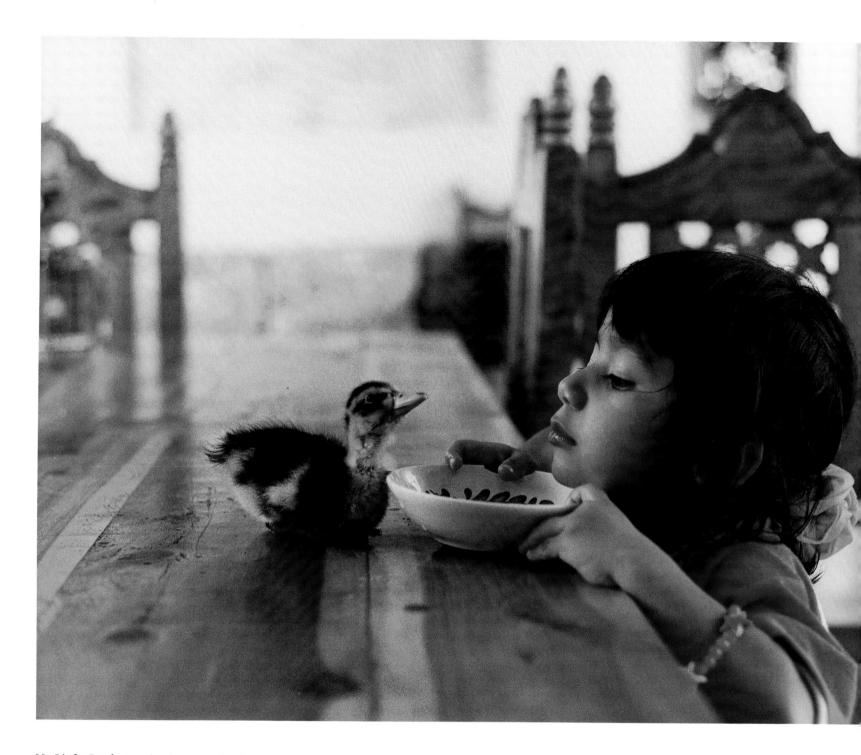

My Little Duck My daughter tempting her pet with a special treat.

MERIT AWARD JUAN IGNACIO ORTEGA JIMENEZ
Lindavista MEXICO El Universal KODAK GOLD 100 Film

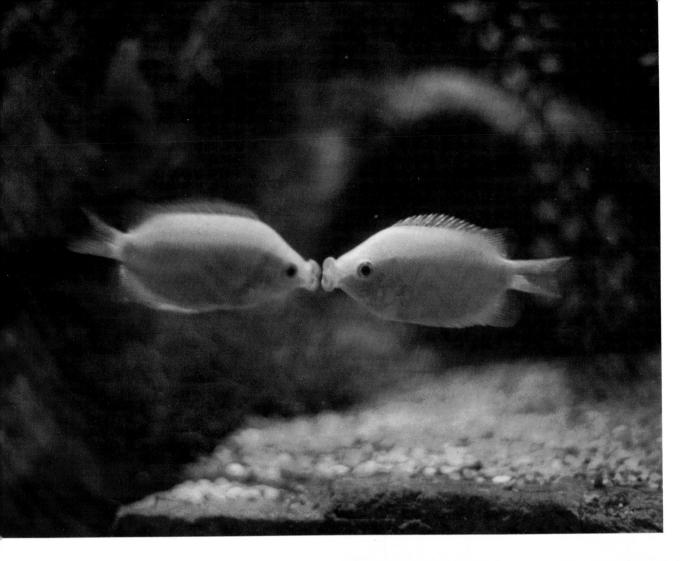

Love Bubbles Above: Fish kissing? Not really. Just a reflection from the wall of the aquarium. Merit Award Gustavo A. Bonilla Garcia Monclova Mexico *Vanguardia* Kodacolor vr.g 100 Film

Good to the Last Lick RIGHT: Shar-pei puppies making a mess of themselves while eating baby rice.

MERIT AWARD RUSS WALLACE ASOTIN WN USA The Morning Tribune KODAK GOLD 100 Film

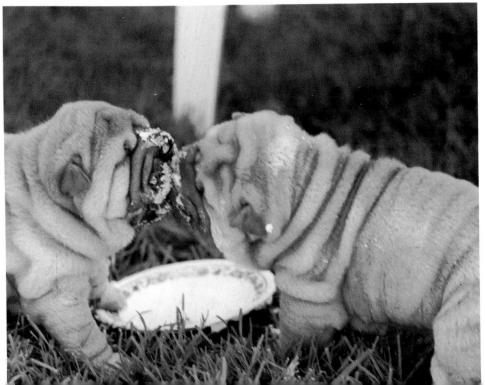

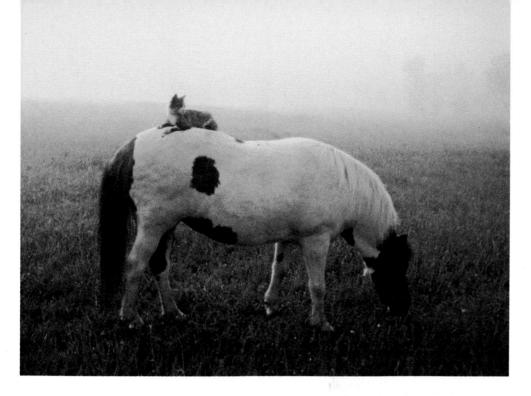

Home on the Range LEFT: My pony with our cat on her back, the only dry place on a foggy day.

MERIT AWARD CYNDI HAYES
Cambridge Springs PA USA The Times-News
KODAK DISC Film

Waiting for the Next Meal BELOW: Two pigs in a pen on my father's farm in Rockville, Virginia. HONOR AWARD JENNIFER LYNN RADA Glen Allen VA USA The News Leader KODAK GOLD 100 Film

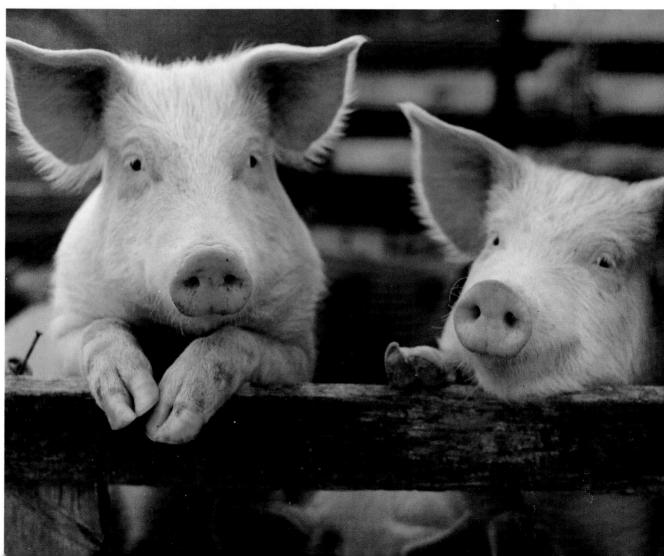

GRAND VISTAS LANDSCAPES AND SCENICS

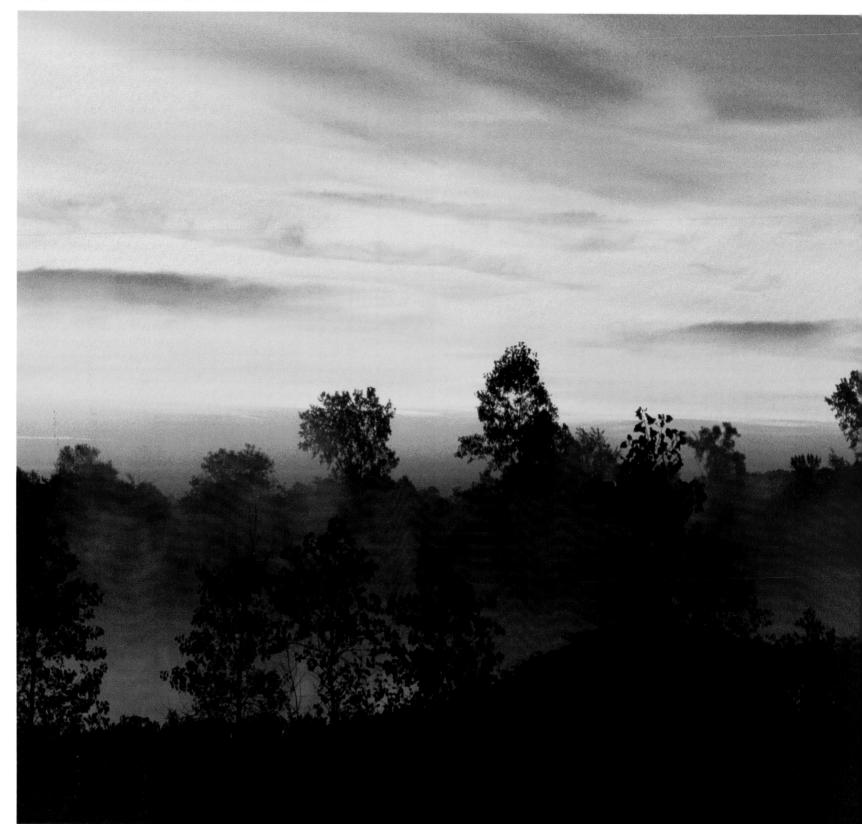

The Pond ABOVE: The peace and stillness of an autumn sunset.

HONOR AWARD CULLEN NUGENT Lumsden, Saskatchewan Canada The Leader-Post KODAK VERICOLOR III Professional Film

Hindered Sunrise

OPPOSITE: Looking east into an overcast sunrise with morning mist covering a lake near Carey, Ohio.

MERIT AWARD JOHN A. KELLER BUCYTUS OH USA *The Inquirer* KODAK GOLD 200 Film One never tires of the beauty of nature as expressed in photographic vistas of sea, mountain, prairie, and desert. Light plays on the landscape, creating dramatic shadows in early morning or late afternoon, or landing with full force in midday. The sheer variety of scenes offered here—draped in soft and dreamy mists, or shimmering with vibrant color, or bristling with rocky crags—is a travelogue of places we have been or long to visit.

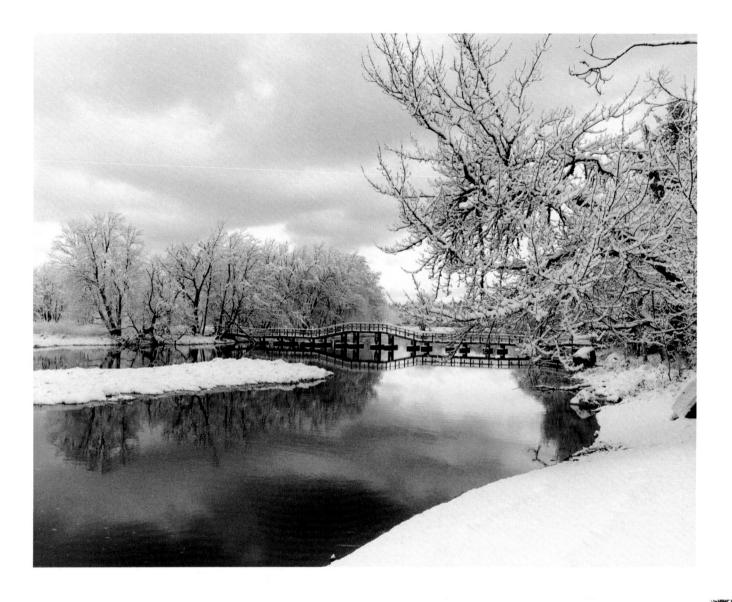

Keji at Its Best ABOVE: Winter scene in Keji National Park, Japan.

MERIT AWARD DAVE G. HISCOCK

Halifax, Nova Scotia canada The Daily News Kodak Gold 100 Film

Morning Mist RIGHT: A silent lake with trees reflecting in the water in early morning.

HONOR AWARD GEORGE GREEN

Tewksbury MA USA The Sun KODAK PLUS-X Film

Winter Water Wonderland Opposite: Winter slush covers the pier at Benton Harbor on the St. Joseph River at Lake Michigan.

MERIT AWARD DOUGLAS GEIGER

Sturgis MI USA The Journal KODAK T-MAX 100 Professional Film

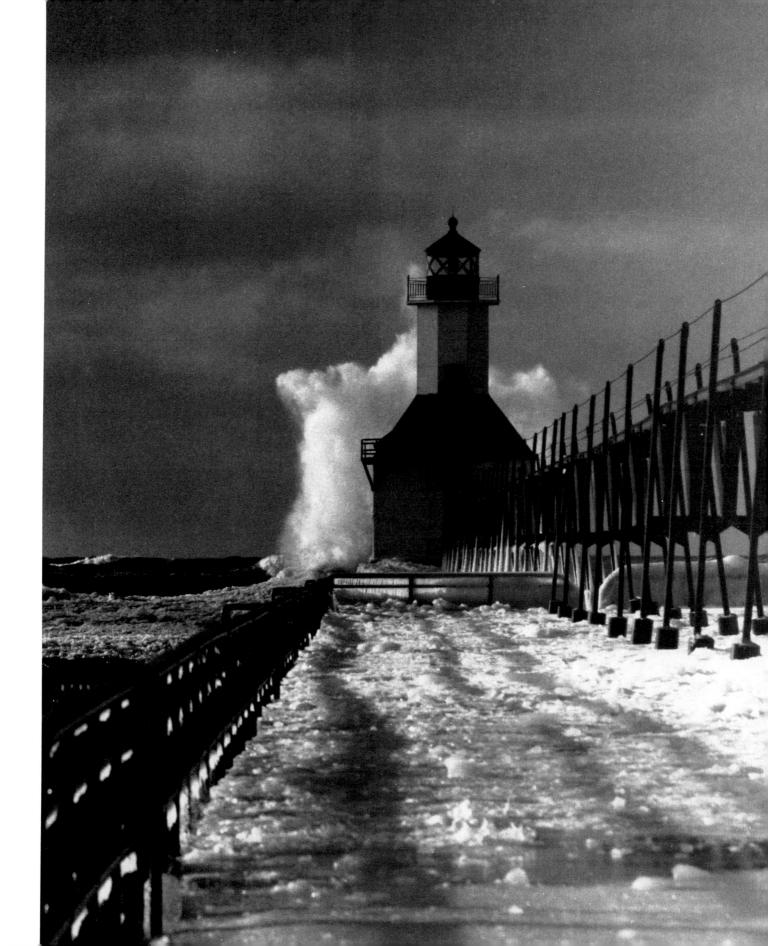

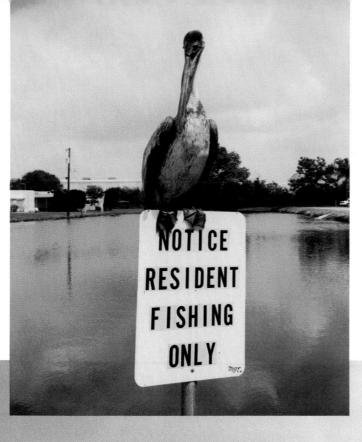

An Unwelcome Non-Resident LEFT: A pelican perched for a wonderful moment.

MERIT AWARD DUDLEIGH SCHRODER

Escanaba MI USA The Daily Press KODAK GOLD 200 Film

Storm Study in Blues BELOW: Stormy day on the English Channel at Sheringham, England.

MERIT AWARD JOANNE JACKSON LISK

Vidalia LA usa The Democrat Kodak Gold 200 Film

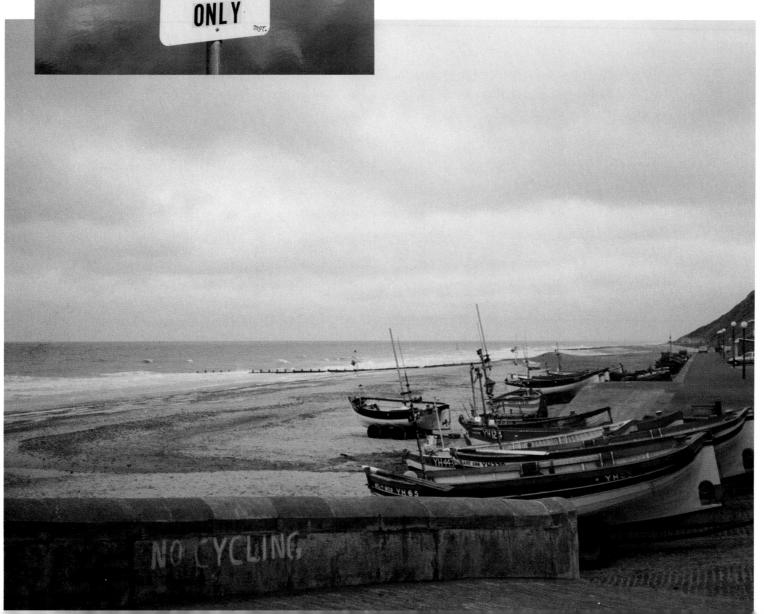

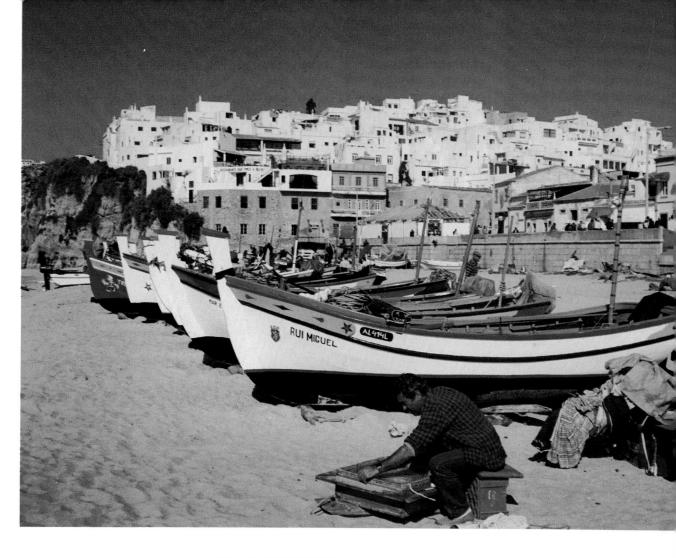

Preparing for the Catch TOP: Portuguese fisherman make morning repairs to nets in Algarve, Portugal.

MERIT AWARD ROBERT L. VASS

West Bend WI USA The Daily News KODAK GOLD 200 Film

Marooned BOTTOM: Shipwrecked boats at Puerto Juarez, Mexico.

MERIT AWARD JULIO ALBERTO SANTANA CRUZ

Cancun Mexico Novedades de Yucatan Kodak Gold 100 Film

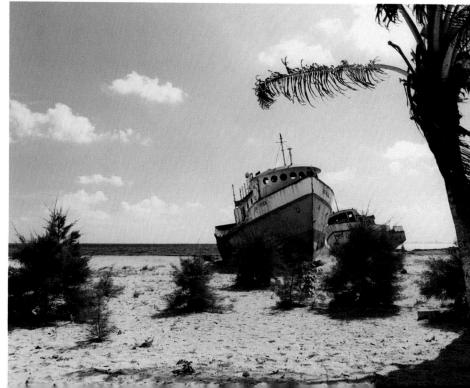

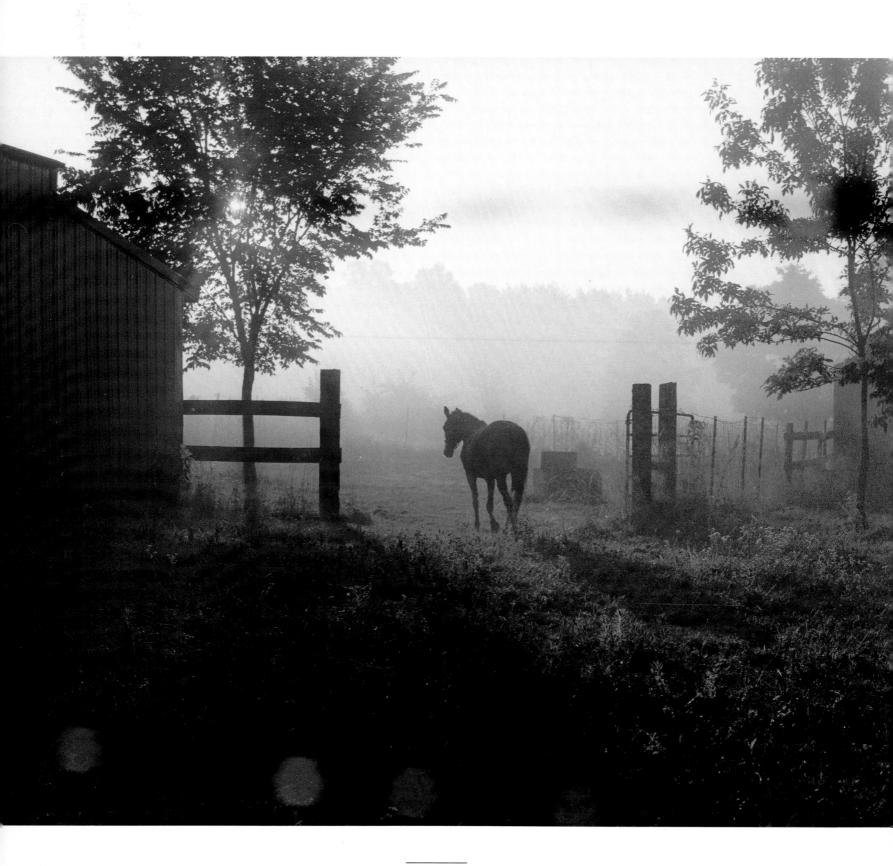

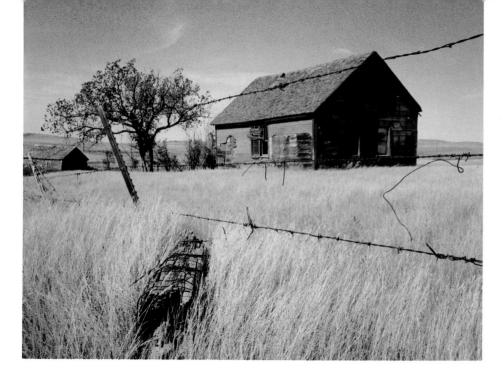

Rainbeau in the Morning OPPOSITE: A horse walking into the sun through a gate on a mist-shrouded morning.

MERIT AWARD ANN MICHELE GARRETT

Mt. Vernon IL usa *The Southern Illinoisian* Kodak gold 100 Film

Grampa's Farm TOP: My grandparents' homestead north of New Leipzig, North Dakota, vacant for many years.

MERIT AWARD LUCILLE BENDER

Bismarck ND usa *The Tribune* KODAK GOLD 200 Film

Hay There! BOTTOM LEFT: Bales of rolled hay surround an abandoned farm building overgrown with vines. **HONOR AWARD** BARBARA A. LAWLOR

Saint John, New Brunswick CANADA

The Telegraph & Evening Times KODAK GOLD 100 Film

Summertime Adventure BOTTOM RIGHT: Eoghan Hayes in an open meadow in Easthampton, Massachusetts. **MERIT AWARD** MARY M. HAYES

Lake Ariel PA USA The Times KODAK GOLD 100 Film

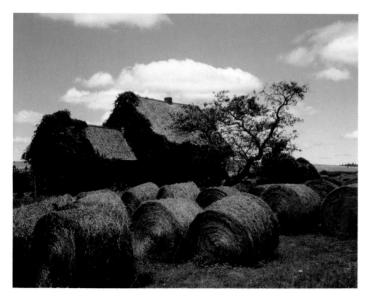

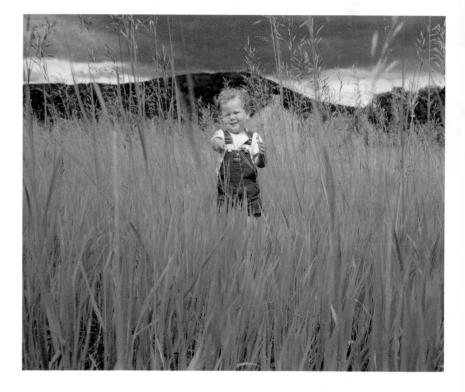

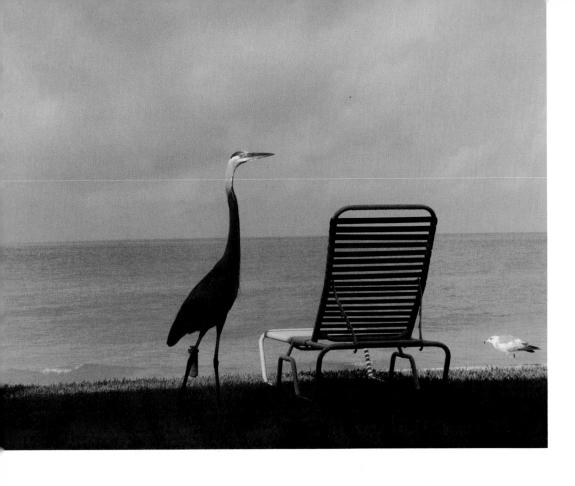

Sand, Sea, and Sky OPPOSITE, TOP LEFT: A seagull in flight.

MERIT AWARD LORI LOHMANN Fond du Lac WI USA *The Reporter* KODAK GOLD 200 Film

Wait for Me . . . I'm Coming! OPPOSITE, TOP RIGHT: A boy buries himself in sand.

MERIT AWARD VICTORIA GRAY

Halifax, Nova Scotia Canada The Daily News KODAK T-MAX 400 Professional Film

Girl on the Beach OPPOSITE, BOTTOM: A lightcolored beach and turquoise sea on Grand Cayman Island.

MERIT AWARD PAUL M. VIGNEAULT
Manchester NH usa The Union Leader
KODAK GOLD 200 Film

Maybe I'll Sit a Spell Above: Heron looking at a chaise lounge at Longboat Key, Florida.

MERIT AWARD AUDREY E. TRACY

Orlando FL USA The Union-Sun & Journal

KODAK GOLD 200 Film

The Arch of Love RIGHT: Natural stone formation in Los Cabos, Mexico.

MERIT AWARD MARIA ESTHER JUAREZ SEGURA
Col. Valle De Luces MEXICO El Universal

KODAK GOLD 100 Film

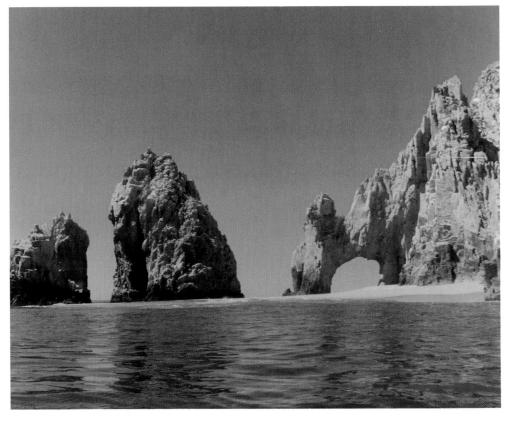

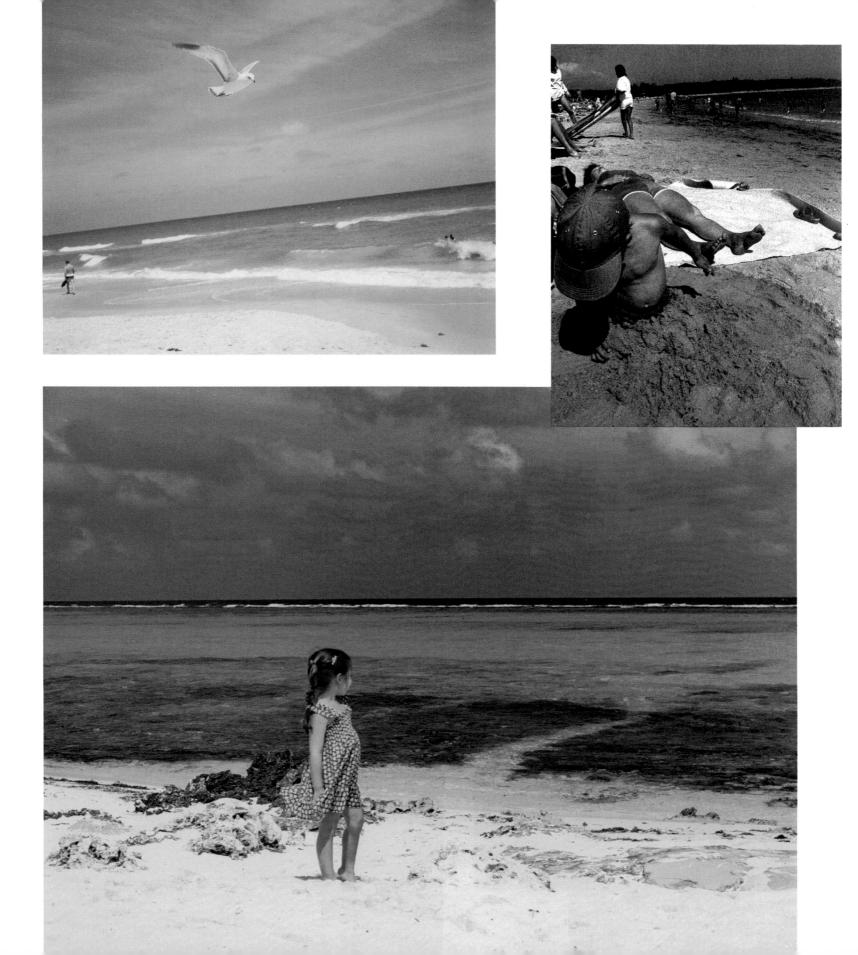

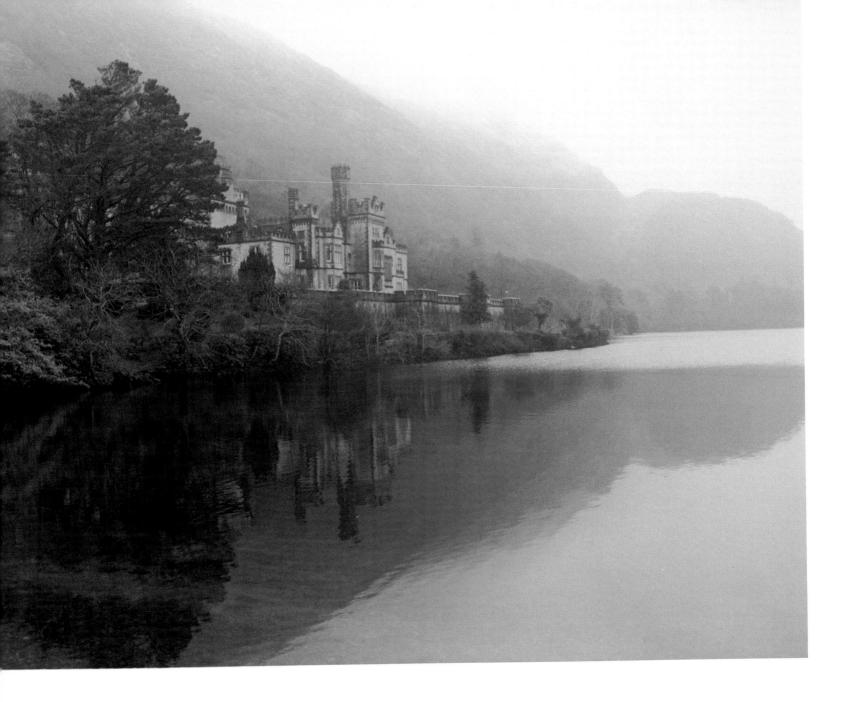

Castle and Reflections ABOVE: Connemara Castle in Ireland, from a bridge across water in the rain.

MERIT AWARD GENE AVAILONE Henrietta NY USA

The Democrat and Chronicle KODAK GOLD 100 Film

Fountain in the Sunset Opposite, top left: In a park in the city of Oaxaca, Mexico.

MERIT AWARD SRA. Tomas Rodriguez Reyes Oaxaca mexico

El Sol de Tampico Kodak Gold 100 Film

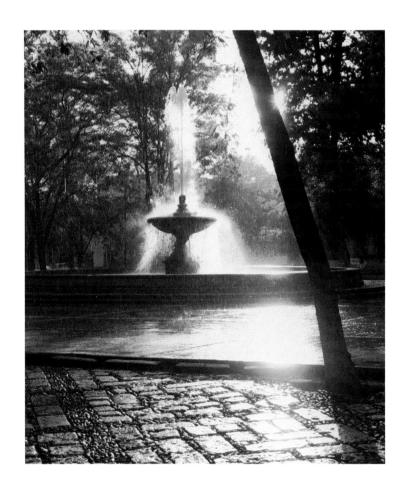

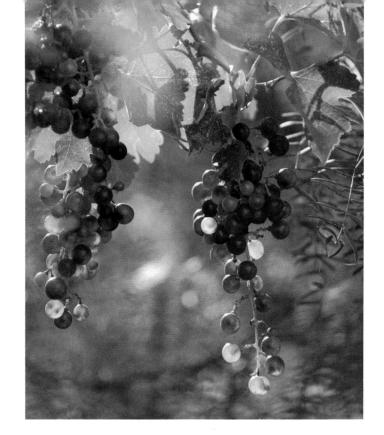

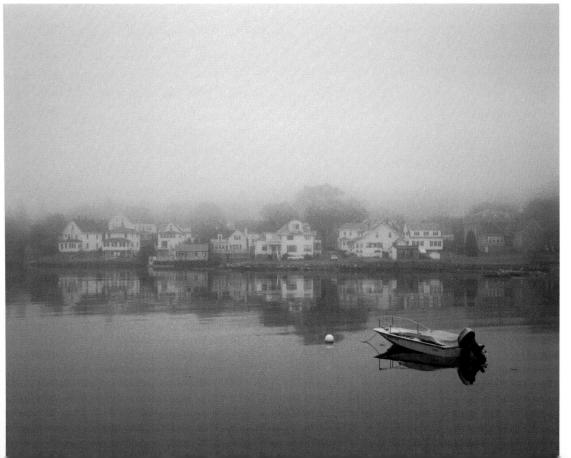

Grapes on the Vine Above: Backlit grapes on a vine in Old Mesella, New Mexico.

Merit Award Renate Schuetz El Paso TX usa

The Herald-Post Kodak Gold 100 Film

Foggy Morning in Boothbay Harbor LEFT: Houses of Boothbay Harbor, Maine,

LEFT: Houses of Boothbay Harbor, Maine, shrouded in early morning fog and reflected in the still waters, stand watch over a solitary dinghy.

MERIT AWARD CAROL A. EULER Colchester VT USA
The Free Press KODAK GOLD 100 Film

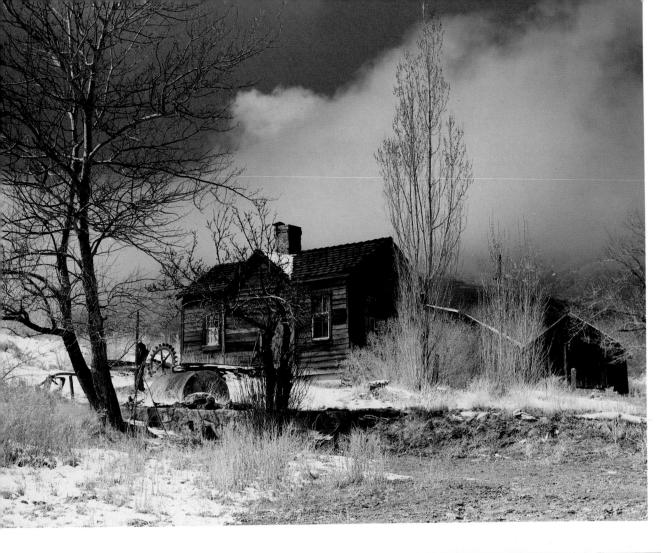

The Old Homestead ABOVE: Old house in Wrightwood, California.

MERIT AWARD NORMAN REDFORD Apple Valley CA USA
The Daily Press KODAK EKTAR 25 Professional Film

Hope in the Bristlecone RIGHT: My daughter, Emerald, in a Bristlecone pine tree at 12,000 feet in the nation's newest national park, Great Basin, Nevada.

MERIT AWARD FRANK DAVIS Ft. Wayne IN USA
The Journal-Gazette KODAK GOLD 100 Film

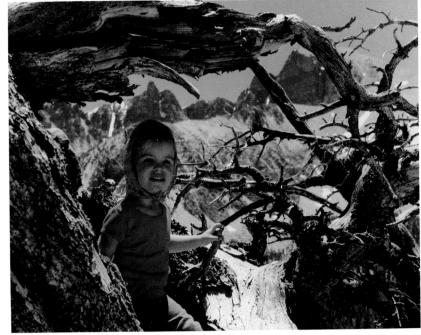

GRAND VISTAS

Island Erosion: Beauty Exposed RIGHT: Weathered beach cliffs exposing rock strata layers at Martha's Vineyard. **MERIT AWARD** JOHN R. GLOVER Annapolis MD USA *The Capital* KODAK T-MAX 100 Professional Film

Memories BELOW: An infrared photograph, taken on an early spring day, creates a ghost-like rendering of the scene.

HONOR AWARD DR. DONALD W. BOULAND Mt. Vernon IL USA
The Southern Illinoisian KODAK High Speed Infrared Film 2481

Sunset Overleaf: Sunset on a North Dakota farm. **Honor Award** Agnes Emineth Baldwin ND usa *The Tribune* kodak gold 200 Film

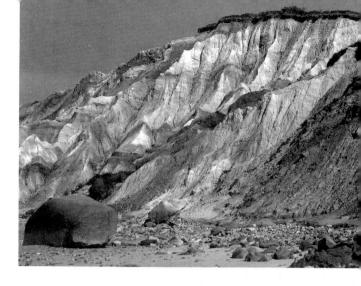

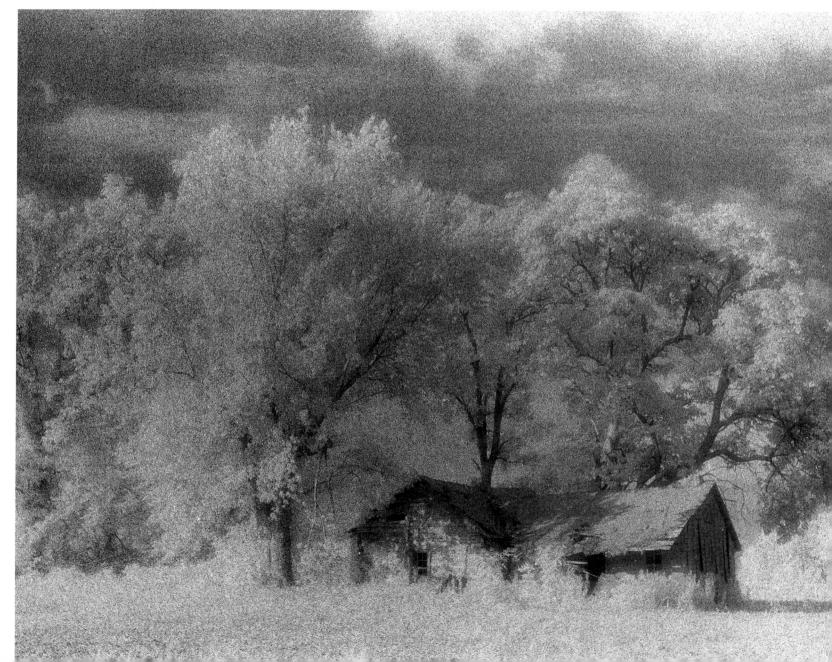

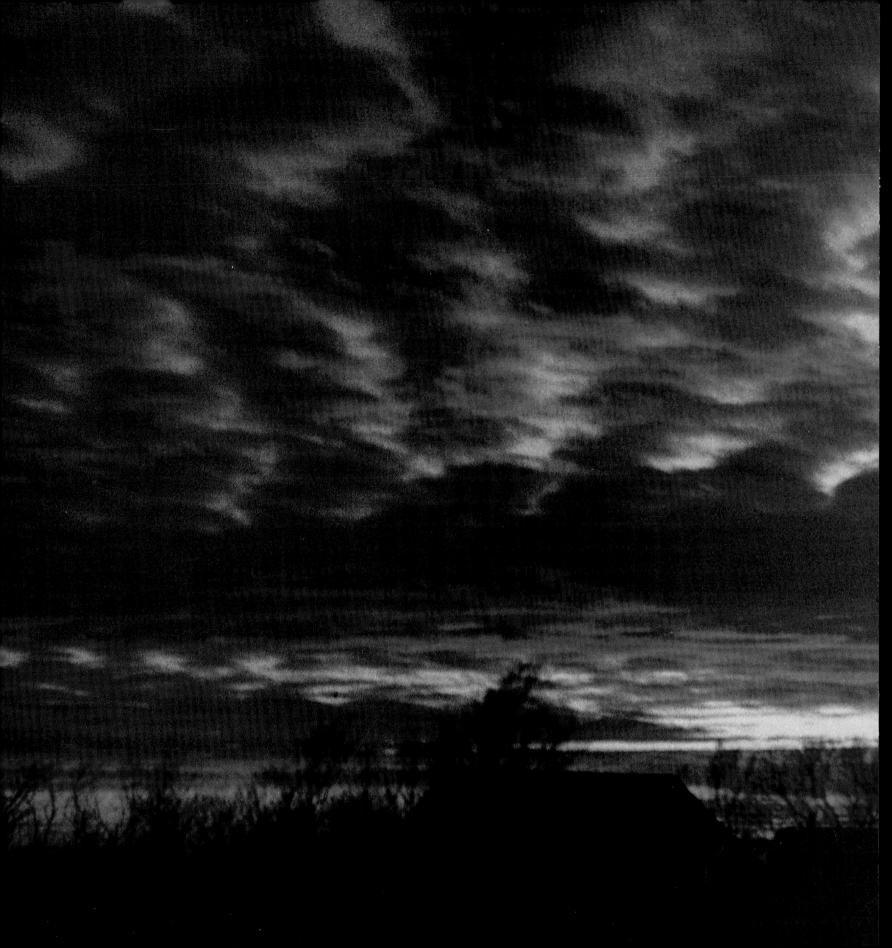

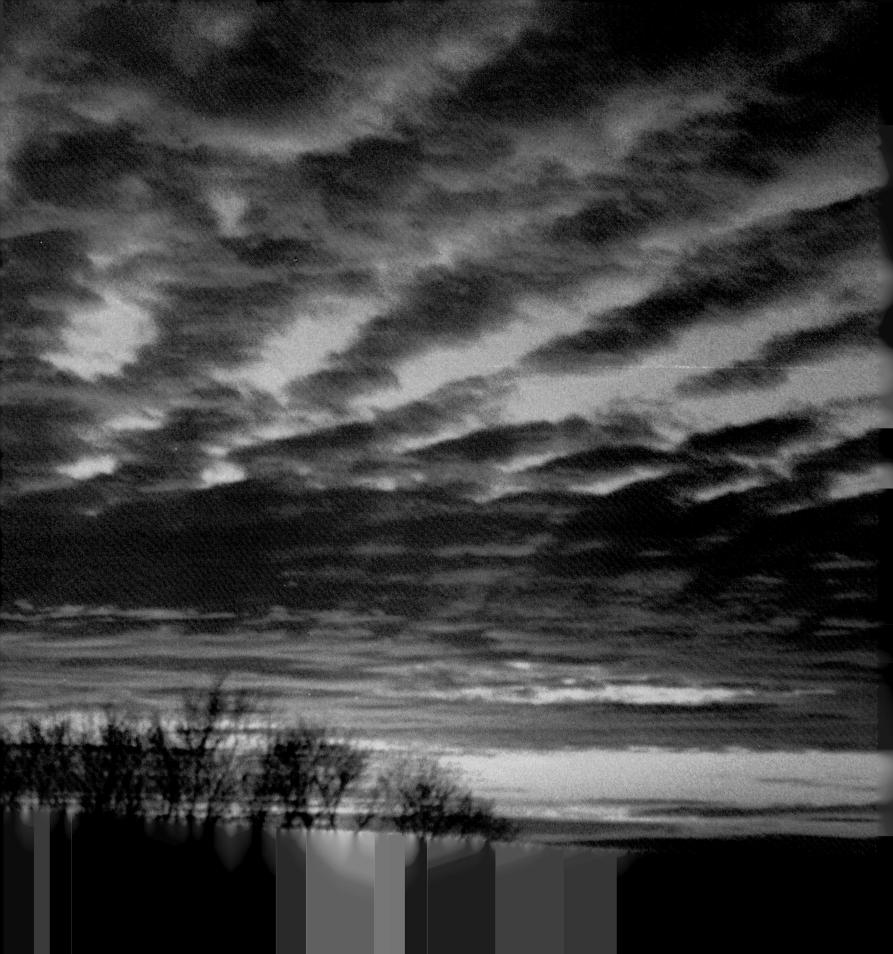

CELEBRATING OUR WORLD THE ENVIRONMENT

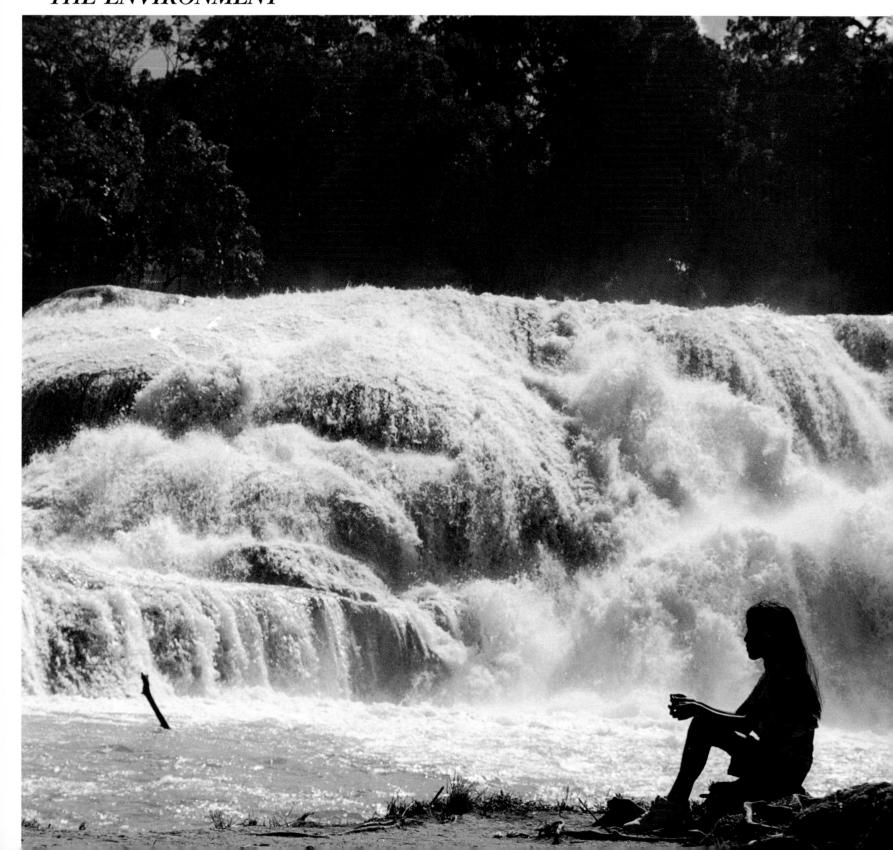

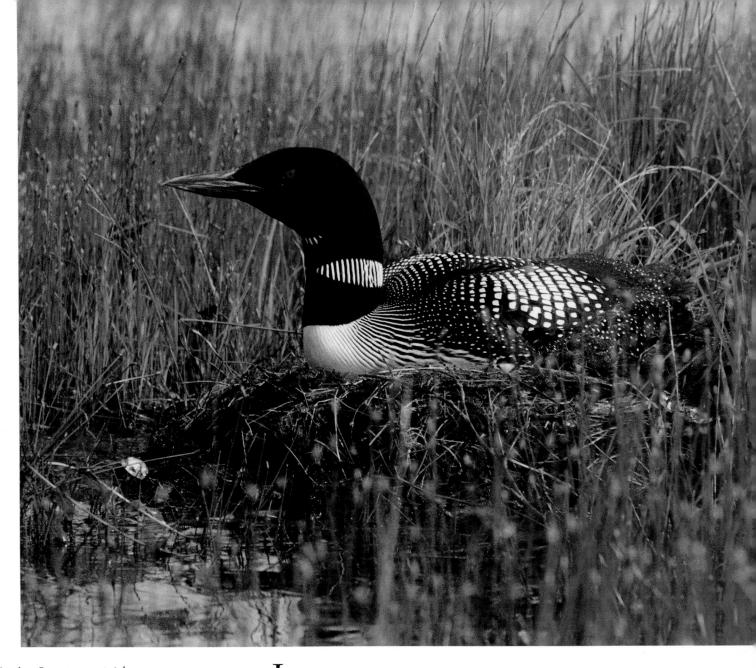

Nesting Loon ABOVE: A loon on its nest in Barry's Bay, Ontario.
HONOR AWARD
GRANT STEPHEN BOULAY
Belleville, Ontario CANADA
The Intelligencer
KODACOLOR VR-G 100 Film

Meditation OPPOSITE: Karen Cabello Gonzalez contemplates a waterfall.

HONOR AWARD

MARIO ALBERTO CABELLO PEREZ Madero MEXICO El Sol de Tampico KODAK GOLD 100 Film In 1990, KINSA created the environment photography category to reflect the growing concern for the health of the world and its inhabitants. Presented here are photographs of ideal environments—those we should preserve and protect, as well as those that have been restored to beauty through dedicated effort. They illustrate what is right about our world—glimpses of a healthy planet that deserves our stewardship.

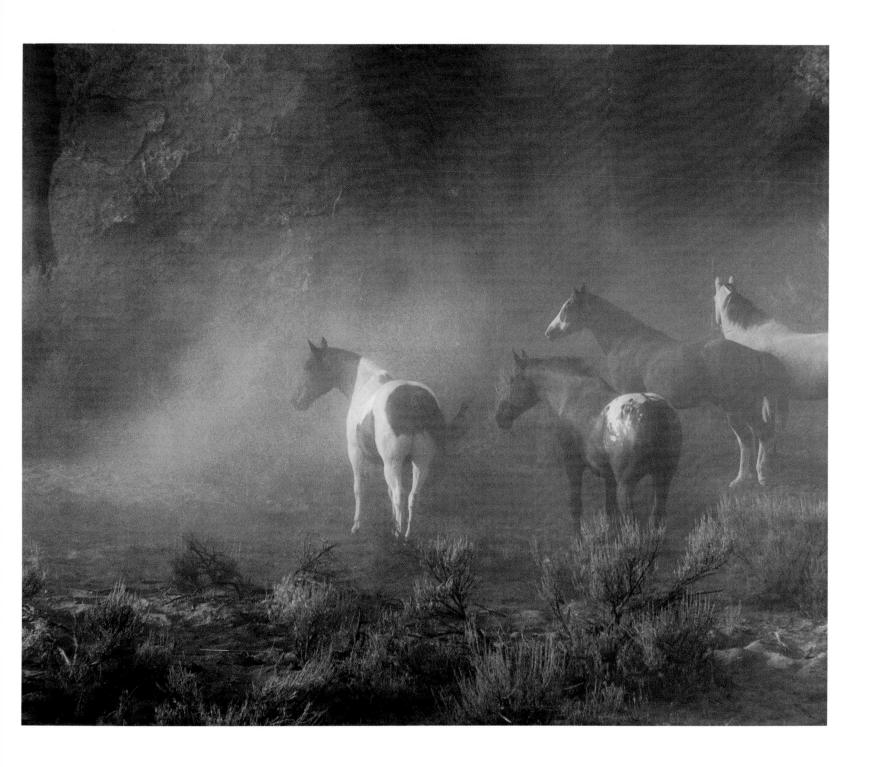

Horses in Evening Light Horses in Bend, Oregon, dust shrouding their movement in evening light.

HONOR AWARD SHARP W. TODD Boise ID USA

The Idaho Statesman KODAK EKTAR 125 Film

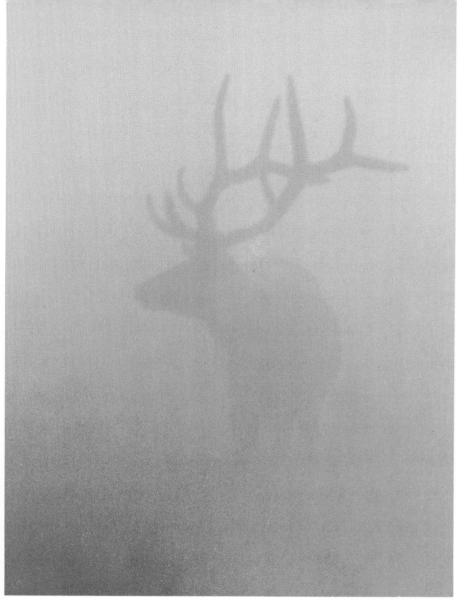

Spirit Elk Left: Early morning in Yellowstone National Park recalls an Indian legend of an animal spirit visiting a warrior. **MERIT AWARD** CARL H. LATCHFORD Rock Falls IL USA *The Daily Gazette* KODAK GOLD 400 Film

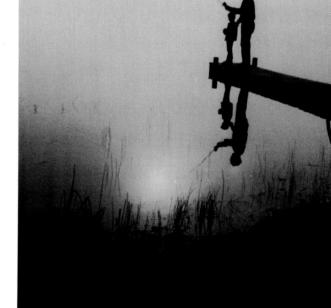

Grandpa and Josh Right: A father and boy fishing from a dock during early morning fog.

MERIT AWARD KAREN BOELK Oakfield WI USA The Reporter KODAK VERICOLOR III Professional Film

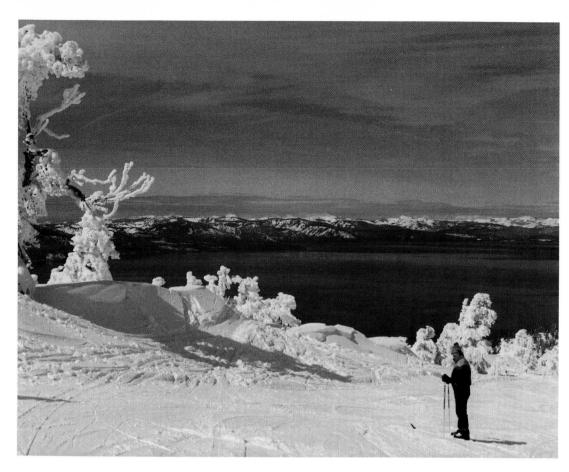

At the Summit TOP LEFT: Skiing at Lake Tahoe, California.

MERIT AWARD JAN LESCHKE Manitowoc WI USA
The Herald Times KODACOLOR VR-G 100 Film

Swan Lake BOTTOM: Swan on a lake in Germany with the Hopfen am See mountains in background.

MERIT AWARD RACHEL B. MONTMINY
LOWELL MA USA The Sun KODAK GOLD 100 Film

New Hampshire Fall Morning OPPOSITE: Early morning near Jefferson, New Hampshire, with Mount Washington in the background.

MERIT AWARD DEBORAH A. WEBB

Great Bend NY USA The Daily Times

KODAK GOLD 100 Film

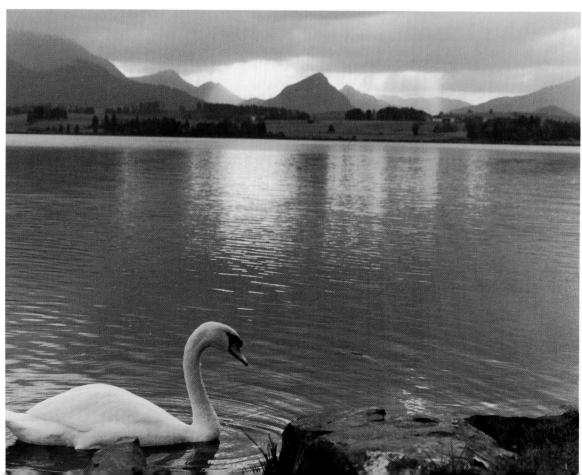

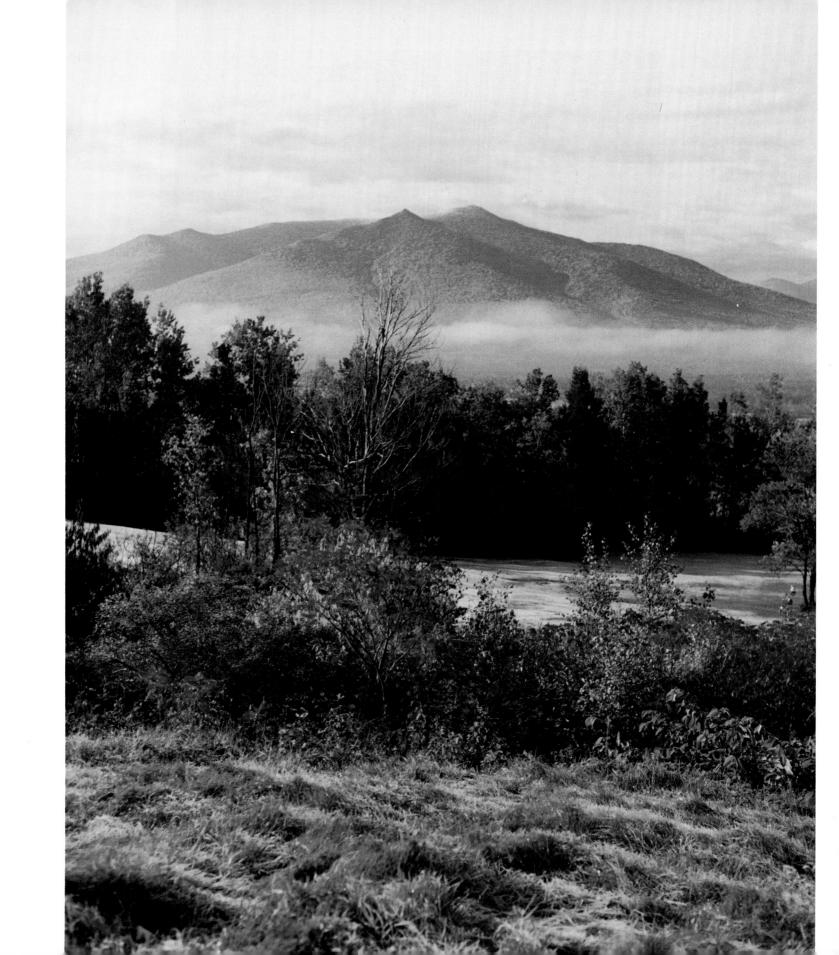

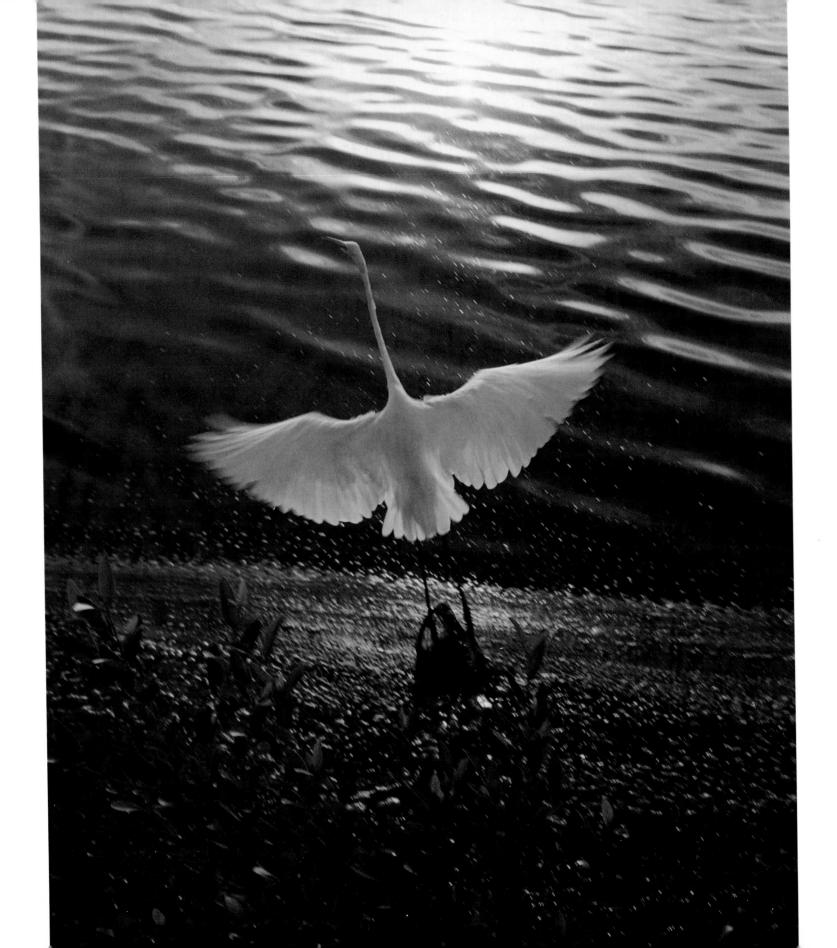

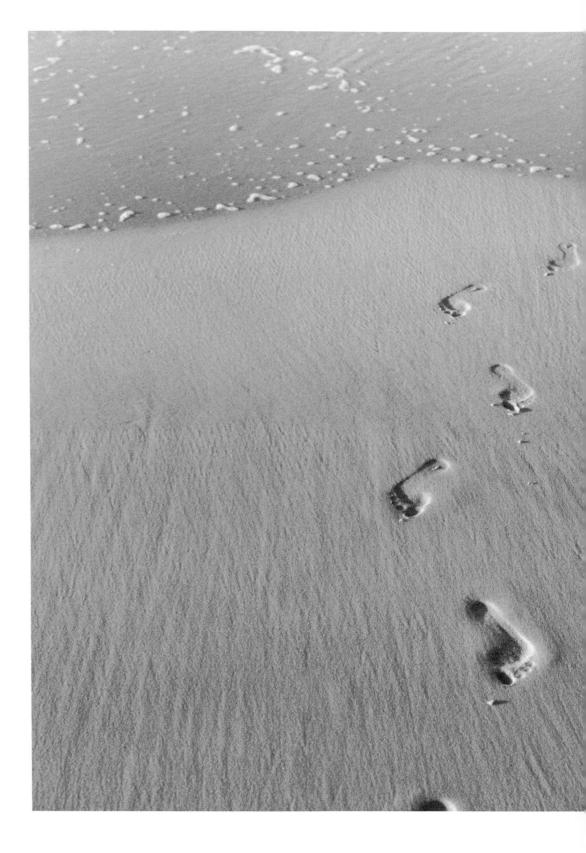

Graceful Departure

OPPOSITE: Visiting the "Ding"
Darling wildlife refuge on Sanibel Island, Florida, I surprised myself by catching a great egret's takeoff.

HONOR AWARD PATRICK JONES
Greer SC USA The News-Piedmont KODAK EKTAR 125 Film

Footprints in the Sand

RIGHT: Solitary, sandy footprints at a beach in Gulf Shores, Alabama. HONOR AWARD HARRISON L. JAMES Decatur AL USA *The Decatur Daily* KODAK GOLD 200 Film

ENLARGING COLORS KODAK EKTAR *FILM*

This category was established in 1990 to recognize photographs taken on KODAK ektar Film—a technically advanced 35 mm color negative film. Its micro-fine quality allows photo negatives only one-inch tall to be enlarged to 40 times their original size with little or no reduction in image clarity. The category includes photos ideally suited for such enlargement because of their superior composition, color, and design.

Last Rays of Lightfall Last rays of light fall onto the fantastic landscape of Monument Valley, Utah.

HONOR AWARD WES BROOME BOCA RATON FLUSA

The Sun-Sentinel KODAK EKTAR 125 Film

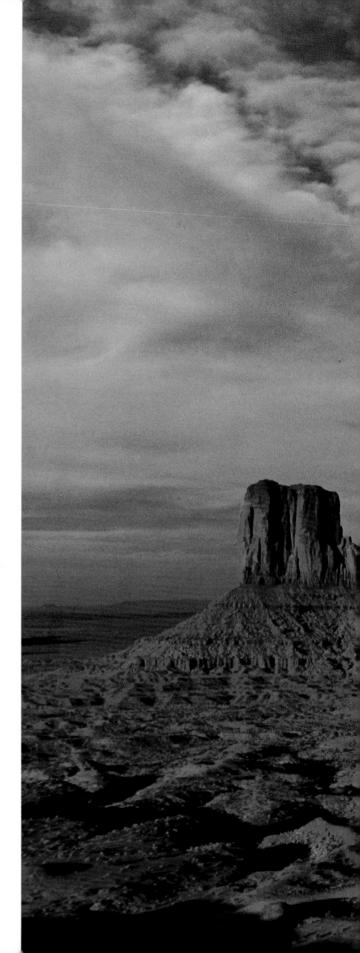

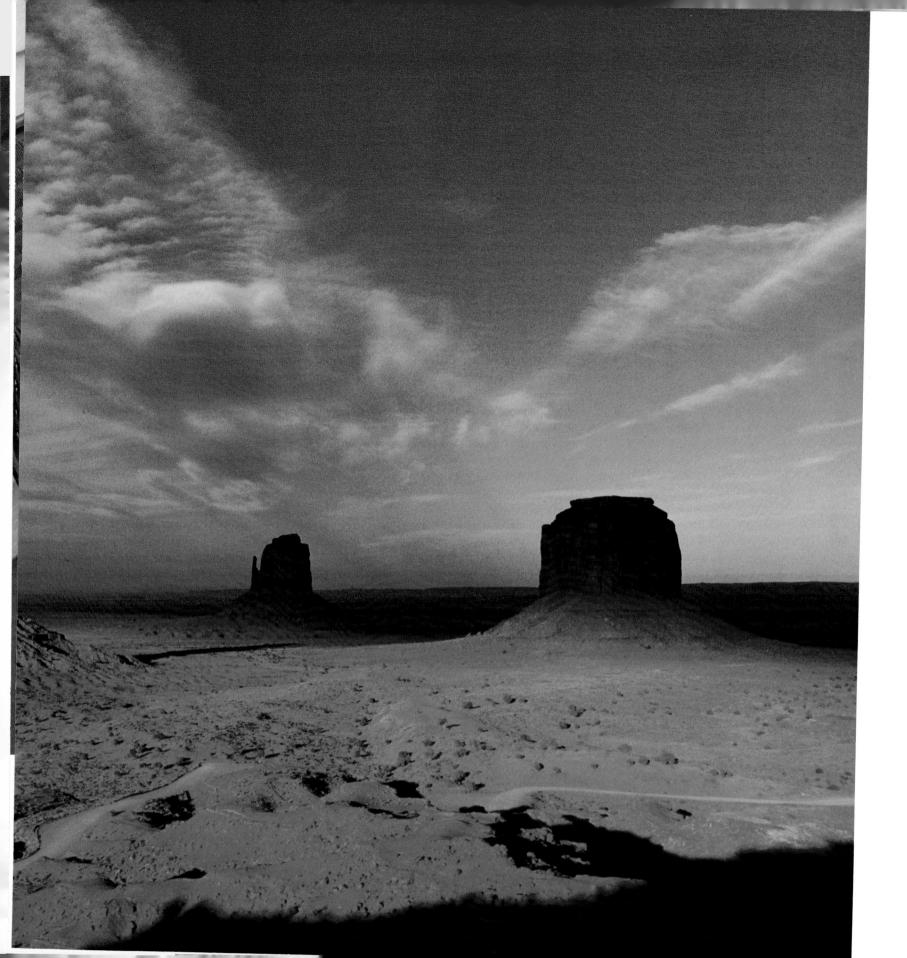

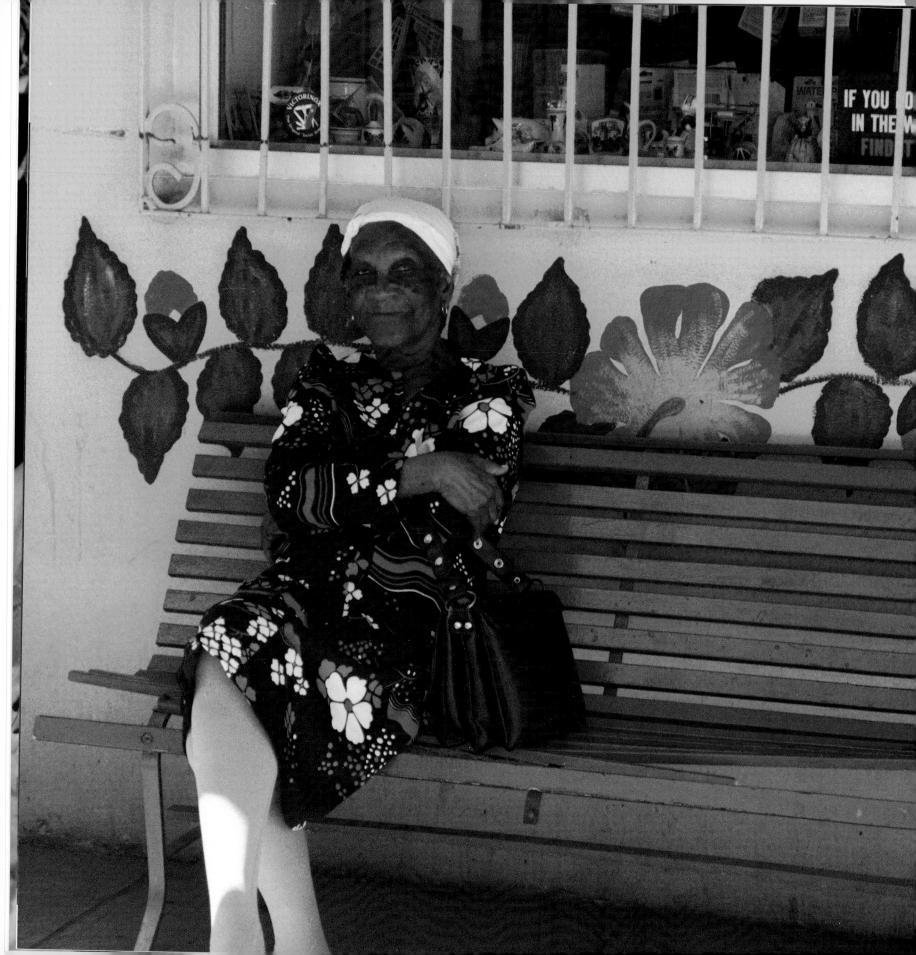

About to Bloom This woman in St. Martin, sitting on a bench, with her arms crossed looks like she's about to bloom with her bright, flowered clothing and expression. **MERIT AWARD** KAREN HILL Middletown NJ USA *The Times*KODACOLOR VR-G 100 Film

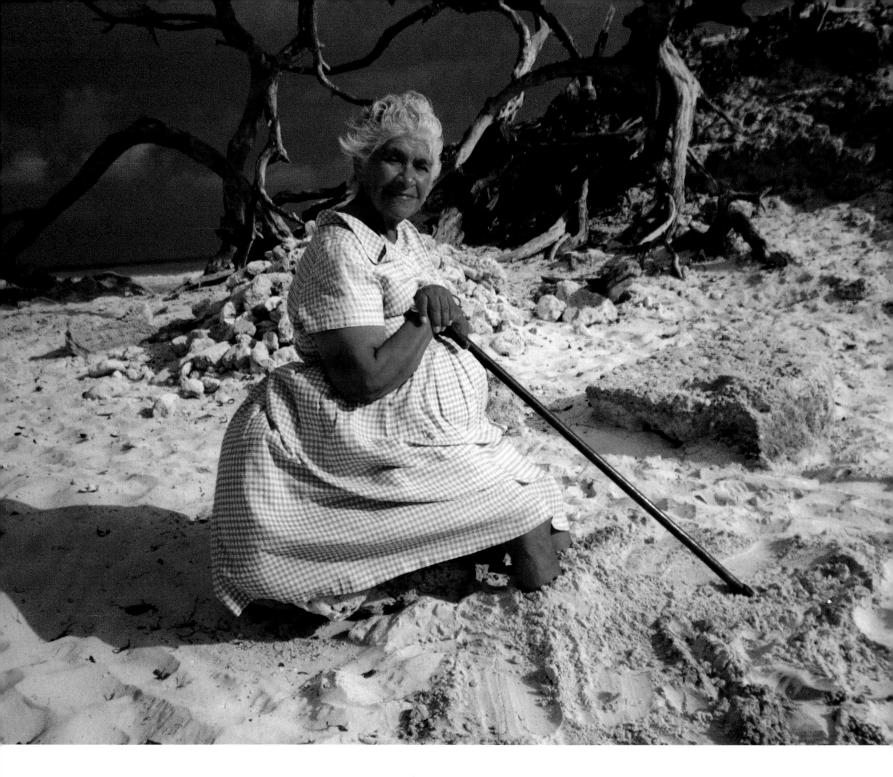

Cancun Cameo Above: Woman on the beach at Cancun, Mexico.

HONOR AWARD HOWARD S. Alexander
Lookout Mountain TN USA The News-Free Press
KODAK GOLD 100 Film

Wilbur was 86 when she posed with her great-granddaughter, Rebecca. Edith died the following year.

HONOR AWARD SUSAN L. LAKE Hillsboro OR USA The Argus KODAK GOLD 200 Film

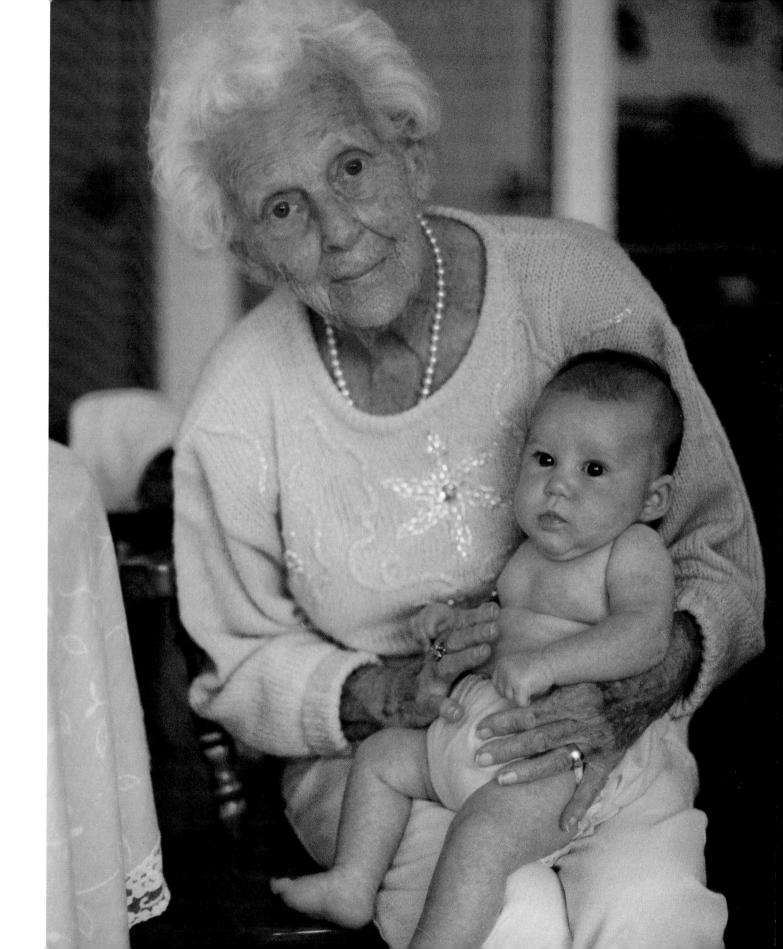

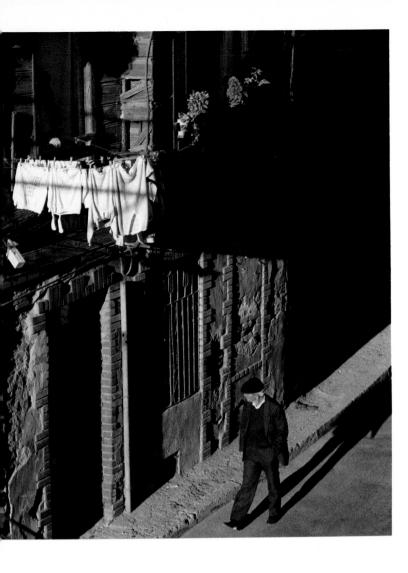

Constitutional Walk LEFT: Gentleman on a late afternoon walk in Istanbul, Turkey.

MERIT AWARD JIM CHAMBERS Greenville AL USA *The Advocate* KODAK GOLD 200 Film

Old Traveler BELOW: This man on his cart is very old and travels the road between Encarnacion and Aguascalientes, Mexico.

MERIT AWARD JOAQUIN DUENAS NEGRETE
COI. SAN MARCOS MEXICO El SOI del Centro KODAK GOLD 400 Film

Humble Kindness OPPOSITE: Feeding pigeons is an act repeated every day throughout the world.

MERIT AWARD RUBEN R. LOZANO MONTATTEY MEXICO El Norte KODAK GOLD 100 Film

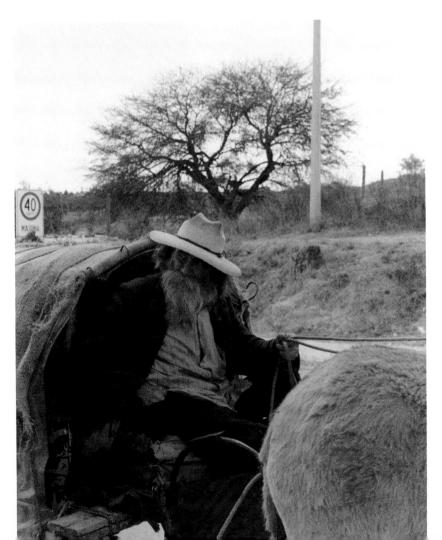

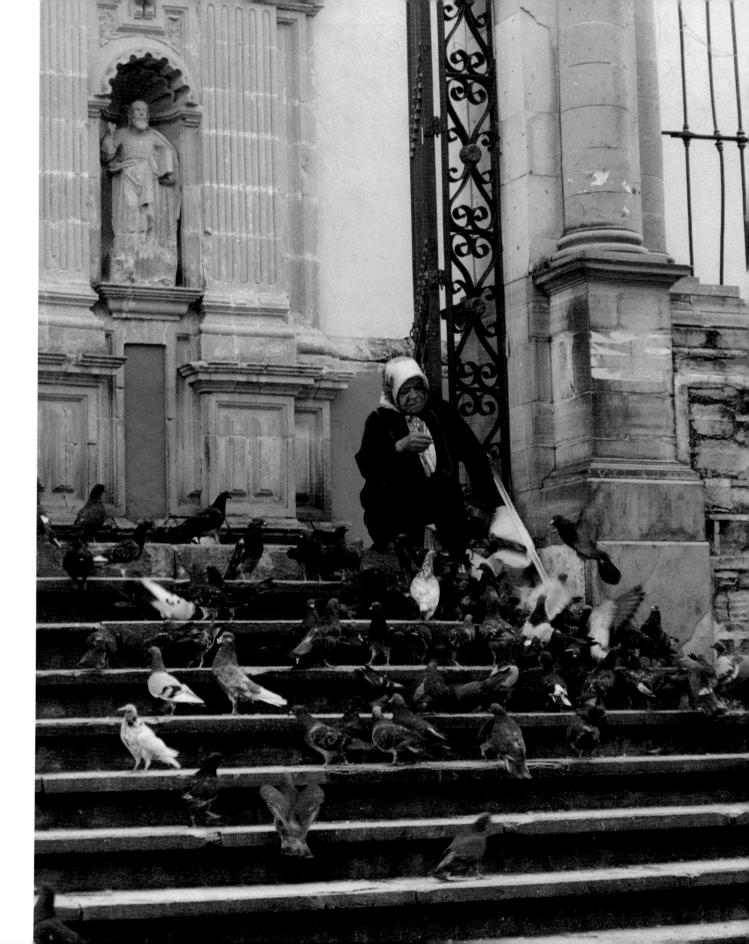

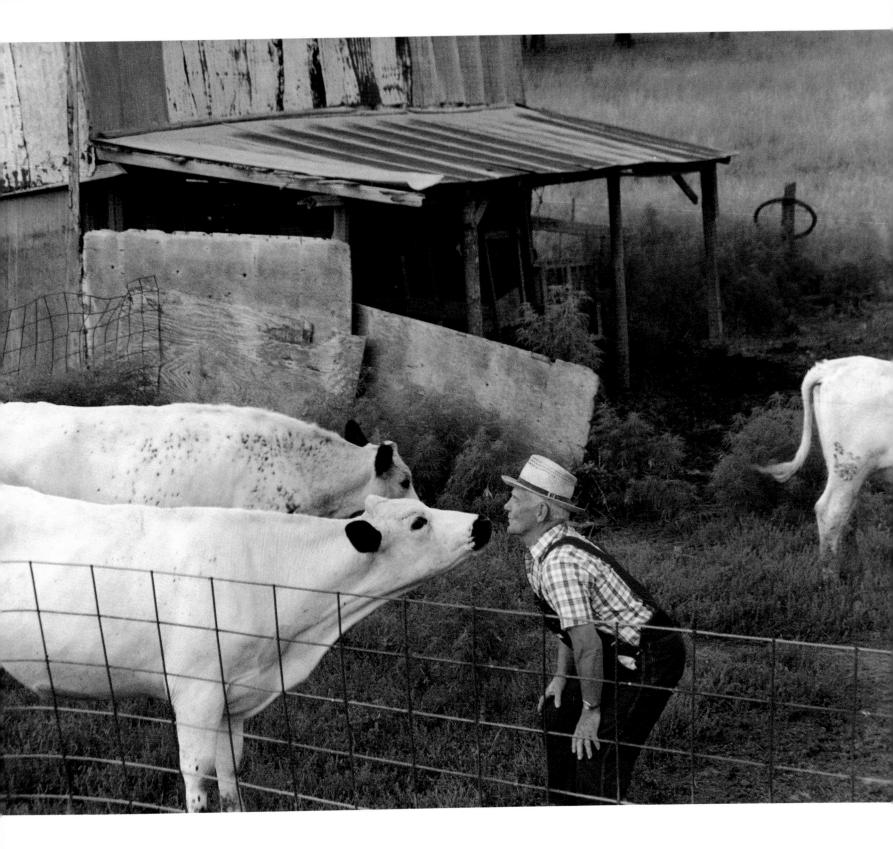

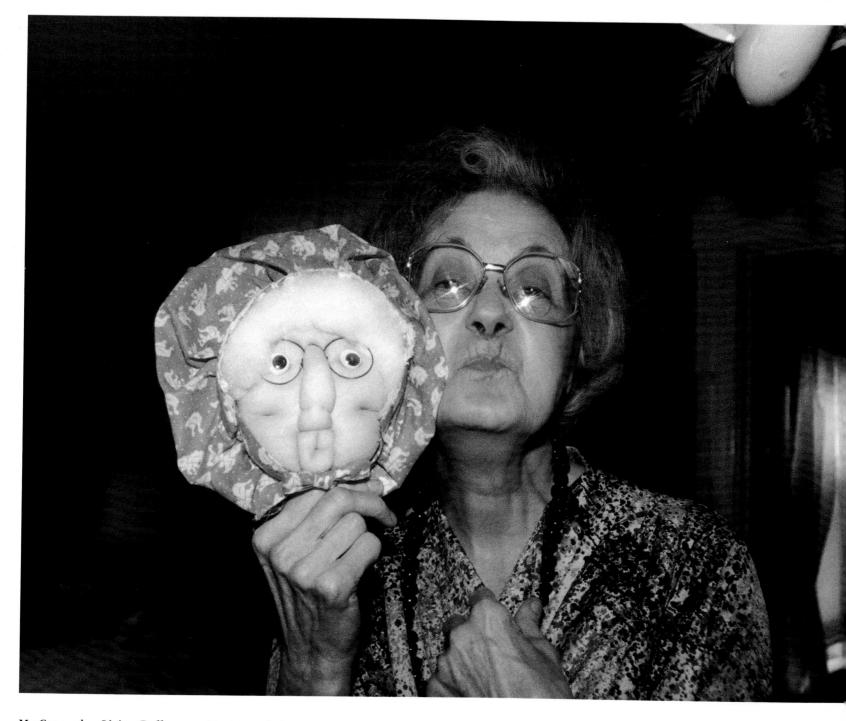

My Granny's a Living Doll Above: My Granny holding a Granny doll to compare the likeness.

MERIT AWARD MELISSA LYNN HOWELL Dover TN USA

The Leaf-Chronicle KODAK GOLD 400 Film

Gimme a Smooch! Opposite: My father-in-law about to receive a kiss from one of his steers. **MERIT AWARD** CAROL HAGER Atchison KS USA *The Daily Globe* KODAK GOLD 200 Film

Stroke Overleaf: My husband at rowing school in West Palm Beach, from the chase boat.

MERIT AWARD MAY ELIZABETH BERRY Shreveport LA USA

The Times Kodak Gold 100 Film

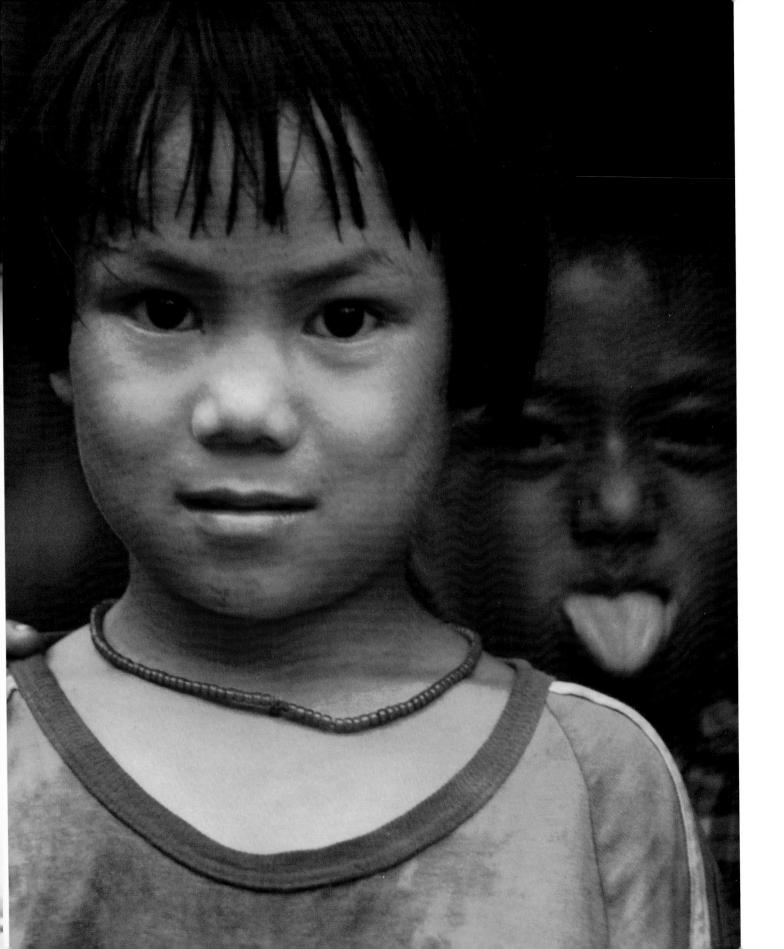

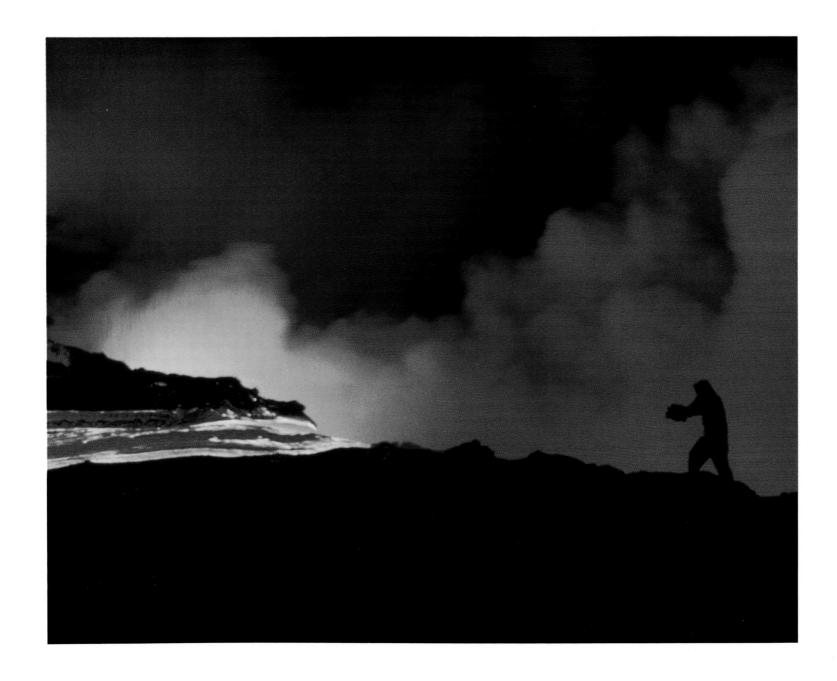

Edge of Fire Above: Molten lava breaks out at the coastline in Volcanoes National Park, Hawaii.

MERIT AWARD HAROLD G. SMITH Oak Ridge TN USA

The Oak Ridger Kodak ektachrome 64 Film

Innocence of Childhood OPPOSITE: Two Thai children in Aku Village, Thailand.

HONOR AWARD DR. MICHAEL A. NEWMAN Yardley PA USA

The Times KODACHROME 64 Professional Film

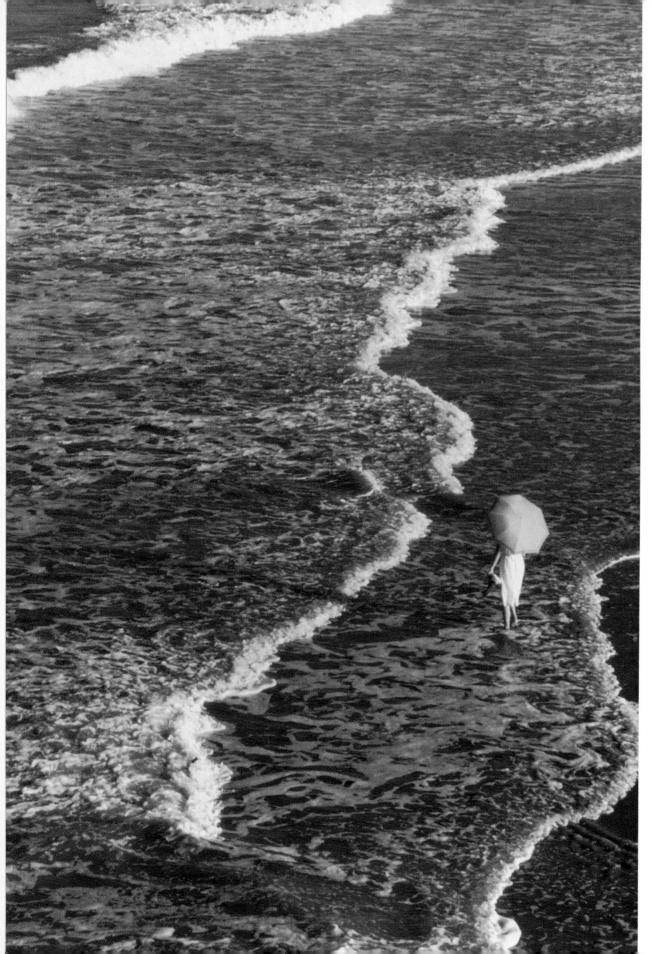

The Sea LEFT: Ocean, woman, and parasol.

MERIT AWARD CHARLES JING
Baltimore MD USA

The Baltimore Sun

KODAK EKTACHROME 64 Film

Early Morning at Peggy's Cove

OPPOSITE, TOP LEFT: Dinghy, lobster traps, and reflections in calm water.

MERIT AWARD DEAN PENNALA Plainwell MI USA *The Gazette* KODACHROME 25 Film

Fish Out of Water OPPOSITE, TOP RIGHT: Outdoor market in Tokyo, Japan.

MERIT AWARD LEON GOLDENBERG Tampa FL USA The Tribune KODACHROME 64 Professional Film

FOUR River Boats OPPOSITE, BOTTOM LEFT: Pattern of boats in Nova Scotia from a nearby bridge. **HONOR AWARD**

DIANE FERBER COLLINS
Stamford CT USA The Advocate
KODAK EKTACHROME 200 Film

Abstract with Flower Petals

OPPOSITE, BOTTOM RIGHT: Rose petals and yellow lily petals through textured glass.

MERIT AWARD PARASTOO FARZAD Vestavia AL USA The News KODAK EKTACHROME 100 Film

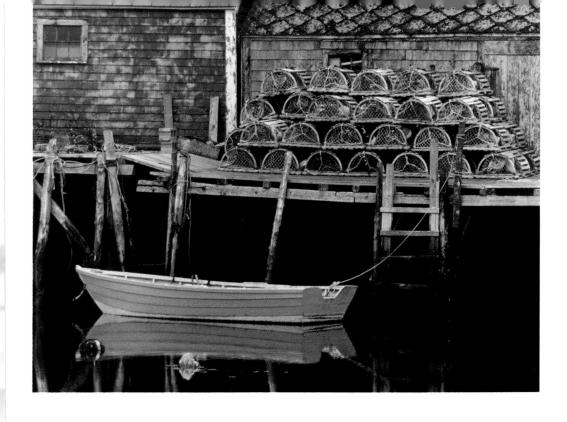

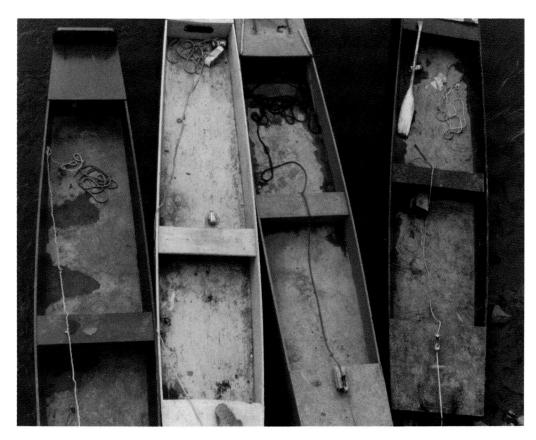

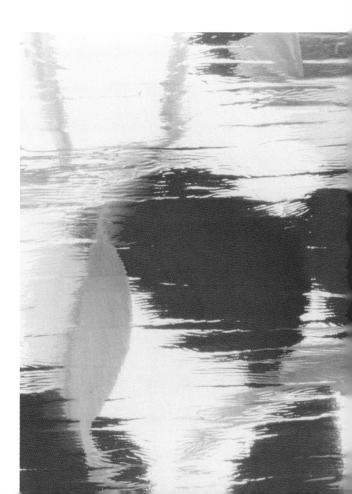

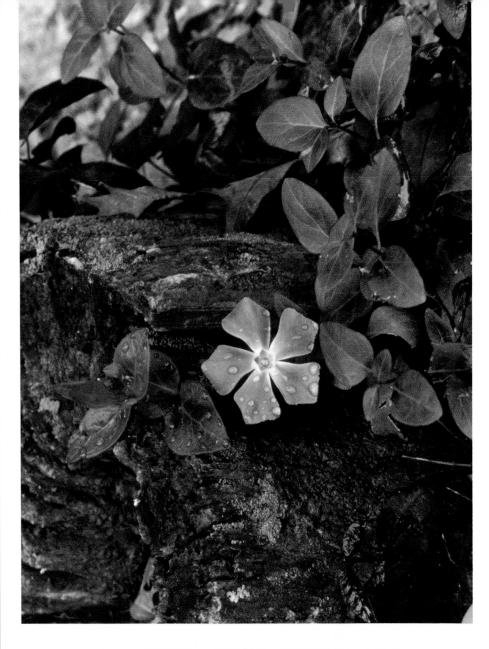

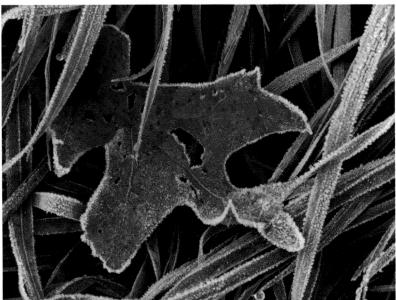

Wild Periwinkle LEFT: Wild periwinkle. I sprayed on the water drops.

MERIT AWARD C. P. GODDARD Natchez MS USA The Democrat KODACHROME 64 Professional Film

Autumn BOTTOM LEFT: Oak leaf and grass laced with frost.

MERIT AWARD MAX GIDDINGS Kalamazoo MI USA The Gazette

KODACHROME 64 Professional Film

Bloom Where You Are Planted BELOW: Flowers among large green leaves.

MERIT AWARD DR. JAMES W. MUNSON Kalamazoo MI USA The Gazette KODACHROME 64 Professional Film

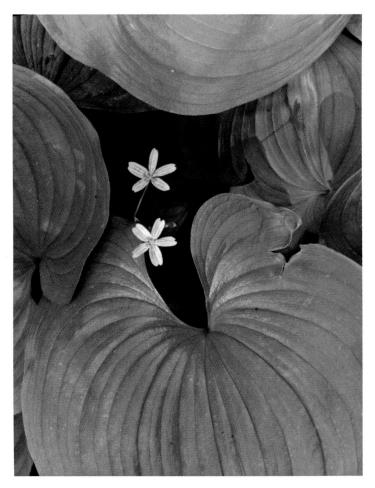

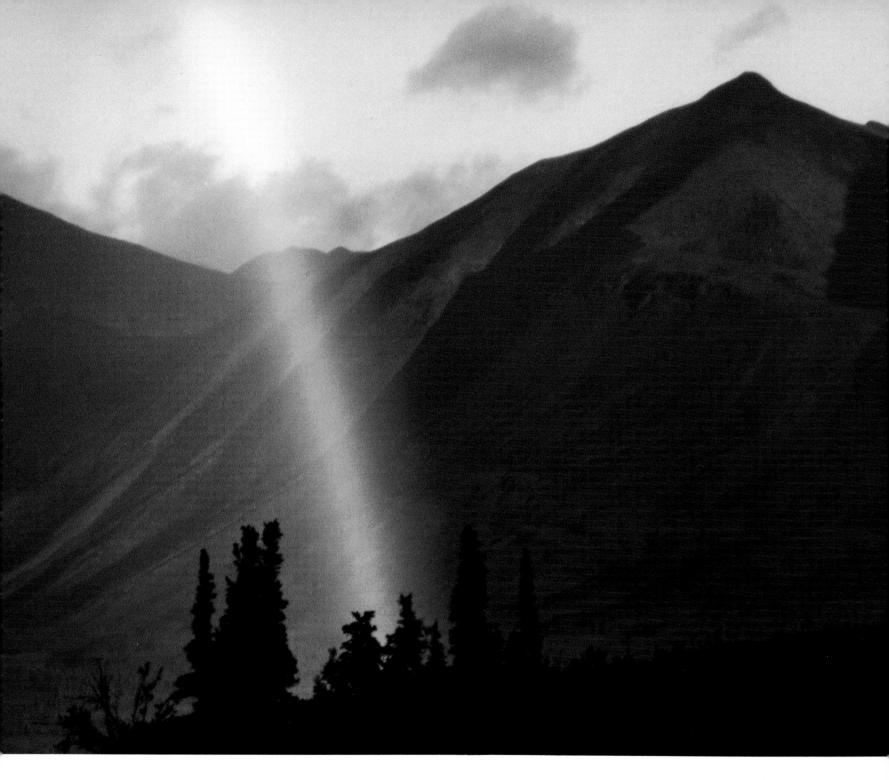

Treasures of Alaska Arched across our passage into the interior bush country of Alaska, this rainbow promises a safe journey.

MERIT AWARD EVA MOORE Marion NY USA *The Times-News* KODACHROME 64 Professional Film

VISIONS OF THE HEART SPECIAL MOMENTS

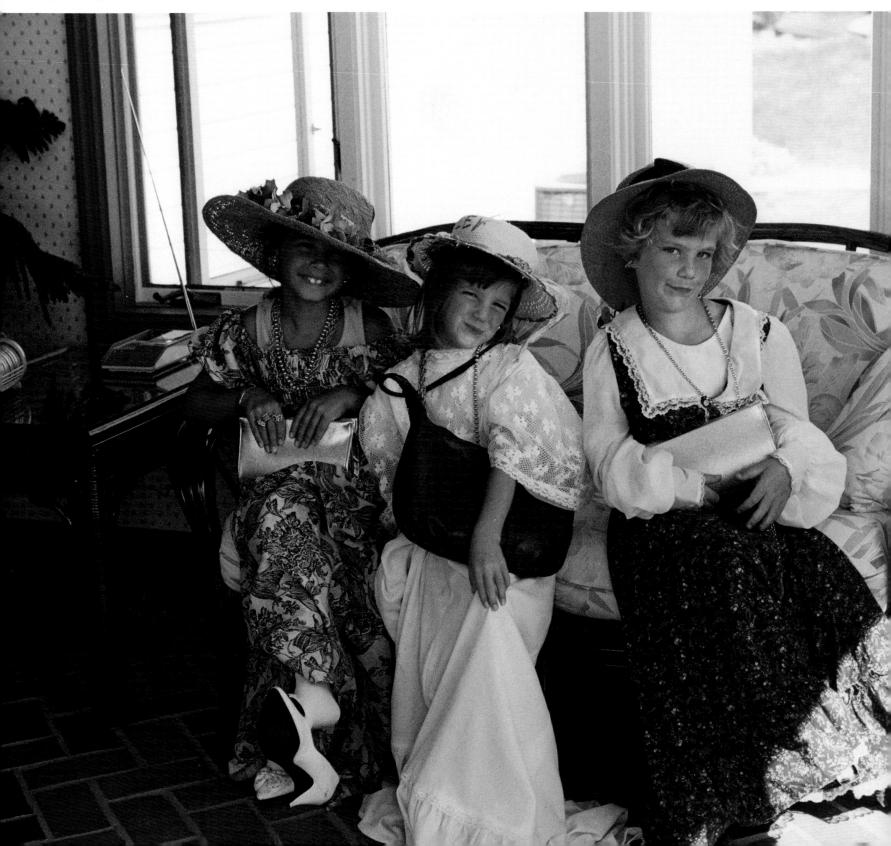

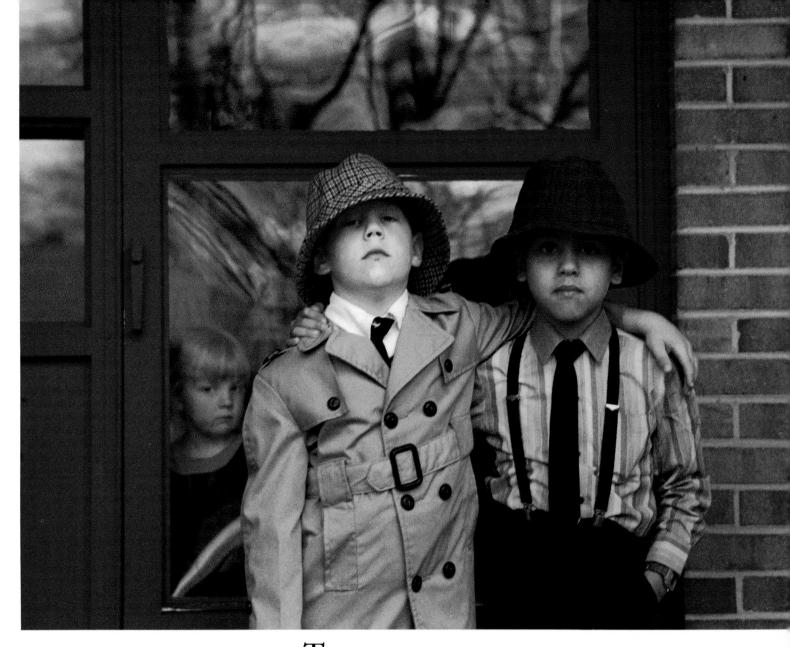

Tomorrow's Tycoons

ABOVE: Small boys playing business tycoons.

MERIT AWARD JEAN JONES
Anchorage AK USA The Times KODAK GOLD 200 Film

Sitting Pretty Opposite: Girls play dress-up on the sun porch. Honor Award Ned Ensminger Lancaster PA USA The Sunday News KODAK GOLD 100 Film

The wonderful thing about these photographs is that they make the invisible visible. The bonds of friendship, the optimism of youth, the shock and delight of surprise, the joys of love—whether quiet or exuberant—are conveyed in the images presented here. Photographers who capture such moments feel a great satisfaction—as if the photo itself were a prize. And we viewers feel a connection to these familiar expressions of the human spirit.

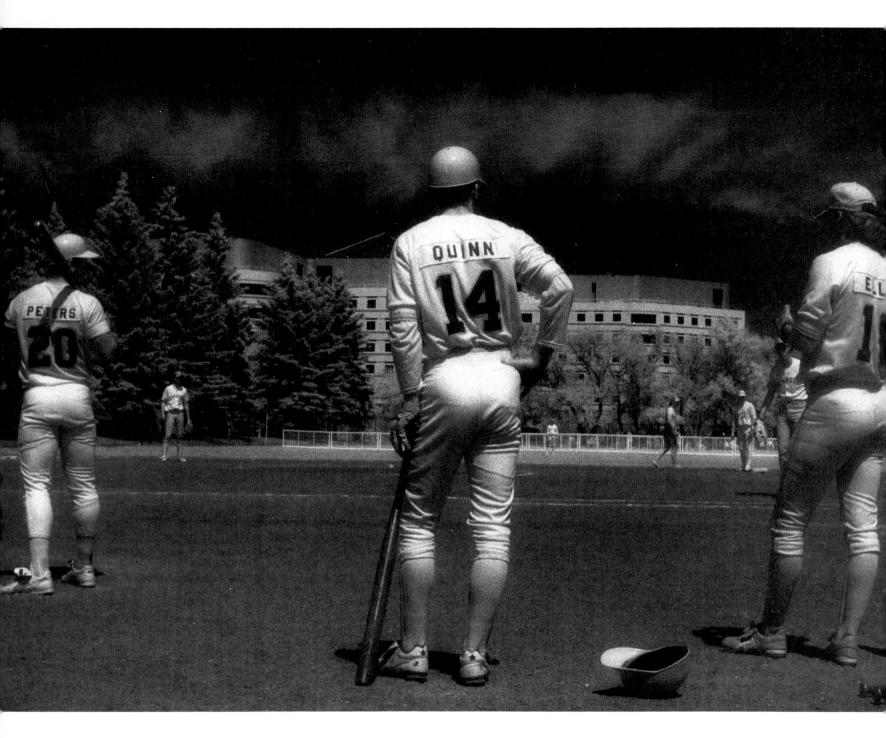

Field of Dreams Ball players at a fastball game on a sunny day.

HONOR AWARD NICK LEUNG Saskatoon, Saskatchewan Canada The Star Phoenix Kodak High Speed Infrared Film 2481

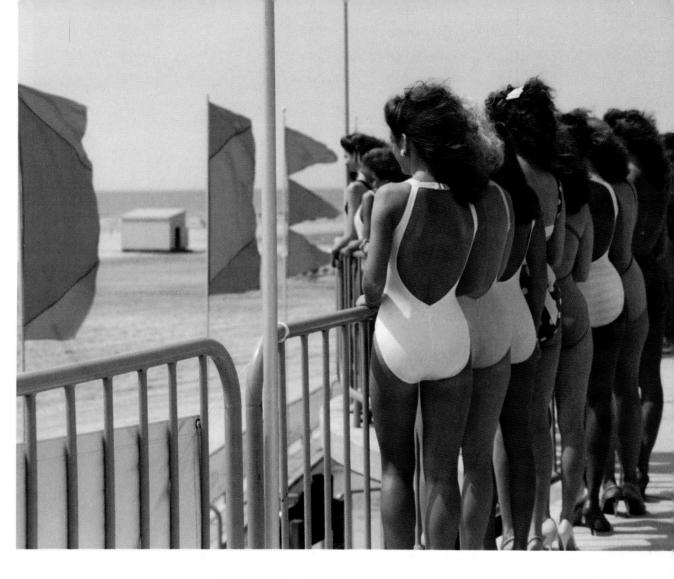

Beauty and the Beach Above: New Jersey beauty contestants look longingly at the beach.

MERIT AWARD JOANNE J. HECKMAN Wildwood NJ USA The Press KODAK GOLD 100 Film

Sleeping Police RIGHT: Four tired policemen on the last day of a karate tournament.

MERIT AWARD HORACIO GABRIEL RIVERA RANGEL

Col. Condesa MEXICO El Universal KODAK GOLD 200 Film

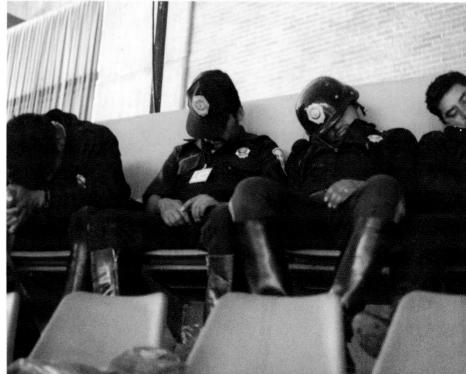

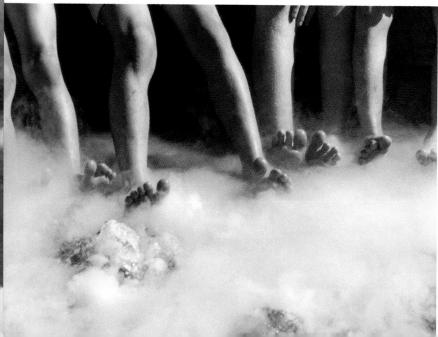

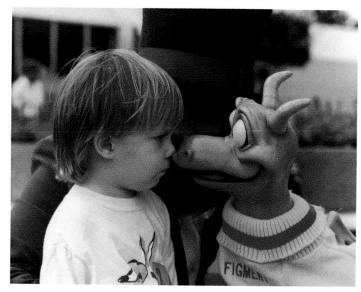

The Meeting of the Minds ABOVE: My son, Eddy, face to face with an unexpected character.

MERIT AWARD CHARLES EDWARD KNIGHT, JR.

Daytona Beach FL USA The News-Journal

KODAK EKTACHROME 64 Film

The Boy Hero Left: My son, the hero of Chapultepec. **MERIT AWARD** SANDRA GO JON DE DELSOL Tampico MEXICO

El Sol de Tampico KODAK GOLD 100 Film

Dry Ice LEFT: Children's feet sitting in water with dry-ice fog.

MEET AWARD, JOHN A. CLARK. Delegle Junction N. V.

MERIT AWARD JOHN A. CLARK Dekalb Junction NY USA
The Daily Times KODACHROME 64 Professional Film

VISIONS OF THE HEART

Girl Watcher Daddy's little boy at the beach.

MERIT AWARD SRA. IGNACIO GONZALEZ ALVAREZ Leon MEXICO

El Sol de Leon KODAK GOLD 100 FILM

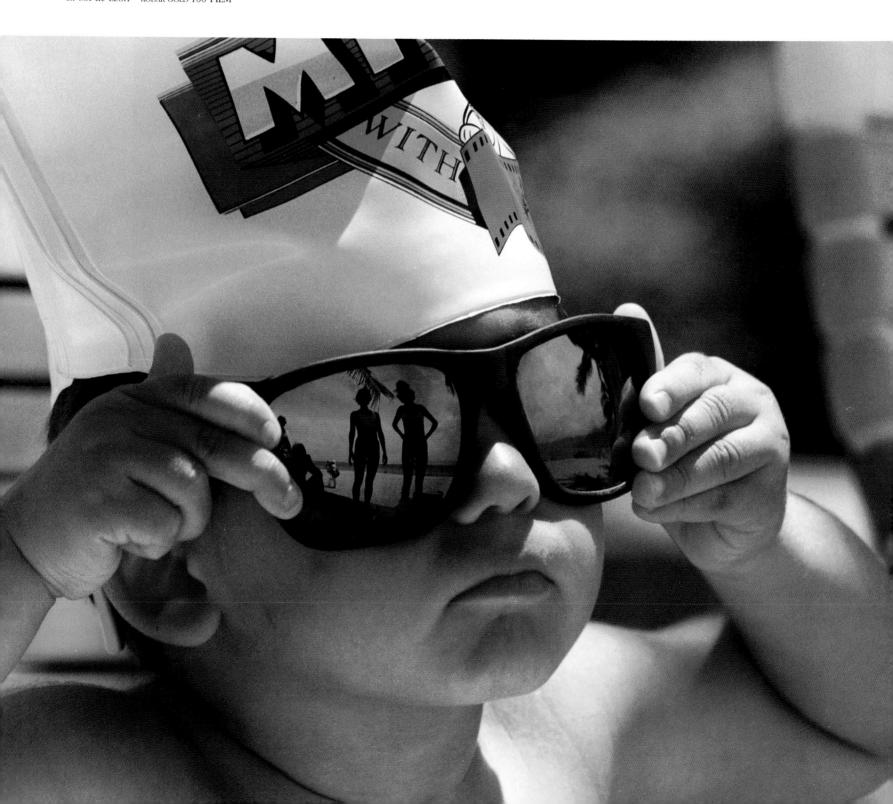

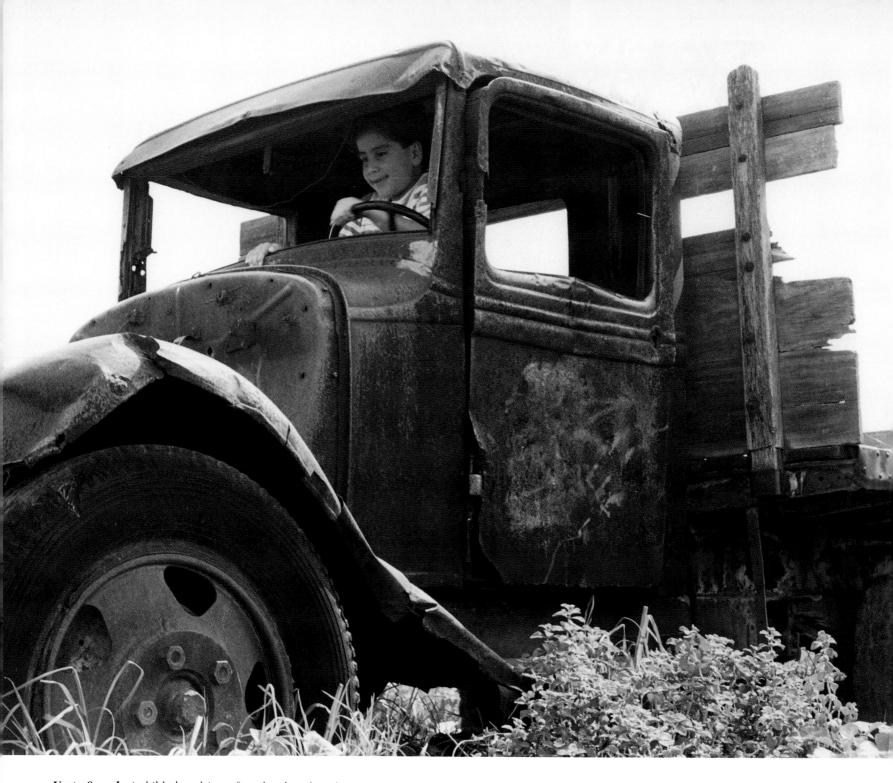

Up to SpeedA child plays driver of an abandoned truck.MERIT AWARDDR. MIGUEL CARRANZA LOPEZTuhepel MEXICOEl UniversalKODAK GOLD 100 Film

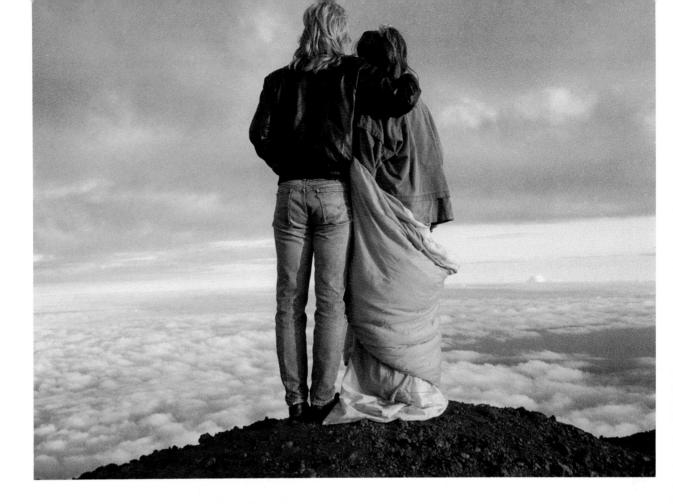

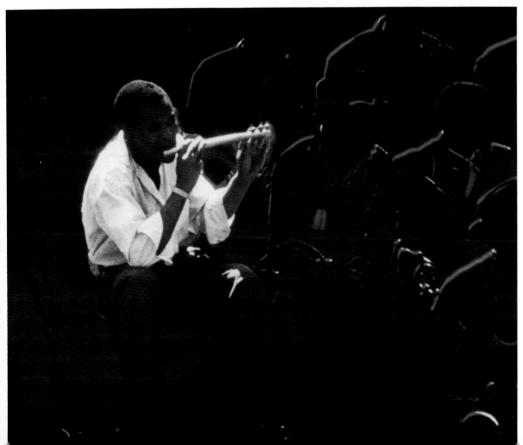

Serenity ABOVE: Haleakala, Maui, Hawaii. I placed the camera on some lava rock, set the automatic timer, and tried to look tranquil. **MERIT AWARD** TODD RUCYNSKI New York NY USA *The Palladium-Times* KODAK GOLD 200 Film

Musical Flute Left: Making music alone, despite the crowd.

MERIT AWARD GERALD A. ZUROWSKI
OCONOVIOWOC WI USA The County Freeman KODACHROME 64 Professional Film

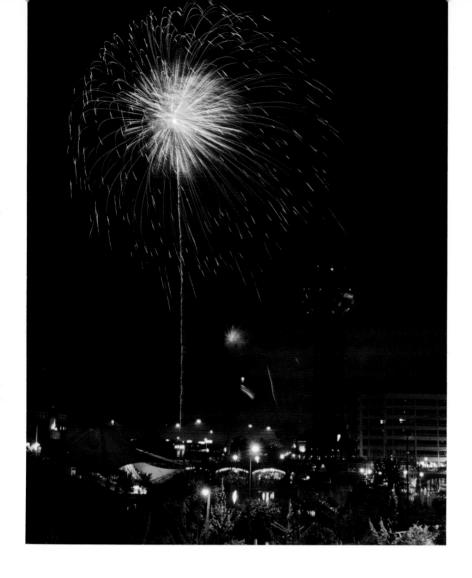

Independence Night ABOVE: Fourth of July fireworks in Knoxville, Tennessee.

MERIT AWARD KEITH L. WILLIAMS Knoxville TN USA
The News-Sentinel KODAK EKTAR 125 Film

Play Ball! Opposite: The puppy was brand new. My niece enjoyed chasing it and being chased, in turn. **HONOR AWARD** NANCY L. Ross Toronto OH USA

The Herald-Star KODAK GOLD 200 Film

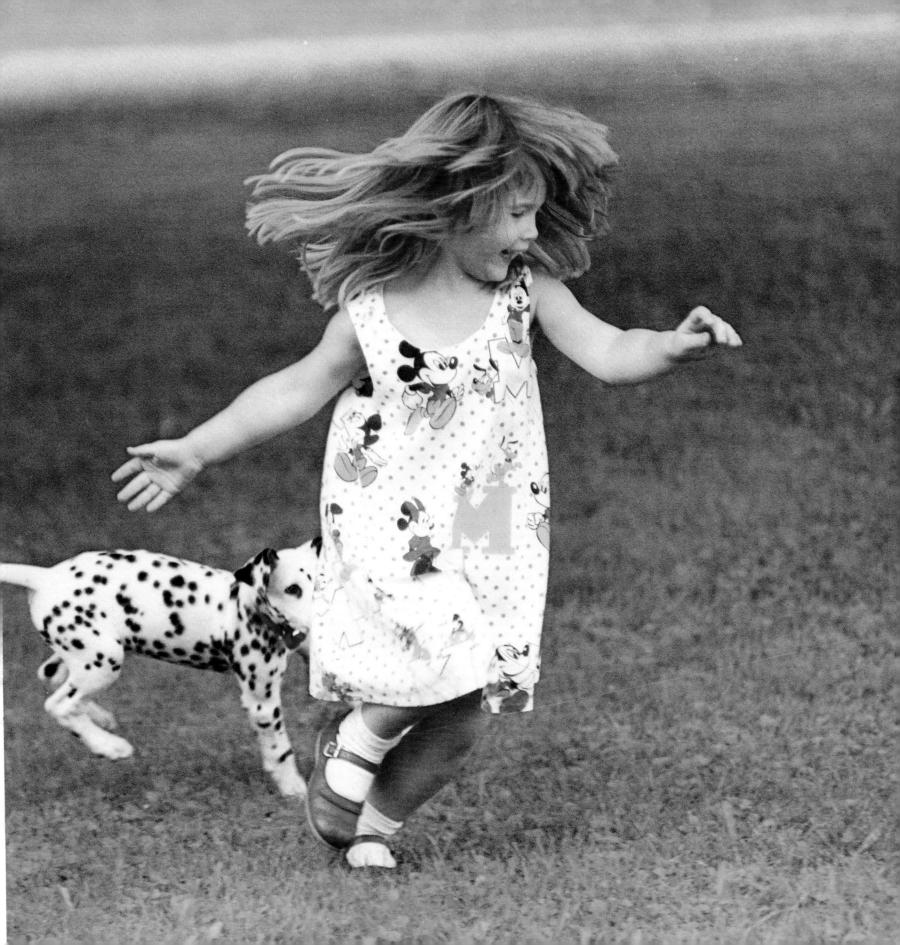

DAVID W. LEWIS
PHOTOGRAPHER AND
PHOTO HISTORIAN

DAVID LEWIS, a resident of Callander, Canada, in the province of Ontario, has devoted his life's work to mastering historic photographic processes. He is one of the last surviving craftsmen able to produce photographs by the bromoil, carbon and carbro, gelabrome, and cyanotype processes, all common

to an earlier era.

Besides a strong dedication to his craft, Lewis is an active professional photographer. He is Senior Vice President for Gilbert Studios in Toronto, Canada, where he is responsible for all corporate photography. His professional work includes portraiture, public relations, and advertising photography.

Before joining Gilbert, Lewis was a freelance photographer whose work included a contract with The Ministry of Natural Resources. Previously, he had been a photographic supervisor for Creative Light and Sound, Ltd. of Toronto.

Gilbert has studied extensively in England and Wales with masters of historic photographic processes, including Georgia Procter-Gregg and Trevor Jones.

OPPOSITE: Judging the 1991 KINSA photography contest at Eastman Kodak Company headquarters in Rochester, New York.

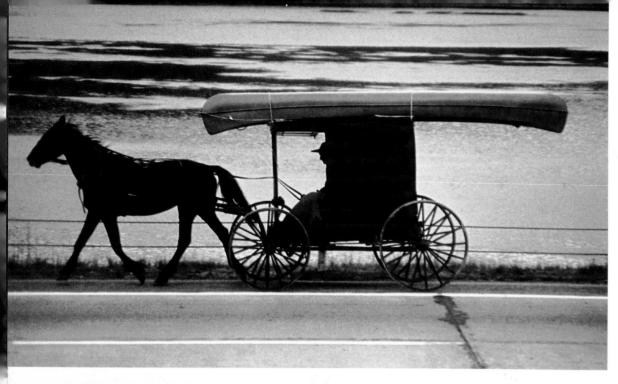

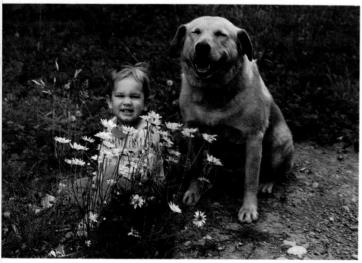

ABOVE: Two happy friends, 1990.

TOP: A surprising moment in Pennsylvania, 1968

Surely the sight of a canoe traveling atop a horse-drawn Amish carriage was as startling to Eric Stewart in 1968 as it is to each viewer of his photograph. One imagines him coming upon the unlikely scene, doing a double take, then having the presence of mind to take his memorable snapshot. The kinsa contest judges recognized Stewart's spontaneity, his proficiency, and the whimsy of the situation with their top award.

In recent years, especially since Mexican newspapers joined the contest in 1977, KINSA has become an international contest, underscoring the oneness of individuals in today's global society. Despite this, as the contest has become more international, it has stayed more and more the same. Of the thousands of pictures entered each year, the three most popular themes remain babies, pets, and animals.

Against a background of ongoing strife in Asia, Africa, and the Middle East, a dramatically changing Eastern Europe and Soviet Union, and a warming planet beset with environmental concerns, kinsa photographs overwhelmingly reflect the optimism, beauty, and tenderness of our people and our world.

The contest has expanded to include photographs from Canada, Chile, and Mexico, as well as from the United States. People of many nations appear in suspended animation, as do their children, pets, homes, and modes of transportation. Through KINSA eyes and images, the world remains a beautiful place, filled with charm, humor, and irony.

Whatever the coming years may bring, KINSA will continue to reflect in its photographs our world, its people, and a fascinating glimpse into a thousand lives.

KINSA Judges Since 1935

1935 SARA DELANO ROOSEVELT, Mother of President Franklin D. Roosevelt EMILY POST, Authority on Modern Manners & Social Customs Lowell Thomas, World Traveler, Author, Lecturer, News Commentator HIRAM PERCY MAXIM, President of Amateur Cinema League Kenneth W. Williams, Eastman Kodak Company

1936 AMELIA EARHART, AVIATTIX
ALBERT W. STEVENS, Cdr/National Geographic Army Air Corps
Stratosphere Balloon
GEORGE HENRY HIGH, FRPS of Great Britain
MRS. CALVIN COOLIDGE, Wife of President Calvin Coolidge
KENNETH W. WILLIAMS, Eastman Kodak Company

1937 RUTH ALEXANDER NICHOLS, Babies & Children Photographer FRANKLIN L. FISHER, Chief of Illustrations, National Geographic HOWARD CHANDLER CHRISTY, Portrait Photographer, Illustrator & Writer MARGARET BOURKE-WHITE, Photographer of Industrial & News-Interest Subjects

KENNETH W. WILLIAMS, Eastman Kodak Company

1938 TONI FRISSELL, Society & Fashion Photographer
GEORGE HENRY HIGH, FRPS, Oval Table Society
NORMAN ROCKWELL, Artist & Illustrator of Human-Interest Subjects
CORNELIA OTIS SKINNER, Actress, Radio Star & Amateur Photographer
KENNETH W. WILLIAMS, Eastman Kodak Company

1939 NEYSA MCMEIN, Artist & Illustrator
JOHN OLIVER LAGORCE, ASSOCIATE Editor, National Geographic
WALTER DORWIN TEAGUE, Industrial Designer & Photographic Critic
LOWELL THOMAS, World Traveler, Author, Lecturer, News Commentator
KENNETH W. WILLIAMS, Eastman Kodak Company

SIR E. WYLY GRIER, Canadian Painter & Art Critic FRANK LIUNI, Camera Pictorialist, President of Photographic Society of America DR. ARTHUR D. OLMSTED, Photographic Authority, Smithsonian Institution NORMAN BEL GEODES, Designer & Expert Photographer

1941 IVAN DMITRI, Internationally Known Photographer Mrs. Osa Johnson, Famous Explorer & Photographer McClelland Barclay, Noted Illustrator, Painter & Amateur Photographer Dr. Gilbert Grosvenor, President & Editor, National Geographic Society Kenneth W. Williams, Eastman Kodak Company

1942 WALT DISNEY, Artist, Creator of Disney Cartoons ELEANOR PARKE CUSTIS, FRPS, Pictorialist & Salon Exhibitor MAJOR GENERAL DAWSON OLMSTEAD, Chief Signal Officer, U.S. Army JOHN S. ROWAN, Pictorialist & President of Photographic Society of America

KENNETH W. WILLIAMS, Eastman Kodak Company

KENNETH W. WILLIAMS, Eastman Kodak Company 947 Toni Frissell, Photographic Illustrator

YOUSUF KARSH, Photographer of Celebrities
CHARLES B. PHELPS, JR., President of PSA & Prominent Salon Exhibitor
LOWELL THOMAS, World Traveler, Author, Lecturer, News Commentator
KENNETH W. WILLIAMS, Eastman Kodak Company

1948 VALENTINO SARRA, Photographic Illustrator FRANKLIN L. FISHER, Chief of Illustration Division, National Geographic TANA HOBAN, Photographer of Babies & Children ANSEL ADAMS, Photographer of the West, Author & Lecturer KENNETH W. WILLIAMS, Eastman Kodak Company

1949 HAROLD BLUMENFELD, Editor of Acme Newspictures
JULIEN BRYAN, Photographer & Lecturer
MEINILE GROSVENOR, Assistant Editor, National Geographic
LEJAREN A. HILLER, Photographic Illustrator
KENNETH W. WILLIAMS, Eastman Kodak Company

1950 KIP ROSS, Staff Picture Editor, National Geographic Josef Schneider, Photographer of Babies and Children S. W. Mautner, Executive Editor, IN Photos John G. Mulder, President, Photographic Society of America Kenneth W. Williams, Eastman Kodak Company

1951 EDWIN L. WISHERD, Chief of Photography Lab, National Geographic YLLA, Photographer of Animals
OLLE ATKINS, Photographic Illustrator
EVAN DMITRI, Photographic Illustrator
KENNETH W. WILLIAMS, Eastman Kodak Company

1952 STEVAN DOHANOS, Magazine Artist & Illustrator HALLECK FINLEY, Photographic Illustrator B. Anthony Stewart, Senior Staff Photographer, National Geographic ROBERT BOYD, President, National Press Photographers' Association Kenneth W. Williams, Eastman Kodak Company

1953 ROBERT KEENE, Photographic Illustrator WILLIAM TAYLOR, Chairman, School of Journalism, Kent State University THOMAS CRAVEN, President, White House News Photographers' Association WALTER M. EDWARDS, Asst. Illustrator, Editor, National Geographic

Walter M. Edwards, Asst. Illustrator, Editor, National Geograph Kenneth W. Williams, Eastman Kodak Company

1954 LOUISE DAHL WOLFE, Staff Photographer, Harper's Bazaar ANTON BRUEHL, Nationally Known Photographer JOSEPH COSTA, Chairman, National Press Photographers' Association LUIS MARDEN, Photographer/Member, Foreign Ed. Staff, National Geographic

KENNETH W. WILLIAMS, Eastman Kodak Company
RICHARD BEATTIE, Eminent Photographic Illustrator
HAROLD BLUMENFELD, Executive Newspictures Editor, UP Association
RAY MACKLAND, Picture Editor, Life
ANDREW POGGENPOHL, Senior Illustrations Editor, National Geographic
KENNETH W. WILLIAMS, Eastman Kodak Company

1956 Henry Burroughs, President, White House News Photographers' Association

HERBERT S. WILBURN, JR., ASST. Illustrations Editor, National Geographic Don Bennett, Editor, PSA Journal
SIR Ellsworth Flavelle, Canadian Photographer & Salonist
Kenneth W. Williams, Eastman Kodak Company

1957 PHOEBE DUNN, Camera Editor, Parents Magazine
NORMAN ROCKWELL, Illustrator & Painter
FRANC SHOR, Assistant Editor, National Geographic
MURRAY AIVEY, President, White House News Photographers' Association
PETER J. Braal, Eastman Kodak Company

1958 JOHN W. HUGHES, Chief, Still Pictures, National Film Board of Canada Edward Wergeles, Cover Director, Chief of Photography, Newsweek Leonard J. Grant, Asst. Illustrations Editor, National Geographic Howell Conant, Magazine Photographer & Illustrator Peter J. Braal, Eastman Kodak Company

1959 JAMES M. GODBOLD, Director of Photography, National Geographic Max Despor, Supervising Editor, Wide World Features Pix, AP Larky Keighley, Special Assignment Photographer, Saturday Evening Post George R. Gaylin, Manager, Washington Bureau, UPI Newspictures Peter J. Braal, Eastman Kodak Company

1960 ROBERT L. BREEDEN, ASST. Illustrations Editor, National Geographic GORDON N. CONVERSE, Chief Photographer, The Christian Science Monitor
SUZANNE SZASZ, Magazine Photographer & Illustrator

CLIFF EDOM, ASSOC. Professor & Director of Journalism, Univ. of Missouri Peter J. Braal, Eastman Kodak Company

1961 GILBERT M. GROSVENOR, Editorial Staff, National Geographic Arthur Rothstein, Technical Director, Photo Department, Look Irving Desfor, Photo Columnist, AP Jon Abbot, Photo Illustrator & Color Specialist Peter J. Braal, Eastman Kodak Company

1962 Chris Lund, Photographer, National Film Board of Canada Robert E. Gilka, National Geographic Society Yoichi R. Okamoto, U.S. Information Agency Otto Storch, Art Director, McCall's Peter J. Braal, Eastman Kodak Company

1963 Mary S. Griswold, Assistant Illustrations Editor, National Geographic Walter Chandoha, Noted Photographer of Animals Frank Zachery, Art Director, Holiday William A. Berns, VP for PR, NY World's Fair Corporation Рете

1964 WILLARD N. CLARK, Editor & Publisher, U.S. Camera Ormond Gigli, NY Photographer & Color Specialist Thomas R. Smith, Editorial Staff, National Geographic Conrad L. Wirth, Retired Director, National Parks System Peter, J. Braal, Eastman Kodak Company 1965 RICHARD BEATTIE, Freelance Photographer ALLEN HURLBURT, Art Director, Look WILLIAM E. GARRETT, National Geographic Society JULIA S. SCULLY, Editor, CAMERA 35 PETER J. BRAAL, Eastman Kodak Company 1966 IVAN DMITRI, Director, Photography in the Fine Arts JOHN DURNIAK, Editor, Popular Photography JOSEPH B. ROBERTS, Asst. Director of Photography, National Geographic LORRAINE MONK, Head of Still Photography, National Film Board of PETER J. BRAAL, Eastman Kodak Company DEAN CONGER, Writer-Photographer, National Geographic MAURICE JOHNSON, Staff Photographer, UPI MYRON MATZKIN, Senior Editor, Modern Photography Ozzie Sweet, Freelance Photographer PETER J. BRAAL, Eastman Kodak Company 1968 RICHARD O. POLLARD, Director of Photography, Life WILLIAM W. CARRIER, JR., President, PPofA WINFIELD PARKS, Photographer, National Geographic GLEN FISHBACK, Glen Fishback School of Photography PETER J. BRAAL, Eastman Kodak Company JACK DESCHIN, New York Times CHRIS LUND, National Film Board DICK LEACH, Scholastic BATES LITTLEHALES, National Geographic Society PETER J. BRAAL, Eastman Kodak Company 1970 Brother Norman Provost, Photo Teacher, Mater Christi High School O. Louis Mazzatenta, Asst. Illustrations Editor, National Geographic ROBERT BODE, Freelance Photographer JOHN JACKSON, VP & Director of Stage Operations, Radio City PETER J. BRAAL, Eastman Kodak Company 1971 IRVING (DOC) DESFOR, AP, NYC GORDON N. CONVERSE, The Christian Science Monitor VOLKMAR (KURT) WENTZ, Foreign Editorial Staff, National Geographic BYRON E. SCHUMAKER, White House Photography Staff PETER J. BRAAL, Eastman Kodak Company 1972 RAY ATKESON, Freelance Photographer BROTHER NORMAN PROVOST, Photo Teacher, LaSalle Military Academy JOSEPH SCHERSCHEL, Photographer, National Geographic PROF. ARTHUR TERRY, Illustrations & Photojournalism Dept., RIT PETER J. BRAAL, Eastman Kodak Company 1973 Jon Abbot, Color Specialist & Photo Illustrator SETH FAGERSTROM, Senior VP, Art, Rumrill Hoyt ALAN ROYCE, Assistant Illustrations Editor, National Geographic Julia Scully, Editor, Modern Photography PETER J. BRAAL, Eastman Kodak Company 1974 EDWARD E. BETZ, Owner & Professional Photographer, Marsh Studios Ozzie Sweet, Freelance Photographer

DICK FAUST, Professional Commercial Photographer, Dick Faust Studio, JAMES L. STANFIELD, Staff Photographer, National Geographic LEE HOWICK, Eastman Kodak Company 1975 ELIE ROGERS, Assistant Illustrations Editor, National Geographic MARGARET W. PETERSON, Freelance Photographer CHARLES REYNOLDS, Photo Editor, Popular Photography CASEY ALLEN, Professor, NY Univ. & Host of "In & Out of Focus" TV LEE HOWICK, Eastman Kodak Company

1976 Patricia A. MacLaughlin, University of Illinois BEN KUWATA, J. Walter Thompson Company ROBERT S. PATTON, National Geographic Society JAMES E. McMILLION, JR., RIT LEE HOWICK, Eastman Kodak Company

1977 CHARLES E. MORRIS, APSA, Photographic Society of America DECLAN HAUN, National Geographic Society Jose Rodriguez Estrada, PR Director, Novedades, Mexico ROBERT W. HAGAN, Ford Motor Company LEE HOWICK, Eastman Kodak Company

1978 WILLIAM L. ALLEN, JR., National Geographic Society WILLIAM S. SHOEMAKER, Professor, Photographic Sciences, RIT JOHN BARRAS WALKER, Contributing Editor, Canadian Photography JORGE FERNANDEZ, El Imparcial de Hermosillo, Mexico LEE HOWICK, Eastman Kodak Company

1979 Anne Dirkes Kobor, Illustrations Editor, National Geographic Том Bochsler, Commercial & Industrial Photographer, Ontario, Canada HECTOR HERNANDEZ AVILES, PR Director, El Sol de Tampico, Mexico Manfred H. Strobel, Corporate Photographer, Chrysler Corporation LEE HOWICK, Eastman Kodak Company

MONICA CIPNIC, Associate Picture Editor, Popular Photography & Camera

THOMAS POWELL, Illustrations Editor, Spl. Publications, National

Geographic PROFESSOR WILLIAM S. SHOEMAKER, RIT

Dora Luz Guerrero, General Manager, La Opinion, Mexico LEE HOWICK, Eastman Kodak Company

1981 Dr. RICHARD ZAKIA, Chairman, Fine Arts, Photography Dept., RIT HENRY GREENHOOD, President, Photographic Society of America Frank Grant, President, Professional Photographers of Ontario JAMES AMOS, Photographer, National Geographic JORGE MEDINA MORA, Creative Director, Ad Agency, Mexico

NORMAN KERR, Eastman Kodak Company 1982 Mark Hobson, Freelance Photographer

DAVID JOHNSON, Picture Editor, Special Publications, National Geographic H. Warren King, Teacher of Photography, Reseda High School ALEJANDRO SEGURA, Novedades, Mexico LEE HOWICK, Eastman Kodak Company

1983 LENORE HERSON, VP, Imagebank BANK LANGMORE, Freelance Photographer BILL BUCKETT, Bill Buckett Associates SUSAN A. SMITH, Chief of Film Review, National Geographic LEE HOWICK, Eastman Kodak Company

1984 LUCY H. EVANKOW, Picture Editor, Scholastic ROBERT M. HERNANDEZ, Illustrations Editor, National Geographic Frank Pallo, President, Photographic Society of America ARTHUR ROTHSTEIN, Associate Editor, Parade NORM KERR, Eastman Kodak Company

DEWITT BISHOP, Past-President, Photographic Society of America RICHARD CLARKSON, Assistant Director of Photography, National

> FREEMAN PATTERSON, Professional Photographer, Author & Lecturer Myron Sutton, Professional Photographer & Author

KEITH BOAS, Eastman Kodak Company

BETTY DIMOND, Honorary Member, Photographic Society of America ALVA DORN, Photo Columnist, Retired Picture Editor, The Kalamazoo

KENT KOBERSTEEN, Illustrations Editor, National Geographic NORM ROTHSCHILD, Senior Editor, Popular Photography CARL NIELSEN, Eastman Kodak Company

EDDIE ADAMS, Professional Photographer, Winner of Pulitzer Prize JANET CHARLES, Professional Photographer FRED GRAHAM, Director of Photography, Walt Disney World THOMAS KENNEDY, Director of Photography, National Geographic DEREK DOEFFINGER, Supervising Technical Editor, Eastman Kodak Company

1988 WILLIAM T. DOUTHITT, Illustrations Editor, National Geographic FRED GRAHAM, Photography & Audio Visual Productions, Walt Disney

Louis Psihoyos, Professional Photographer BILLIE B. SHADDIX, Director (retired), The White House Photographic

SUSAN VERMAZEN, Picture Editor, New York Magazine

JOSEPH H. BAILEY, Staff Photographer, National Geographic FRED GRAHAM, Manager of Photography, Walt Disney World Douglas Kirkland, Professional Photographer & Author of Light Years ELIANE LAFFONT, President of SYGMA Photo Agency MARIANNE BUMP LURIE, Associate Film Producer & Rep of INMA

FRED GRAHAM, Manager of Photography, Walt Disney World GENE HATTORI, Professional Photographer, Saskatchewan, Canada GERARDO LARA GZZ., El Norte, Mexico Paula Markiewicz, International Newspaper Marketing Association

KATHY MORAN, Picture Editor, National Geographic

w.				
	161			